Dot·To·Dot
CULTURE

ALL YOU REALLY NEED TO KNOW ABOUT ART, MUSIC, THEATRE, DANCE & ALL THAT STUFF

By James D. Smith

Illustrated by Jonathan Massie

Peachtree Publishers, Ltd.

Published by
Peachtree Publishers, Ltd.
494 Armour Circle, N.E.
Atlanta, Georgia 30324

Manufactured in the United States of America

10 9 8 7 6 5 4 3 2 1

Library of Congress Catalog Card Number 87-80970

ISBN 0-934601-29-1

Cover design by Paulette L. Lambert

CONTENTS

In memory of
James Curtis Smith
and
Paul Joseph Scully

INTRODUCTION

Art! Who comprehends her? With whom can one consult concerning this great goddess?
— *Ludwig van Beethoven*

So you slept through Fine Arts 101. Don't worry, you've got plenty of company. So did nearly everybody else, except for that anemic little toad with the lisp who sat in the front row and invariably had the correct answers to all the questions. The problem now is that the toad is president of your company, has converted his lisp into an upper-crust accent, and is schmoozing with everybody in sight who knows the difference between Manet and Monet, Picasso and Pissarro.

But that's not the half of it. The other problem is that when and if you *do* get a chance to spend some time with the Boss — eyeball-to-eyeball over a business luncheon — you'll be so nervous about whether you're using the right fork that you're likely to dribble salad dressing all over yourself. And heaven forbid if the Boss should turn the conversation to tennis, movies, antiques or whatever subject he or she holds dear.

Were you paying attention in Fine Arts 101?

What to do?

A year in Europe would certainly take the rough edges off your crude exterior, but that's expensive and impractical. A top-notch finishing school could probably teach you the difference between "black tie" and "white tie" on invitations to formal affairs. And there are tons of self-help books on the market if you ever have time to wade through them all.

There must be a better way.

And there is. The fact is, 99 percent of all small talk is exactly that — small talk. Whether it is about art, music or drama, most chitchat rarely strikes beneath the surface. And the social graces — from ordering wine to apologizing gracefully when something goes awry — are all matters that a few well-placed pointers can do wonders to improve.

You don't need the Encyclopedia Britannica *or* Amy Vander-

bilt. What you do need is a quick course in the finer things in life on the cultural and social levels. And, at the same time, you've got to protect yourself against the fatal *faux pas* [FOE PA] — literally, in French, a *wrong step* — confusing architect I.M. Pei with linguist Mario Pei, for example — while holding up your end of the conversation.

The purpose of this book is to give you a quick and handy insight into those subjects collectively known as culture, whether they be fine art, pop art, high, low or in-between art. At the same time, the emphasis will be on telling you, in a nutshell, what you *really* need to know rather than loading you down with an encyclopedic repertoire of knowledge. You know, sort of a Cliff's Notes on What's What in the Arts.

At the minimum, you should be able to get enough of a feel for culture to be able to pitch in with a choice comment at a particularly appropriate moment, letting whomever you must impress know that you haven't just fallen off the proverbial turnip truck.

DOT-TO-DOT CULTURE is what you *really* need to know. Then you're on your own. Armed with the gist of things cultural — and basic good sense — you're ready to hold your own in any company.

Keep in mind Spencer Tracy's sage advice on acting: "Just know your lines and don't bump into the furniture."

And try not to knock over your host's prize Ming vase while arguing the superiority of Mozart over Brahms.

Expanding Your Frame of Reference

The first virtue of painting is to be a feast for the eyes.
— *Eugene Delacroix*

It's pretty, but is it Art?
— *The Devil, as quoted by Rudyard Kipling*

If you don't have to be afraid of Virginia Woolf, or things that go bump in the night, or fear itself, you certainly have nothing to fear from the Mona Lisa. Or from her friends.

The nicest thing about art is that you don't need to be an expert to enjoy it. Paintings, sculpture and photographs — the sorts of things you'll find on display in most art galleries and museums — can be taken "as is" and enjoyed for your response to them. This is not, of course, the way the critics look at art, but it's certainly a starting place. At some point, however, it's nice to know a little something about the artists who created the works. And once you find out more about the artists, you might just want to know a little bit about art movements, history and so forth. Then you're well on your way to becoming as much (or as little) of an expert as you care to be.

But, relax, you're not about to have to endure an art history

course replete with scores of slides of paintings, sculptures and photographs whose names you'll be expected to memorize. The idea here is to hit the high points and leave the small stuff to the professionals. And, there are no pop quizzes in DOT-TO-DOT CULTURE!

So plop down in your favorite overstuffed chair, pull something cozy up over your toes, and take it easy. If you sip a little French wine (a "delightful" Beaujolais) along the way, so much the better. When talking art, it always helps to be in the right frame of mind.

First, the Background Stuff

Skimming a Few Thousand Years

In the beginning, many thousands of years ago, primitive people in France and other countries used pigments to paint hunting scenes featuring deer, elk, bison, goats, cows and pigs on the walls of the caves they used for shelter.

Obviously, this was long before anyone realized you could make millions of bucks as a famous artist and wind up on the cover of *People* magazine. These prehistoric folk simply wanted to add a little pizazz to the interior decor by recording images of things and events that were important in their lives.

Since France is where many of these cave paintings are found, at places such as Lascaux [La-SKOH], it is only fitting that France has long been considered the center of the art world.

Between the cave paintings and the Renaissance, you need to be aware that African, Egyptian, Greek, Roman, Indian, Chinese and Japanese cultures all had their own forms of art.

So, if someone you hold in high esteem rambles on about the splendor of the Elgin [a hard "g"; it's EL-gen, not EL-jin] marbles in the British Museum, for heaven's sake don't respond by getting maudlin over your favorite childhood boxcar or cateye. They're not those kind of marbles. Rather, you should praise the beauty of these ancient Greek marble sculptures from the Par-

Sprucing up the cave with artwork

thenon, which were brought to England by Thomas Bruce, the seventh Earl of Elgin.

You can always use any mention of the marbles as the appropriate moment to slip in a line or two from the English romantic poet John Keats, who was so impressed by the beauty of classical Greek art that he wrote *On Seeing the Elgin Marbles* ("each imagined pinnacle and steep/ Of godlike hardship tells me that I must die/ Like a sick eagle looking at the sky") and the more well-known *Ode on a Grecian Urn* ("Beauty is truth, truth beauty").

You can spend a lifetime studying any one of these ancient cultures' art forms. It's indisputable that primitive African art influenced the great European artists such as Pablo Picasso (art buffs point out the similarities, for example, between African tribal masks and the faces of the women in *Les Demoiselles*

d'Avignon), and Japanese art had an impact on Vincent van Gogh, as well as others.

But the fact is that the bulk of art you'll find on display in American or European museums or that you're likely to encounter references to in cultural circles is of fairly recent origin (especially the last two hundred years) and is largely from American and Western European sources.

It's a nice touch, though, if you know that the Freer and Arthur M. Sackler galleries for Asian and Near Eastern art in Washington house two of the world's great collections of Oriental art. Or that the Nelson A. Rockefeller Collection at the Metropolitan Museum in New York is one of the finest holdings of African art.

Forget the Middle Ages, Bring on the Renaissance

Not quite so long ago, especially during the fifteenth and sixteenth centuries, all the arts and sciences experienced a rebirth, particularly in Italy. For a period of about ten centuries after the decline and fall of the Roman Empire, the world had been in a cultural (and otherwise) state of ill health (that's why a large chunk of this period was called the Dark Ages; it had nothing to do with the lack of electricity or television, but the lamp of inquiry had become but a dim flicker).

The Renaissance, which is simply a culturally elegant word for rebirth, not only affected the world of art, but saw a period of widespread reawakening in all fields. The discovery of the New World by Columbus, the use of movable type for printing by Gutenberg, the formulation of new theories about the solar system by Copernicus and Galileo and the rise of English literature through such writers as Chaucer, Shakespeare and Spenser are all events that occurred roughly during the period of time known as the Renaissance.

The Renaissance got the world all fired up again after the long, hard trek slogging through the Middle Ages. It was like a week in the ocean air after a gruelling year pent up in the city. And there at the beach, catching the best waves, were two who today bear the

tag of *Renaissance men*. Multifaceted and talented, they exemplify the best of what the era was all about. Their names are Leonardo da Vinci and Michelangelo.

Mona Lisa's Mystery: Why Is This Woman Smiling?

She's the woman with a thousand faces, the lady with the enigmatic smile you can't figure out or forget, the Mona Lisa. Leonardo da Vinci's greatest puzzle, she hangs out at the Louvre [LOOV] art museum in Paris.

That coy half-smile of hers is a mystery that has been driving art *aficionados* (a Spanish word for avid fans) bonkers for centuries. Maybe she's smiling because she's remembering the excuse she gave the traveling wine merchant from Venice who tried to pick her up at the *ristorante* bar the night before. Or perhaps *La Gioconda*, as she's also known, is practicing her "come hither" look for her next great flirtation. Some think she was flirting with Leonardo, but that's mostly speculation.

What she doesn't know is that her face will become so famous that one day other artists will borrow it for their works, as dada artist Marcel Duchamp did in his 1919 parody *L.H.O.O.Q.* (he added a mustache and goatee) or as pop artists Robert Rauschenberg and Andy Warhol did in 1958 and 1963 versions that each titled *Mona Lisa*.

But, if you really want to impress, you'll chat about the theory that the model for the Mona Lisa was none other than crafty old Leonardo (his friends never call him "da Vinci" and you shouldn't, either). The sculptor, architect, engineer, mathematician, musician, poet, painter and naturalist wrote thousands of pages of notebooks in mirror script, writing from right to left. The latest theory — thanks to a computer-imaging technique — on the Mona Lisa is that the smiling face in the painting is none other than a mirror image of Leonardo's own puss. The joke, it seems, may have been on us all along.

Although the *Mona Lisa* is one of those works that just about anybody could pick out of a lineup, there's another painting of the same era that far fewer people would identify as being *Renais-*

sance. Titled *The Garden of Earthly Delights*, this phantasmagoric vision of Hell (done on three panels, called a *triptych*) by Dutch painter Hieronymus Bosch is as macabre and unsettling as anything twentieth-century surrealist Salvador Dali would later produce.

Leonardo's other great work is the *Last Supper*, which was painted on a plaster wall in the refectory of Santa Maria delle Grazie cloister in Milan (so don't ever claim you saw it hanging in a museum). Art buffs like to extol Leonardo's mastery of perspective (the ability to create an illusion of depth) and composition (the way the various elements are arranged) as demonstrated in the *Last Supper*. An alternative version of the Last Supper (and there have been many down through the years) that you can see in an American museum is Dali's *The Sacrament of the Last Supper* in the Chester Dale Collection at the National Gallery of Art in Washington.

That Divine Angel of a Man, Michelangelo

Michelangelo Buonarroti was an architect, sculptor and poet in addition to being a painter. It was easier to be a Renaissance man in Leonardo and Michelangelo's time since they never wasted entire Sunday afternoons in front of the TV set, watching two lower-division NFL teams battle it out for last place.

Michelangelo spent about four years of afternoons painting the ceiling of the Sistine Chapel in Rome. The most well-known of these frescoes (which are painted in wet plaster) is *The Creation of Man*, which shows God's finger reaching out to touch Adam's finger with the spirit of life. *The Last Judgment*, another work of Michelangelo's in the Sistine Chapel, was begun on a wall twenty-five years later and should not be confused with the work on the ceiling.

In addition to his work as a painter, Michelangelo is remembered for his sculpture, particularly three pieces: the *Pietà*, which is a work showing Mary grieving over the body of Christ; *David* (without a fig leaf, please); and *Moses*, which bears a striking resemblance to Zeus. Michelangelo gave life to the human form in marble in a way that few have been able to approximate.

The Dutch painters were masters, especially Rembrandt

Bridging the Gap After the Renaissance

Some people argue that the Renaissance never really ended, that it simply continued at a slower pace until the twentieth century popped things back into high gear. That is the sort of highly philosophical argument best left for future generations with a greater gift of hindsight. Suffice it to say that most scholars write *finis* to the Renaissance sometime around the end of the sixteenth century.

Between that somewhat fuzzy point in time (there was never a bell that sounded, followed by an announcement that the Renaissance would be ending in fifteen minutes) and the beginning of the next great movement, impressionism, the dominant form of art that held sway was realism.

In the seventeenth century especially, an ornamental, highly

elaborate form known as *baroque* flourished not only in painting, but in sculpture, architecture and music. Today, we look upon baroque art as heavily overdecorated, even to the point of being gaudy. One of the most famous baroque painters is Peter Paul Rubens, a Flemish artist whose works are characterized by their enormous size, peopled with fleshy men and women who must have been perpetually in need of going on a diet. *The Apotheosis of Henry IV* in the Louvre is typical of his exuberant baroque style.

Perhaps the most famous painter of the time, however, was the Dutchman known today simply as Rembrandt. Although extremely successful, especially as a portrait painter of the rich and famous, he had an appetite for the finer things in life, which would eventually lead him to bankruptcy. His most famous paintings include *The Anatomy Lesson of Professor Tulp* and *The Night Watch,* as well as numerous self-portraits.

Among baroque sculptors and architects, the name of Giovanni Bernini stands above the rest. Bernini's fountains in Rome, especially the *Four Rivers* in the Piazza Navona, and his statue of *David* remain his signature pieces.

In the eighteenth century a form known as *rococo* developed in France during the reign of Louis XV. It was even more florid than the baroque and its most well-known practitioner was Antoine Watteau, who was sort of an eighteenth-century Robin Leach (you know, *Lifestyles of the Rich and Famous*). His works often depict society's upper crust decked out in all their delicate finery amid elegant settings of mansions, grand fetes, and country excursions. One of his most well-known paintings is *Embarkation for Cythera*.

Rococo sculpture and architecture are noted for their elaborate ornamentation, using flowers, foliage or shells in such a heavy-handed manner that the object itself often becomes lost underneath the decoration.

However, neither of these styles caught on particularly well in England, where portraiture was still the preferred art form in the eighteenth century, as demonstrated by the work of Thomas Gainsborough whose *Blue Boy* was painted in response to his

Thomas Eakins's nudes were controversial

rival Sir Joshua Reynold's double-dog-dare-you pronouncement that blue could not be used as a dominant color in a painting.

Others you should know from this period in England include William Hogarth (a painter turned satirist whose *Rake's Progress* series of engravings was immensely popular), John Constable (he painted the landscapes that poets Wordsworth and Keats were writing about), William Turner (his landscapes and seascapes, such as *The Snowstorm,* contain swirls of color that appear as if they're being viewed through a frost-coated window; *The Burning of the Houses of Parliament* is one of his most famous works), and William Blake (the visionary poet-painter, you know, "To see the world in a grain of sand") whose works were primarily illustrations for his books, such as *Songs of Innocence.*

This period in England did produce one notable exception, a group of mid-nineteenth-century painters (Dante Gabriel Rossetti, John Everett Millais and W. Holman Hunt) who sought to bring about a "back-to-the-basics" movement. Since Raphael, a Renaissance painter and sculptor, was seen as the epitome of the style in favor among academicians of the day, their name reflected their desire to take art back to simpler times — before Raphael.

In the United States, Thomas Eakins was developing the art of realism to a fine point with his portraits that tended to shock and offend with their bold authenticity. A proponent of paintings from nature, especially the nude, he stayed in hot water with the critics of his day, who sought a more genteel art. The realism of his *Gross Clinic*, with its blood on the operating table, was more than nineteenth-century Philadelphia society could endure.

Meanwhile, back on the Continent, Eugene Delacroix was leading French painters into nineteenth-century romanticism (not in the Romeo and Juliet sense) with works that stressed emotion and individuality over the classical notions of restraint and form. Delacroix, who is considered the father of modern French art, was not only a painter, he was a journalist, critic and lover of music. Two of his paintings, *The Execution of Marino Faliero* and *Death of Sardanapalus,* were based on themes provided by the British romantic poet Lord Byron.

Making a Lasting Impression

Marcel Marceau is not a French impressionist. He's French, but he's a mime. Rich Little is not a French impressionist, either. He does impressions, but he's not French. French impressionists are the painters associated with the nineteenth-century art movement known as impressionism.

For impressionists, the central problem of art had to do with how light affected the objects it illuminated. Claude Monet [Mo-NAY], for example, got carried away with painting a view of the front of Rouen Cathedral numerous times to catch the various shadings of light at different times of the day. This explains why *Rouen Cathedral* shows up in so many different museums — they're not copies or forgeries, just different versions.

Be careful not to confuse Monet with Edouard Manet, who supported the impressionist movement and is sometimes called the father of impressionism, but is not an impressionist himself. He pointedly refused to exhibit his works with the impressionists, opting instead for the status and prestige of the Salon, the famous and exclusive Paris exhibition. An easy way to keep the two painters straight is to remember that Manet (with an "a") comes before Monet (with an "o") in alphabetical and chronological order. One of Manet's well-known works is *The Picnic*, which depicts two fully clothed men in a pastoral setting with one nude woman and another woman preparing to go swimming.

Paul Cezanne (famous for his landscapes that give the world a patchwork quilt look), Pierre Auguste Renoir (best known for his portraits), Henri Toulouse-Lautrec (renowned for his posters, especially of dancing girls, advertising Paris hot spots such as the Moulin Rouge), and Edgar Degas [Ed-GAR Duh-GAH] (known for his ballet dancers) are others who've made a lasting impression on the art world.

Across the ocean, an American impressionist, Mary Cassatt, specialized in warmly human scenes of women and children, such as her *Mother and Child*. Her rosy-cheeked boys and girls and her upper-class women in their Sunday finery harken back to the slower-paced time at the dawning of the twentieth century. Cassatt was great buddies with Degas, who painted a portrait of

van Gogh's girl would have preferred roses

her. Some hoped the relationship was more than the buddying kind, but as far as we know, it wasn't.

And if you really want to strut your stuff, mention your deep affection for the Courtauld Collection in London, one of the world's great collections of impressionist and post-impressionist art, brought together (and bought) by Samuel Courtauld, a British textile baron.

It's All in the Ear of the Beholder

Vincent van Gogh [van GOH] was the epitome of the misunderstood, starving artist. He was so poor he once cut off an ear and gave it to his girlfriend, who was a hooker. She probably thought that a dozen roses would have been nicer. ("None of the

other girls got ears from their boyfriends for Valentine's Day —
why me?'')

Van Gogh, who was born in Holland, liked to go out at night
and sit in a field in the howling wind (called *the Mistral*) of
southern France (known as *the Midi*) and paint canvases (called
canvases) filled with swirling waves of stars.

Sometimes, Van Gogh, who humbly signed his paintings sim-
ply as "Vincent," would wear a wreath of candles on his head at
night to illuminate the canvas. One of his most famous paintings
is *The Starry Night*, which appears to be the way a starry night
would look if you had a wreath of candles baking your skull at
450 degrees Fahrenheit for thirty minutes and dripping wax all
over your head.

Another well-known Van Gogh work is *Sunflowers*, which sold
for $39.9 million in 1987. This should tip you off that Van Gogh
is *hot* these days. His paintings are consistently fetching top dollar
at auctions, and even the record set by *Sunflowers* isn't likely to
hold up long. Unfortunately, Van Gogh, who sold only one
painting during his short lifetime, didn't make a cent off it.

One reason he didn't sell more work in his own time was that
many people simply thought he was crazy as a loon. And he may
have been. Any number of theories have been put forward as to
just what Van Gogh's problem was; the fact is, nobody knows for
sure. It is a fact, however, that he spent time in asylums at St.
Remy and Auvers. But being aware of such things about him,
you'll refer to the "psychologically disturbing" and "emotional"
nature of his paintings.

To really show your stuff, however, talk about "the frail,
sensitive nature" of the artist as revealed in his letters to his
brother, Theo, who was his lifelong financial supporter and
patron. You, of course, prefer the New York Graphic Society's
hefty three-volume collection of more than 1,600 letters to the
condensed, mass market version, *Dear Theo*, which was com-
piled by Irving Stone. And yes, that was Leonard Nimoy (*Star
Trek*'s Mr. Spock) who played Theo in a one-man stage produc-
tion (*Vincent*) based on the letters.

And you can't help but like the movie version of Stone's biography of Van Gogh, *Lust for Life*, which starred Kirk Douglas as Van Gogh. If you want to score points with the art *and* film crowds, drop a line about Anthony Quinn winning an Oscar in 1956 for best supporting actor for his portrayal of Paul Gauguin [Goh-GAN], who tried rooming with Van Gogh for a while but found the Dutchman flying off in the wrong direction all too often.

Paul Gauguin, a Man of Several Seasons

Before Gauguin attempted living with Van Gogh, he had been a stockbroker and family man who painted as a hobby, though well enough to be exhibited at the Salon. He chucked it all, however, to seek the painter's life, eventually traveling to the South Pacific island of Tahiti. Influenced by Japanese as well as Egyptian art, he pioneered a style known as synthetism, noted for its awareness of the symbolic nature of color.

Though plagued by a lack of funds and problems with the authorities, he spent much of the rest of his days eating pineapples and drinking coconut milk while painting Polynesian nudes. Perhaps Gauguin's most well-known painting is from his Tahitian days: *Where Do We Come From? Who Are We? Where Are We Going?* Earlier paintings you should know are *The Vision After the Sermon* and *The Call*.

Another post-impressionist you like is Georges Seurat [Ser-RAH] (*An Afternoon at La Grande Jatte* and *The Circus*), who developed a type of painting known as pointillism, a technique that called for placing closely spaced dots of different colors on the canvas to achieve various affects of lighting. If you look at each dot individually, it's simply a point of color, but when you step back — voila — you've got yourself a certified work of art. Pointillism is basically the same idea that allows a color television screen to produce a color picture — and DOT-TO-DOT CULTURE to work!

Full Speed Ahead: Welcome to the Modern Era

As the twentieth century dawned, a new movement, expressionism, was already forming in reaction to the impressionists. Leading the expressionist movement was an ex-lawyer, Henri Matisse, who argued that art should be an expression of subjective feelings and emotions. The expressionists liked vivid colors and primitive forms (Matisse's *Lady in Blue*, for example, with its bold blue, red, yellow and black).

Other expressionists worth knowing include members of the German *Die Brucke* and *Blaue Reiter* groups. Two important artists from these groups are Vassily Kandinsky, considered one of the fathers of abstract art, and Oskar Kokoschka, whose *Tempest* is a self-portrait of himself and Alma Mahler, the wife of the expressionist composer Gustav Mahler.

Matisse was also associated with fauvism, a term applied to its practitioners by its critics, who scorned the expressive use of color. The artists — who included Raoul Dufy, Andre Derain, Georges Braque, and Georges Rouault — were branded *fauves*, or "wild beasts." The name stuck. Most of the *fauves* moved on to other things, such as cubism.

Just Call Him Pablo "The Fridge" Picasso

Pablo Picasso, a Spanish-born painter and sculptor, lived most of his adult life in France and is to the world of twentieth-century modern art what William "Refrigerator" Perry is to pro football opponents of the Chicago Bears. You can't go over him, you can't go under him, you can't go around him.

Picasso is *big*. He's the one indisputable *given* of modern art.

During his Blue Period — a time when his work dealt a lot with down-and-out people — he painted in subdued tones, often in a bluish hue. These paintings have been described as melancholic and bleak.

After a few years, Picasso loosened up and entered what is known as his Rose Period, a time when he concentrated on lighter subjects (carnival people and acrobats) and used brighter colors.

Just be sure to refer to it as his Rose (as in flower) Period and not his Rosé (as in wine) Period.

One of Picasso's most well-known works is *Guernica*, a gigantic mural in black and white and gray, which is an allegorical statement (meaning it's based on a real event, but can be viewed on a symbolic level as well) on the destructiveness of war as wrought on the town of Guernica during the Spanish Civil War.

However, Picasso's most influential painting is probably *Les Demoiselles d'Avignon* (*The Women of Avignon*), which, in 1907, heralded the arrival of the art movement connected with his name — cubism.

Long before Rubik hit the toy market with his perverted plastic puzzle, Picasso startled the art world with his version of the cube, a form of art known as cubism. In cubism, everything looks like it was drawn by a computer-crazy, whacked-out engineering student from Toyota Tech.

Central to cubism was the notion that while for years objects in painting had to look like what they were (Michelangelo's angels always looked like angels; his cows and pigs always looked like cows and pigs), it now became acceptable for things to look like geometric shapes. This had to do with the artistic realization that the essence of all objects could be reduced to approximate geometric forms.

Another painter important to cubism is Georges Braque, a pal of Picasso's. Braque liked to draw triangular mandolins, violins, and guitars, as in his *Young Girl With Guitar*. He also developed the art of collage, the placing of various bits of unrelated pieces of paper, cloth and other material together on a flat surface.

Good Golly Miss Molly, It's Dali

Another great modern artist you should know is Salvador Dali. Like Picasso, Dali was born in Spain (any mention of Picasso *and* Dali is a great opportunity to trot out Gertrude Stein's quip: "Painting in the nineteenth century was only done in France and by Frenchmen … in the twentieth century it was done in France but by Spaniards"). Dali liked to paint scenes overflowing with

Dali's clocks seemed to be running

clocks that looked like they had melted from being out in the sun too long. Some people think Dali's brain melted from being out in the sun too long.

Much of Dali's work is considered surreal, which means it looks like he was tripping on drugs when he chose his subjects. Surrealism, a movement linked to the writings of the French poet André Breton and to the psychological theories of Sigmund Freud, emphasized placing everyday objects and apparently unrelated objects together in dreamlike settings (sort of free associating on canvas). For example, one of Dali's paintings is *Ordinary French Bread with Two Fried Eggs, Without a Plate, on Horseback, Trying to Sodomize a Crumb of Portuguese Bread.* And Portnoy thought he had a complaint.

Other surrealists you should know include Max Ernst (a leader of the dada movement), Joan (a man) Miró (*The Birth of the World*) and René Magritte (sometimes called a "philosopher painter"; his *The Use of Words I* is a painting of a pipe with "This is not a pipe" written in French underneath. And, of course, it's not a pipe; it's merely a painting of a pipe.

Time for a Deep Bow to the Bauhaus

One of the most influential of twentieth-century art movements took root in Germany between the two world wars, first at Weimar and then at Dessau. Known as the Bauhaus [BOUGH-house], the school, under the direction of architect Walter Gropius, brought together architects, painters, sculptors and craftsmen in an effort to use the materials of the modern world — glass, steel, concrete and chrome — to produce articles for everyday living.

Among the painters, sculptors and photographers who spent time at the Bauhaus were:

Paul Klee [CLAY], who spent ten years there, from 1920 to 1930, teaching glass painting and weaving. He became fascinated with color ("Color and I are one!"). Many of his works resemble works of children; he usually painted without a preconceived

notion of what the work would become, supplying a title only when he came to the moment of recognition.

László Moholy-Nagy [Mo-holee-Na-dya] was a Hungarian writer, painter and sculptor who became involved as a teacher, provoking widespread experimentation with photos as art. He pioneered the creation of mechanized sculpture (kinetic art).

Vassily Kandinsky, a Russian painter, worked at the Bauhaus from 1922 to 1933, a period during which his style evolved from expressionism to abstract expressionism.

Coming to Terms With Modern Art

Modern art — especially of the abstract or abstract expressionist variety — has been largely shunned by the masses who don't have the slightest inkling why cows and pigs shouldn't *look like* cows and pigs. They don't *understand* it. Their attitude is nothing new in the world of art. Artists tend to outpace their audiences (and potential customers), which may have more to do with the number of *starving* artists than any other factor.

In the nineteenth and twentieth centuries, the awakening of the mind to itself — the advance of the science of psychology — largely through the work of Sigmund Freud and Carl Jung [Young] altered forever our notions about what is art. Prettiness alone was no longer enough. Anything and everything became the subject matter of art; anyone and everyone became artists.

In addition to cubism, numerous new forms developed. Here are some terms you need to know to keep you on your toes when it comes to modern art.

Armory Show — The first exhibition of modern art in the United States. It was held at the 69th Regiment Armory in New York City in 1913 and is credited with opening the doors of the U.S. to the works of such modern artists as Picasso, Matisse, Braque, Cezanne, and the sculptor Constantin Brancusi.

Art deco — Decorative style of the late 1920s derived from cubist principles, placing an emphasis on geometric forms and clean, sleek lines. Interest in art deco was revived in the sixties.

Art nouveau — "New art" of the late nineteenth and early twentieth century characterized by sinuous and highly ornamental lines. Graphic artist Aubrey Beardsley and artist Louis Comfort Tiffany (you know, the Tiffany lamp) were two prominent proponents of the style.

Ashcan School — Also known as "The Eight." A New York City group of early twentieth-century painters led by Robert Henri. Critics who didn't care for their brand of art labeled them the "Black Gang" and the "School of the Ugly." Their work often showed the ordinary (and sometimes seamy) side of everyday life. They were very un-Norman Rockwell.

Concept (conceptual) art — Form that considers the *idea* behind the artwork to be more important than the art itself. Thus, the artwork itself is often withheld and only the idea, the concept, is presented to the viewer, unadorned by the "prettiness" of art. Yoko Ono, the widow of former Beatle John Lennon, displayed her works of concept art in a book titled *Grapefruit*.

Constructivism — Movement that took cubist principles and applied them to three-dimensional forms, adding the elements of time and motion. Works are put together out of various materials rather than being sculpted. Leading proponent was the Russian, Vladimir Tatlin (model of *Monument to the Third International*; the actual work, which called for a gigantic tower, was never carried out).

Dada — The name given an early twentieth-century movement that sought to be as outrageous as possible. Marcel Duchamp, one of its chief proponents, once displayed a porcelain urinal, titling the work *Fountain*. Stories abound as to the origin of the term, but dada is quite literally French baby talk, not for "daddy" (a

French baby would say *papa*) but "hobbyhorse." Jean Arp (also known as Hans Arp; he was from Alsace-Lorraine) and Marcel Janco are considered dada's co-founders.

Functionalism — The theory that an object that is functionally perfect is inherently beautiful: "Beauty is as beauty does."

Futurism — Modern art movement centered in Italy prior to World War I that sought to express the realities of the time through depictions of speed, energy and violence. Noted for its use of automobiles, trains and airplanes as symbols of modern, mechanistic life. Italian sculptor and painter Umberto Boccioni's *States of Mind: The Farewells* is considered a classic futurist work.

Group f64 — Group of proponents of straight photography, which included Edward Weston and Ansel Adams. The name comes from a camera aperture setting which would be extremely small, therefore producing the sharpest possible details, the basic requirement of the form.

Happenings — Popular in the 1960s, happenings are a form of performance art that often included a degree of audience participation. Happenings could be strictly impromptu or they could include planned events. Allen Karpow is credited with the name, derived from his *18 Happenings in 6 Parts*, performed in New York in 1959.

Minimal art — Based on the idea, as popularized by modern architect Mies van der Rohe, that less is more. The ultimate minimalist art is a painting of a single color (as exemplified by Mark Rothko, the abstract expressionist, whose moods range from orange to black; he was commissioned to do paintings for van der Rohe's Seagram Building in New York, naturally) or a sculpture of a single form (a single cube, as done by Tony Smith).

MOMA — The Museum of Modern Art in New York City.

Pop art — So called not because it has anything to do with soda pop, but because it turned to the everyday world of popular culture for its inspiration. Hence, anything and everything — from soup can labels to comic books to billboards and beverage bottles — became the subject of artistic endeavor. Andy Warhol, Jasper Johns, Roy Lichtenstein, and Robert Rauschenberg were among the leading perpetrators of the pop movement in the United States. Originally, the term referred to those aspects of the popular culture of the 1950s that were not ordinarily thought of as art.

Superrealism — Ultimate tribute to the impact of photography. Paintings are so realistic, they look like photographs. Richard Estes (*Supreme Hardware*) and Chuck Close (*Nat*) are two who prefer the paintbrush to the camera to achieve the height of verisimilitude.

A Rogue's Gallery of Famous Names

Dropping names? Try a few of these, who are listed not necessarily for their importance as painters, sculptors or photographers, but because they're often the most talked-about.

Ansel Adams — When the talk turns to photography as an art form, you can bet your last roll of Kodachrome and half-a-dozen used Sylvania Blue Dot flashbulbs that American landscape photographer Ansel Adams's name will crop up. Adams, who died in 1984, stalked the West and its tumbling tumbleweeds, dusty dirt trails, and lofty mountain peaks like an impoverished prospector in search of an elusive vein of gold. His signature photograph, taken in 1941, is of the moonrise over Hernandez, New Mexico. His photographs are known for their vivid detail and sharp lines (*straight photography*).

Diane Arbus — She played peeping Tom on the wild and wack-eyed world of drag queens, prostitutes, nudists, dwarfs, giants, and others not necessarily in the mainstream of society. Many of her photographs were shot for *Life* magazine, but the

Ansel Adams photographed the American West

nature of her work is such that her portraits of people can be viewed on a higher plane than mere portraiture. She committed suicide in 1971.

Richard Avedon — American photographer famous for his fashion shots for *Vogue* and *Harper's Bazaar* magazines. Also well-known for his portraits of celebrities.

Francis Bacon — Don't confuse him with the other Francis Bacon, who was a writer who lived in Shakespeare's time (hence, the "Baconian Theory"). Bacon, the artist, does scary work that often has a central figure whose face looks like a bloody side of meat.

Cecil Beaton — Fashion and portrait photographer who did much work for Condé Nast publications (such as *Vanity Fair*).

Margaret Bourke-White — A World War II correspondent for *Life* magazine, who brought back haunting images from the Nazi death camps.

Mathew Brady — His wartime photographs are impressive, especially when you take into account the times and conditions under which they were shot, but remember that most of the Civil War photos credited to him were actually shot by his assistants. Brady takes credit because he planned, directed and footed the bill for the massive undertaking.

Constantin Brancusi — Probably the most well-known of twentieth-century abstract sculptors. His work is so abstract (*Bird in Space* resembles a silver fountain pen; *Endless Column* is a series of identical iron and steel forms that rise almost a hundred feet over his native Rumania) that he was involved in a lawsuit in the 1920s because U.S. Customs officials said one of his sculptures was scrap metal and subject to import duties.

Alexander Calder — Cut out some iddle-biddle fish or some iddle-widdle birds and drape them over the ends of several metal coathangers that you've twisted and contorted so they'll flop around when hung in the breeze. Then, remember to say thanks to American sculptor Alexander Calder, who is credited with inventing the *mobile*. Many of Calder's works (*Lobster Trap and Fish Tail* or *Red Petals* are two easy ones to remember) are major museum pieces and, of course, much larger than your homemade version. Calder's works ("kinetic sculpture") are usually very "clean" (meaning sharp, well-defined lines) and colorful, with lots of red, blue and yellow.

Harry Callahan — Photographer noted for his individualistic approach and for the austere imagery of his famous *Chicago* photo (bare trees stark and black against the white snow).

Henri Cartier-Bresson — The original "candid camera," French documentary photographer Henri Cartier-Bresson is

known for his ability to capture people in everyday situations (especially on the streets of Paris) that are revelatory of their inner beings and nature and show the essence of a person's character. He is also one of the charter members of the Magnum photo cooperative.

Christo — Bulgarian concept artist who wrapped a huge chunk of Australian coastline in plastic sheeting in 1970 (*Wrapped Coastline*) and who hung a gigantic orange curtain across Rifle Gap, Colorado, in 1972 (*Valley Curtain*).

Louis Daguerre — One of the most popular early forms of photography produced what was known as the "daguerreotype" (duh-GHEIR-uh-type), a metal or glass plate that was exposed to light, then treated chemically to produce a permanent image. The daguerreotype was named after its inventor, Louis Daguerre, who was a French painter, thus establishing, early on, the connection between art and photography.

Edward Hopper — Twentieth-century American painter known for his urban scenes that capture the feeling of alienation amid the metropolitan landscape. His *Eleven A.M.* shows a nude woman in a chair staring out the window of an apartment building, while *Nighthawks* isolates a late-night lunch counter scene.

Yousuf Karsh — Photographer whose portraits of the rich and famous (Ernest Hemingway, Winston Churchill, Jean Cocteau) are known for their sharp detail and elegance.

Dorothea Lange and Walker Evans — During the Great Depression, the Farm Security Administration sent photographers across the United States to document the ravages of the economic collapse. Among the group were Dorothea Lange, known for her photos of destitute families (*Migrant Mother, California*), and Walker Evans, whose portraits of sharecroppers in the South became the photographic images for *Let Us Now Praise Famous Men*, a book with text by James Agee.

Henry Moore and the reclining sculpture

Annie Leibovitz — Contemporary American photographer who has gone top-drawer with *Vanity Fair* magazine, but many prefer her as the young, brash and spoiled *enfant terrible* (French for "brat") who toured with the Rolling Stones in the mid-seventies and photographed pop and rock stars for *Rolling Stone* magazine. Her photo of a flamboyant William Hurt, clad only in underpants, is your favorite. Such risqué business.

Georgia O'Keeffe — You love her huge paintings of flowers, and especially like her New Mexico desert canvases, namely, *Cow's Skull: Red, White and Blue*. Her cow skulls look just like cow skulls, but they're red, white and blue.

Henry Moore — An English sculptor, he didn't design the La-Z-Boy lounger, but he should receive a commission from the

Jackson Pollock: a dash of splash

manufacturer for subliminally planting the idea of "reclining" so firmly in the art world's mind. If the title of a sculpture (he did a number of pieces each called *Reclining Woman*, for example) has "reclining" in the name, that's a dead giveaway it's probably a Henry Moore. Moore's women, whether in bronze, wood or stone, always have a smooth, curvaceous form and never a hint of a cellulite bump.

Robert Motherwell — American abstract expressionist who, like Mark Rothko, likes to employ large color fields on which an abstract image is placed (therefore, sometimes called an abstract imagist).

Jackson Pollock — Master of the Sherwin-Williams School. Take several buckets of exterior latex, splash them on a suitably

large canvas, muck across the whole mess in your boots. That's what Pollock did; he even had the gall to charge big bucks for his efforts — and got it! A leading proponent of abstract expressionism in the United States.

Man Ray — In the early twentieth century, he and László Moholy-Nagy experimented with stretching the boundaries of photography. His involvement with the dada movement led to his development of the Rayograph, a picture made without the use of a camera by placing objects directly on a piece of photographic paper. He also pioneered use of the Sabattier effect, which gives images a ghostly outline.

Norman Rockwell — Renowned for his many *Saturday Evening Post* magazine covers that depicted an innocent America as it should have been and perhaps once was for a few moments on a quiet Sunday morning in 1953. Super-realist painter that Jackson Pollock-types thumb their paint buckets at. Precursor of Andrew Wyeth — you know, *Jamie's* father.

Auguste Rodin — Rodin [Ro-DAN], the turn-of-the-century French sculptor famous for *The Thinker*, created quite a puzzle. Nobody really knows just what the *Thinker* is pondering. Maybe he's wondering which of the numerous versions of him is the real one. They all are, but the original *Thinker* is thought to be in Paris at the Rodin Museum. But if it happens to be one of those weekends you can't make it to Paris, you can always take in the impressive collection at the Rodin Museum in Philadelphia. Just don't get Rodin confused with Rodan, the Japanese horror-movie monster. Rodan liked to stomp buildings flat in Tokyo. He never gave it a second thought.

George Segal — Modern American sculptor whose ghostly white lifesize sculptures, such as *Bus Riders*, are placed in everyday settings.

David Smith — Major twentieth-century American sculptor famous for his massive welded iron and steel sculptures. His *Cubi*

Rodin the sculptor, not Rodan the monster

series of stainless steel balancing acts has become his trademark.

Robert Smithson — Conceptual artist whose most famous work is *Spiral Jetty*, a swirling curlicue of rock, salt crystals and earth that coiled 1,500 feet in the Great Salt Lake of Utah in 1970.

Andy Warhol — Imagine Andy Warhol sitting in the studio loft one day trying to decide what to paint next: "How about that still life with fruit over there?" Nah, too easy. "How about that light switch cover?" Nah, just get dirty. "How about that reclining nude in chaise lounge with three left breasts?" Nah, been done before. So he picks up an empty Campbell's soup can: "Hmmm, not bad. Art for the masses, something they can identify with." Then he paints Brillo boxes and famous movie stars

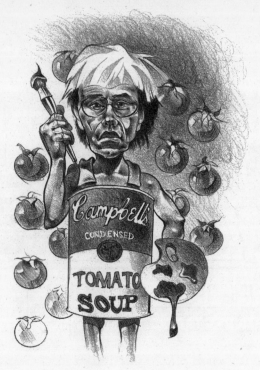

Andy Warhol: art of and for the masses

(like Marilyn Monroe). He was so avant-garde he didn't even call his studio a studio; he called it The Factory.

Weegee — Professional name of Arthur Fellig, considered to be among the top police photographers of all time. He spent most nights chasing New York City police and fire calls, peddling his work to the city's newspapers the next day.

Edward Weston — American Edward Weston preferred taking photos of peppers and cabbages, among other things. And the vegetables didn't even have to be shaped liked Richard Nixon's nose or be the largest ever grown in the county. A proponent of straight photography, his trademark shot is *Pepper No. 30*, which is a bell pepper that reminds you of one of sculptor Henry Moore's reclining nudes (which, in turn, remind you of Edward Weston's

bell peppers). He is also widely known for photos of shells, primarily the chambered nautilus, and sand dunes.

Grant Wood — His *American Gothic* (you know, Ma and Pa Kettle With Pitchfork) has become, if not a classic, a cliche. There have been so many takeoffs and visual puns made on this painting that it's hard to remember what the original looks like.

Andrew Wyeth — American painter of lonely, rural scenes who for years was best known for his *Christina's World*. However, the revelation that he had painted an entire series of works featuring a woman known only as "Helga" produced an avalanche of rumor and speculation in the mid-eighties.

Musings on Museums and a Warning About Collections

The holy of holies is the Louvre in Paris. You prefer to dress comfortably, in well-soled shoes with plenty of miles left on the tread — the museum covers more than forty acres with eight miles of hallways. Touring the Louvre is no Sunday picnic, although chances are you will always find it to be a religious experience.

You also know while in Paris to visit the Pompidou Center and you know it houses great modern art, *not* plumbing supplies as the outside of the building might indicate.

Other great European storehouses of art include the Prado in Madrid, the Vatican galleries in Rome, the National and Tate galleries in London, and the Rijksmuseum in Amsterdam.

In this country, the Metropolitan Museum of Art in New York City and the National Gallery of Art in Washington, D.C., rank as tops. Other important museums are the Museum of Modern Art in New York City (insiders just call it MOMA), the Whitney Museum of American Art in New York City, the Hirshhorn Museum and Sculpture Garden, the Freer Gallery and the National Museum of African Art, all three in Washington, D.C.

You should also be aware of the existence of various art collections. The following story should prove instructive.

He who shall remain nameless was invited to attend the showing of art from a famous collection — the Phillips Collection — at a well-known museum. Nameless even rented a tux for the occasion, so intent was he on making a favorable impression.

Strolling through the exhibition halls, he joined the throngs of the *right people* admiring the works of the great painters of the nineteenth and twentieth centuries that were included in the touring collection.

"Just think," he blurted out, "that guy Phillips painted all of this!"

Nobody had the heart to break it to him that Duncan Phillips had amassed the collection, not *painted* it.

But later, when he suggested he might want to buy himself a tux rather than renting, it was suggested such a move might be an unwise investment.

Some other important collections and their areas of concentration include the Mellon (thirteenth through nineteenth centuries), Kress (Italian), and Chester Dale (French Impressionists) collections, all at the National Gallery of Art in Washington, D.C.; the Frick Collection (European) in New York City; and the J. Paul Getty (yes, *that* J. Paul Getty) Museum in California contains a spendid collection of Greek and Roman art housed in a reproduction of an ancient Roman villa.

Lingering, Eternal Question of Art

For centuries, the basic standard of what was art was simply that it be appealing to the viewer (who was often a very well-to-do person enjoying said painting in the privacy of his or her own eighty-five-room country home). The cultured gentry often commissioned artists to paint works intended to do little more than cover the crack in the plaster in the entry hallway. That in the process they happened to produce some works that we now revere as *masterpieces* falls into the category of events that the English novelist and poet Thomas Hardy labeled "life's little ironies."

For many years in France, the Salon was the major determinator of what *was* and what *was not* officially sanctioned as "art."

The impressionists — who enjoy immense popularity today — were excluded from the Salon and formed their own *Salon des Refuses* (Salon of the Rejected) when their works were not permitted to be displayed.

Van Gogh stacked his paintings on the floor underneath his bed and spent a life of frugality and rejection because his efforts weren't considered "art." Today, his paintings break records, fetching millions at auctions. At some point along the line, our concept of what is art has changed.

Somewhere between Delacroix and the Devil lies a definition of art that should hold you in good stead in almost any company.

MUSIC

Knowing the Score
Without Being a Drag

*Music must rank as the highest of the fine arts — as the one
which, more than any other, ministers to human welfare.*
— *Herbert Spencer*

So you're not really sure who wrote Beethoven's Fifth.

Or whether the Fifth is a bottle of booze, an amendment to the
Constitution, or one in a series of wives.

Don't fret — even if you can't carry a tune in a bucket, you'll
be singing musical jargon to beat the band in no time flat. And
you won't be whistling "Dixie" either.

Now that you've got the world of art under your thumb, it's
time to branch out. And the nice part is, you don't have to go way
out on a limb to do so.

As one of the fine arts, music is a relatively young form. That's
not to say music hasn't been around for a long time — the fact
that there's a book in the Bible called Psalms should tip you off to
that. But as a serious form of artistic endeavor (the stuff people
really like to talk about), music has a relatively short history.

Basically, there are two reasons for this. First, much early

music was never written down — for a long time there was simply no such thing as musical notation — so the form existed as an oral or performing tradition: The daddy shepherd taught his songs to the number one junior shepherd and so on. Second, many of the musical instruments that now are available for the composer or musician's use are of fairly recent origin. The piano (originally known as a *pianoforte*), a key instrument — along with the violin — for much modern composition and performance, is a product of the early eighteenth century. The saxophone, a favorite instrument of jazz performers, came into existence only in the nineteenth century.

Just don't forget that the harpsichord (its strings are plucked), which has experienced a recent revival, is actually an older instrument than the piano, having been especially popular from the days of the Renaissance through the eighteenth century. A smaller, lap-held harpsichord was called a virginal (hold the jokes, please). And the clavichord, a twelfth-century invention, was even more widely used by composers.

But you don't need an exhaustive background in music history to hit the high notes during social chitchat. Most small talk is going to focus on classical music and/or jazz. And if someone *really* wants to discuss ancient Gregorian chants (a form of unaccompanied plainsong) at one extreme or the modern experiments of John Cage [KAYZH] (the "prepared piano," with pieces of paper, rubber, metal, wood placed on the strings to produce percussive sounds; also, a "concert of silence") at the other, then maybe you're simply at the *wrong* party.

All-Time Hits That Never Miss

Gimme a B, Gimme a B, Gimme a B

The Killer Bees of classical music are Beethoven, Bach, and Brahms. Forget Engelbert Humperdinck (the modern version, that is; remember the one who was the German composer of the nineteenth-century opera *Hansel and Gretel*). Forget Michael Jackson. Forget Elvis. Old Swivel Hips is nothing but a princely

Forget Elvis; long live the Killer Bees

pretender compared to these masters of the melodic movement.

The King Bee of them all is the late-eighteenth- and early-nineteenth-century German composer Ludwig van Beethoven, pure and simple. What other composer can claim to have done so much while battling with the loss of his hearing? Beethoven started going deaf in his late twenties and was totally unable to hear by the time he was fifty. Yet he continued his work, mentally playing out his remarkable melodies in his head when he could no longer depend on his ears.

But Beethoven's easy to deal with. Although he wrote numerous shorter pieces, including piano concertos and sonatas (the "Moonlight" sonata), he composed only nine symphonies (Haydn knocked off at least one hundred and twenty-five, by comparison), of which the Fifth (da-da-da-dum, da-da-da-dum) is

the most widely known. So Beethoven's Fifth is a symphony, not a bottle of Johnny Walker Black.

Most of Beethoven's symphonies are known by popular names. The Third is called '*Eroica*, (don't let your Freudian slip show by saying *Erotica*). And the Sixth is usually called the *Pastoral Symphony*.

Beethoven dedicated the *Eroica* to Napoleon. Later, when Napoleon had himself proclaimed emperor, a ticked-off Beethoven rewrote the dedication to read simply "To the Memory of a Great Man." When retelling the tale, the appropriate wry comment is *sic transit gloria mundi* ("Thus passes the glory of the world," an elegant Latin way of saying "When you're hot, you're hot; when you're not, you're not.")

The Ninth Symphony, which includes parts for a chorus to sing, has as it final movement the soaring "Ode to Joy," which uses words from the poem by Schiller for its majestic finale. Joy, in this case, is in the sense of "happiness" and is not the name of one of Beethoven's many girlfriends (he never married, by the way). It's a great number for singing in the shower, especially if you know a little German. Just tell him or her (the little German, that is) to sling in a few extra strokes with the soap when you need to go for those high notes.

When the talk moves from Beethoven to Bach, remember to spit (give it a good guttural German pronunciation) when you mention Bach and his *Brandenburg Concertos*, which are considered the high point of his career. Bach and his predecessor, fellow German composer George Frederick Handel (*Water Music* and the *Messiah*), are considered the masters of the baroque period (roughly mid-seventeenth century to Bach's death in 1750), which saw the use of highly ornamented, exuberant melodies.

It's also smart to associate Bach (as well as Handel) with church music. Bach was a masterful organist, and much of his output was intended for religious purposes (almost three hundred church cantatas and five Masses, for example). But the fact that he fathered twenty children offers evidence that his mind was not always on the purely spiritual (yet it was Haydn whose nickname was *Papa!*)

Just be sure that you're not fooled by Peter Schickele's P.D.Q. Bach, who is a pretender of another sort. A contemporary musical satirist, Schickele claims to be professor of musical weirdology at the University of Southern North Dakota at Hoople. He revels in the derivative music of P.D.Q. Bach and playing such instruments as the left-handed sewer flute and the tromboon. He's a fake, a fraud, a phony.

So, if invited to a P.D.Q. Bach concert, don't don your finery unless you also wear sneakers and a football helmet. But you'll still probably be upstaged by Schickele, who has been known to arrive on stage swinging from a rope. Just don't get P.D.Q. confused with Johann Sebastian Bach. The latter is the real McCoy.

And heaven forbid you should start off any conversation talking about how much you like Brahms's "Lullaby." Talk about his "German Requiem" instead. Brahms, a nineteenth-century German composer, wrote mostly for piano (he created a number of Hungarian pieces) and for chamber instruments. But mentioning the "Lullaby" is guaranteed to put any classical music fan to sleep.

Those Valtzing Strauss Boys

In Vienna during the eighteenth century, there was Johann the Elder and Johann the Younger (Strauss). They were probably just called Big John and Little John by their friends. Johann the Younger's music earned him the nickname "The Waltz King" (remember "The Blue Danube" and "The Emperor Waltz"). His father, who was also an accomplished waltzmaster, is known as the "Father of the Waltz."

But when the name Strauss comes up, you need to know which Strauss is the subject of talk. For there's also the German composer Richard Strauss (no relation), who wrote the composition "Thus Spake Zarathustra" (you know, the title is from Nietzsche; Strauss's music was borrowed for the theme to Stanley Kubrick's *2001: A Space Odyssey*). Richard Strauss, whose life spanned the late nineteenth and first half of the twentieth century, was also

big on the opera circuit, with such hits as *Der Rosenkavalier* and *Salomé*.

Playing in the Sand with Chopin and George

Frederic Chopin [SHOW-pan] and George Sand [SAHN] were lovers. George's real name was Amandine Aurore Lucie Dupin, the Baroness Dudevant. She was a French novelist, and it probably took her hours just to autograph a few books so perhaps her publisher insisted on a shorter name. Chopin probably just called her "Buttercup."*

Like Mozart, the early eighteenth-century Polish composer Chopin was a child prodigy. Unfortunately, he was never good at coming up with catchy titles for his music. His compositions have names like *Scherzo in C Sharp Minor, Opus 39*, and *Polonaise in C Minor*. If those titles sound too much like geometric equations instead of music, just say you like his preludes and nocturnes.

It was apparently only in the twentieth century that composers discovered that if they gave their music catchy titles like *Moon River* and *Boogie Woogie Bugle Boy From Company B*, people would remember the names and play them more often on jukeboxes.

It was also in the twentieth century that Tchaikovsky [Chai-KOF-skee], the late-eighteenth-century Russian composer, became America's patron saint of holiday music. Go to nearly any city's outdoor concert on July Fourth, and you're probably going to hear the "1812 Overture" (the one where they fire real cannons in elaborate productions; wait until Sousa's "Stars and Stripes Forever" to break out the sparklers).

Although he wrote eleven operas, only *Eugene Onegin* is well-known in the United States. Of his six symphonies, his *Symphony No. 5* is considered his tops.

At Christmas, it's the *Nutcracker* for civic ballets across the country. And, in between, *Swan Lake* and *Sleeping Beauty* remain popular. Just remember that the sugar-plum fairies are in the *Nutcracker*, not *Swan Lake*.

Mozart probably made musical bubbles

There Were Always Wolves Waiting at the Door

As a child prodigy, Wolfgang Amadeus (yes, *that* Amadeus) Mozart was so talented he could probably make musical bubbles in the bathtub. Like Shakespeare in the theatre, Mozart had the touch that made him a musical man for all seasons. He rarely hit a sour note. He is considered the greatest musical genius the world has ever known — yes, even greater than Barry Manilow or Ozzy Osborne. (And if you don't know who they are, *don't worry*.)

Despite his current popularity — and the fact that he was extremely prolific, writing more than six hundred works in all — the Austrian composer spent much of his life fighting to keep the wolf away from the door. He often worked as a court musician,

which back in the late eighteenth century was like writing jingles for Coke and McDonald's TV commercials nowadays.

If you're a Mozart fan, you have probably seen the movie *Amadeus* any number of times. When it comes to his music, you like it all, but be sure to mention his comic operas, since they have names that are relatively easy to remember (*The Marriage of Figaro*, *Don Giovanni*, and *The Magic Flute*; stay away from *Cosi fan tutte*, which can be a real tongue twister after a few martinis).

Mozart fans are also big on the summer Salzburg music festival, which pays homage to their patron saint of music, especially his operas, each year.

Among his other works, it doesn't hurt to drop in references to the *E flat Divertimento,* the unfinished *Mass in C minor*, the string quartets and quintets, the symphonies, adagios and fugues. There is a special place in your heart for his unfinished *Requiem,* the piece he was composing for a mysterious stranger at his death. And note with proper philosophical understatement that it was a shame he died a pauper, buried in an unmarked grave.

Chiming in with a Chorus of Other Notes

Now that you've sampled some of the great composers, here's a quick run-through of others you might expect to encounter in music conversations. Any and all of these could easily be on any list of the top composers — it's all a matter of who's making the list. For now, though, you just need a little bit of name recognition. Except for the previously mentioned Strausses, nearly all composers are usually referred to by their last names only.

Austrian: Franz Joseph Haydn [HIDEN] ("the father of classical symphony music," who composed the *Clock* Symphony), Franz Schubert (famous for his many *lieder* — German for songs — such as "The Erl King"), Gustav Mahler [MA-ler] ("dark, serious, stormy and disturbed"; you know, such dark and disturbed works as *Songs on the Death of Children*. Perhaps he didn't like the way the bust of him by Rodin turned out) and Arnold Schoenberg (originator of twelve-tone composition; *Transfigured Night*).

British: Benjamin Britten (the operas *Billy Budd*, *Death in Venice*), Sir Edward Elgar ("Pomp and Circumstance," which is more than the snippet played at high school graduations), and Ralph Vaughan Williams (warning: his last name is Vaughan Williams; *Symphony No. 2*).

French: Louis Hector Berlioz (*Requiem*), Claude Debussy (call him "the father of twentieth-century music," who brought the impressionist movement — remember the painters Monet and Renoir? — to music with "Afternoon of a Faun," based on the French symbolist poet Mallarmé's work, and "La Mer"), and Maurice Joseph Ravel (*Daphnis and Chloe* is usually called his masterpiece; he also wrote the music for the ballet *Bolero*, which is *not* the movie with Bo Derek).

German: Felix Mendelssohn (the *Scottish* and *Italian* symphonies; you have a fondness for *Songs Without Words*, even if the critics once didn't care much for the piano pieces), Robert Schumann (he and his wife Clara, a top pianist, were good friends of Brahms; *Concerto in A Minor* is one of his chief works; he suffered mental problems toward the end of his life and tried to kill himself by jumping into the Rhine River before dying in an asylum), and Richard Wagner [VOG-ner], whose operas include the four-part cycle *The Ring of the Nibelung*, *Die Meistersinger*, and *Lohengrin*, which should not be confused with Löwenbräu, a beer.

Russians: Sergei Prokofiev (strangely, the composer known in his time as "the Bolshevik" is remembered in the United States primarily through a children's piece, *Peter and the Wolf*; it's the one where the different instruments make the sounds of the different characters in the story), Modest [Mo-DEST] Mussorgsky (*Pictures at an Exhibition* and the opera *Boris Godunov*), Sergei Rachmaninoff (*Second Piano Concerto*), Nikolai Rimsky-Korsakov (*Scheherazade*, you know, as in the Arabian Nights), and Igor Stravinsky (the *Firebird* Suite and *Petrouchka*; he later became a French citizen, then an American citizen). Smirnoff is a brand of vodka, not a composer.

Others: Béla Bartók (Hungarian, *String Quartets*), Aaron Copland [COPE-land] (American, *Appalachian Spring*), Antonín Dvořák [DVOR-zhak] (Czech, *New World Symphony*, operas, concertos), Charles Ives (American, experimental composer of such works as *Children's Day at the Camp Meeting*), and Jean Sibelius (Finnish: he wrote "Finlandia," of course).

A Short Measure of Musical Terms

Just as French is the language of art, Italian is the language of music. Most musical terms come from the Italian words used in musical composition. Adagio is simply the Italian *ad agio*, meaning "at ease." Therefore, an adagio is a movement that proceeds slowly or leisurely.

Here are some other musical terms worth noting:

Allegro means "brisk, cheerful"; *con molto allegro* means "very briskly" and has nothing to do with cheese that has gone bad and turned a hairy green.

Concerto is what it appears to be: "a concert." A concerto is usually written for one, two or three solo instruments and an orchestra. It's perfectly fine to refer to concertos, but don't be thrown by purists who use the correct Italian plural *concerti*.

Musica da camera is not getting your picture taken while someone plays a waltz in the background. It's simply the Italian for "chamber music," which is music performed by a small group, usually a string quartet.

A polonaise is music for a Polish court dance, very stately and elaborate; it is not related to the Mayonnaise, a dance reportedly invented by nurse Jane Sockhopz at the Mayo Clinic Christmas party in 1967. In the polonaise, the women wore fancy hoop skirts; Nurse Sockhopz is said to have worn nothing but a doctor's stethoscope and a couple of gauze bandages.

A *scherzo* is a lively, playful movement in three-quarter time. Don't confuse it with a schizo, a person who likes to chop up

precocious coeds in such macabre — and mindless — movies as *Friday the 13th, Part MCMXLVIII*.

Sonata originally distinguished an instrumental piece from a cantata, which was meant to be sung. Today, it usually refers to any longer piece for one or two instruments. A Sinatra could be Frank, so watch your step or you could wind up with daughter Nancy's heel marks (remember "These Boots Are Made for Walkin'"?) all over your face if you catch "Old Blue Eyes" in a bad mood.

Spaghetto (bet you can't eat just one) is the singular form of spaghetti. Don't get it mixed up with Spoleto, an annual music festival in Italy that now has an American counterpart in Spoleto USA at Charleston, South Carolina.

Turning Your Ear to Insider Talk

To show that you really know your stuff, hold your cymbals high and drop in a few of these lines at the appropriate time:

Leonard Bernstein [BURN-stine], a composer and longtime conductor of the New York Philharmonic, wrote the music for *West Side Story* (you know, "Mar-i-i-a, I just met a girl named Mar-i-i-a"), a modern retelling of *Romeo and Juliet* set in the mean streets of New York.

You like pianist Andre Previn as a serious conductor in addition to appreciating his widely known popular work as an arranger, bringing stage musicals to the screen (he won Oscars for *Kiss Me, Kate* and *Gigi*). You also appreciate Yehudi Menuhin, who was first known as a violinist, a child prodigy, in fact, but is now a conductor as well.

And when it comes to pioneers, you know that Boston's Sarah Caldwell was the first female conductor to raise her baton over the New York Metropolitan Opera's orchestra.

Your favorite contemporary violinists are Itzhak Perlman and Pinchas ("Pinky") Zuckerman. A polio victim, Perlman walks with the aid of crutches. But you know he stands — on his own — head and shoulders above other contemporary violinists.

Among the great classical violinists, you speak reverently of Jascha Heifetz (simply "Heifetz"), Fritz Kreisler, and Isaac Stern.

Yo-Yo Ma is not the name of the female world yoyo champion. He is, however, to the cello what good caviar (beluga) is to good champagne (Dom Perignon): the perfect accompaniment.

If you really want to impress someone, vaguely hint that you were at the concert for the opening of the refurbished Carnegie Hall (you, of course, missed the original opening in 1891, which included a performance by Tchaikovsky) and will always remember the unscheduled performance by pianist Vladimir Horowitz. Any concert by Horowitz is grand, but ah, in Carnegie Hall!

You don't have to claim to have paid top price for your ticket ($2,500), but could intimate that you went with someone who had an extra ticket when a friend of a friend couldn't make it. To be really on top of things, sound enormously smug when you remark that you can't help but wonder if the new hall hasn't "lost some of its resonance."

And All of That Jazz

In addition to classical music, it's okay to like jazz. That's because jazz is not widely followed, in fact, is a bit cultish and, therefore, carries a certain amount of snob appeal. You don't have to drag out the bongo drums and a Maynard G. Krebs (the jazz-flavored beatnik on *The Dobie Gillis Show* in the fifties, remember?) goatee to groove on jazz. Just lie back and let the music massage you.

Keep in mind that although jazz is a comparatively young field, it's a type of music that thrives on a diversity of forms (Dixieland, ragtime, swing, bop, West Coast, cool, etc.) and performers (legends such as Jelly Roll Morton, Fats Waller, Woody Herman, Dave Brubeck, Dizzy Gillespie, Bessie Smith and Billie Holiday). Jazz aficionados can — and do — tend to dive very quickly into the depths, but you'll be better able to tag along if you at least know a few key names and phrases.

Wynton Marsalis, a multi-talented trumpeter

It All Started on a Blues Monday Down South

Jazz buffs are aware that jazz started with the blues, a form tied to Southern black work and church songs. In fact, many people consider jazz the only indigenous American art form. "Dixieland" (you know, Louis "Satchmo" Armstrong, Al Hirt and all that New Orleans crowd) is a form of jazz that retains close ties to its blues origins. Progressive jazz (John Coltrane on sax, Dave Brubeck or Erroll Garner on piano, etc.) is the form most often referred to as "modern jazz." Most recent jazz, however, is known as "fusion," which is the melding of jazz and rock (such as performed by the group *Weather Report*).

Contemporary performer Wynton Marsalis (albums *Insane Asylum* and *J Mood*) is a double score when it comes to fusing disparate elements. To sound appropriately hip, say things like it's hard to believe someone so young can be such a good jazz *and* classical trumpeter.

But don't forget that Miles Davis also plays a mean trumpet (his *Tutu* album was dedicated to South African apartheid foe Bishop Desmond Tutu and is not a jazz version of *Swan Lake*, the ballet). His funky sound is such a clean fusion of rock and jazz that it's terrifying. You consider his technique almost as dazzling as his wife, the actress Cicely Tyson.

Shed a Few Tears for Old Times' Sake

There's nothing quite like an evening at a jazz bar or *bistro*. Jazz somehow seems better when heard in small, intimate settings, accompanied by good friends and a little beer or wine. If things go right, an evening something like the following could ensue.

While sipping beer and growing nostalgic about jazz, you state unequivocally that the 1939 "Body and Soul" by tenor saxophonist Coleman Hawkins is superior to other versions. As always, make such comments with authority and without hesitation. If challenged, order another beer and concede it's all a matter of opinion.

Admit over your second beer that one of your favorite pastimes is to sit around and listen to your twenty-two-record set of pianist Thelonius Monk on the Riverside label while thumbing through the jazz classic, *To Be or Not to Bop*.

With your third beer, remark that the "First Lady of Song" is not Nancy Reagan, but Ella Fitzgerald. You love her version of "It Don't Mean A Thing If It Ain't Got That Swing" much better than that silly glass-breaking commercial she did for an audiotape company. And, oh, that Alberta Hunter (how did she wear those big earrings?) is something else.

Then, if you really want to get weepy, wail into your fourth beer that it's a sad commentary on the fate of jazz greats that more people probably knew Scatman Crothers as the actor who played a sweet old man in *Twilight Zone: The Movie* than ever knew him as a musician. But because you're such a jazz know-it-all, you knew him when (wink, wink). By now you should be thoroughly into the cultism of it all.

And it's too bad that alto sax be-bop legend Charlie "Bird" Parker, perhaps the greatest improviser of all times, was only thirty-five when he overdosed on sleeping pills. Just speak his name (it's fine to call him just "Bird") with reverence as you pour your fifth brew.

Finally, as you're being carried from the bar, condescendingly note that you haven't really experienced jazz until you've heard it live, close up. The experience always makes you say something afterwards such as, "Oh, man, the band was tight."

Hitting Just the Right Note Every Time

An extremely easy way to gain more familiarity with the fine-art of fine music is simply by listening to it. The record collections at most major libraries are steeped in the classics, and you'll be surprised how easy it is to pick up the music after you've had it playing in the background for a while. This is one realm of the arts where osmosis does work. And now that most of the country is within reach of a fine-arts FM radio station, even travel time can be made more pleasant with a little bit of highbrow background music.

After a while, you'll find yourself ready to "name that tune" with the best of them, and it'll be you who can confidently (and correctly) note that the music hummed by millions of the unknowing masses as "Stranger in Paradise" has actually been stolen lock, stock and quarter-note from the "Polovetsian Dances" in the opera *Prince Igor*, by the Russian composer Alexander Borodin.

OPERA

Singing on Tune
to the Right Beat

*God sent his Singers upon the earth
With songs of sadness and of mirth.*
— *Henry Wadsworth Longfellow*

So that special friend who's crazy about Luciano Pavarotti and Kathleen Battle went out and did the unthinkable: bought opera tickets for the two of you without even asking.

Now, do you (1) admit that Wednesday's your usual night to go bowling, (2) 'fess up that you never really wanted to go to the opera in the first place, or (3) graciously accept and look forward to a pleasant evening? Remember, if you choose options (1) or (2), you stand a good chance of ruining a perfectly good friendship, especially if the tickets came at a steep price.

Why not dive right in and learn enough about opera to be the perfect evening's companion?

Perhaps the first thing you need to do is shed some of the notions you might have about what opera is all about. For some reason, many people have the preconception that opera is the special province of the upper-crust or well-to-do. Or that there's

something terribly esoteric about a form of art that, in this country, is often performed in languages other than English.

You can, of course, take an elitist stance once you've got a few operas under your belt — and if one-upmanship is your game, more power to you — but the simple fact is that the enjoyment of opera cuts across class lines the same way the enjoyment of other stage or musical productions does. If you get a kick out of musicals such as *West Side Story* or *A Chorus Line*, there's certainly no reason to think you wouldn't enjoy the pleasures of *Carmen* or *The Barber of Seville*.

There's really nothing about a night at the opera that should put you ill at ease. But before plunging into all the whys and where-fores, let's get rid of that primal concern that might be rattling around in the back of your skull, causing all sorts of trauma and anxiety: you don't have to wear a Valentino original or tails and a top hat to take in the opera.

Unless it's a special occasion of some sort, you can don the same outfit you'd wear to the symphony — business suit for men, evening dress for women. If your outfit happens to be sinfully expensive, that's simply your good fortune, but it's certainly not a requirement.

If you *are* going to opening night at the Met (New York's Metropolitan Opera), a tux is definitely a nice touch for the male of the species, though not required unless perhaps it's a benefit function which, of course, will probably mean an invitation with directions for proper dress (black tie, etc.).

Getting a Firm Grip on the Fat Lady

Many grownups and otherwise responsible adults are timid about opera because of the language barrier: most operas are in Italian and quite a few are in French or German. If you don't know any Italian beyond pizza or scampi, there's nothing quite as tedious as sitting through three hours of unrelieved Italian singing.

If you're smart (and that's why you're reading DOT-TO-DOT, right?), you'll look over an English translation of the text (it's

It's not over until the fat lady sings

called the libretto, which should not be confused with the libido. If you check your libido instead of your libretto, you might miss the opening curtain.) Otherwise, the only times you'll know what's going on are when somebody dies on stage or when the irate, drunken father yanks his daughter up by her ponytail and drop-kicks her into the next act.

Reading the down-to-earth, everyday English versions of the librettos, you'll discover the words in opera tend to be mundane rather than poetic. What seems in those mysterious Italian lyrics to be a poignant moment at a dying mother's bedside turns out to be a couple of lines that can be rendered as "I always knew you loved Luigi more than me, Momma," or "But you always said I could have the string of pearls when you died."

Another way to breach the familiarity barrier is to begin with an opera based on a familiar story or play. Rossini's *La Ceneren-*

tola is simply an operatic version of *Cinderella*. Likewise, Engelbert Humperdinck's *Hansel und Gretel* is built around the well-known childhood tale. Or, if you're already a Shakespeare fan, what better way to get to know opera than by taking in a performance of Verdi's *Macbeth* or *Otello*?

Everything's not in a foreign tongue, though. There *are* operas in English, such as Igor Stravinsky's *The Rake's Progress* or Benjamin Britten's *Peter Grimes*. Also, through custom some operas are more often referred to by their English titles: Rossini's *The Barber of Seville*, rather than *Il Barbiere di Siviglia*, for example. Others are equally well-known in either form. Nobody is going to spit into the zucchini salad at a pre-opera buffet if you say *Madame Butterfly* rather than *Madama Butterfly*.

Making an Overture That You'll Remember

Once you're firmly ensconced in your seat and the lights have dimmed, the first thing you'll hear won't be singing at all. Instead, the orchestra will perform an instrumental overture (the operatic equivalent of a theme song). The most identifiable parts of some operas are the overtures (especially those that have been appropriated for other purposes, such as the *William Tell* overture that was borrowed for *The Lone Ranger* theme song). Overtures serve an important purpose by allowing those members of the audience who may be bloated from pre-opera wine and food to straggle to their seats.

Later will come the arias, which are the solo numbers that allow the stars (the diva [DEE-vuh] or the prima donna, sometimes known as the fat lady) to show off their musical talents. Usually there are also several ensemble numbers which allow the whole cast to join in.

Famous divas, who are often sopranos, the ones who can hit the highest notes, but also include coloraturas (especially nimble sopranos), mezzo-sopranos (on the scale, between sopranos and contraltos), and contraltos (the lowest female voices) of the past few years include Kiri Te Kanawa (try saying that rapidly five

Kathleen Battle, diva supreme

Luciano Pavarotti: a big man, a big name

times!), Jessye Norman, and Kathleen Battle. Among those in the opera hall of fame are Beverly Sills (her friends call her "Bubbles"), Leontyne Price (she was Bess in *Porgy and Bess* and Aïda in Verdi's work of the same name), Marian Anderson (in 1955, the first black soloist to sing with the Met), Joan Sutherland (as Lucia in *Lucia di Lammermoor*), Marilyn Horne, and Maria Callas (the infamous, fiery, hot-tempered American-born soprano who loved life amid the headlines).

On the male side (usually tenors, the counterpart to sopranos but lower on the musical scale; also including baritones and basses, the lowest male voices), the current scene is dominated by the handsome Latin, Placido Domingo, and the ever-charming Luciano Pavarotti (he even made a movie, *Yes Giorgio* in 1982). Great opera singers of the past include the Babe Ruth of tenors — generally considered the greatest of them all — Enrico Caruso,

who "owned" the role of Canio, the clown in *Pagliacci* [PA-lee-AH-chee]. Other greats include Richard Tucker (known as the "Jewish Caruso"), Jan Peerce (nothing glitzy, but always dependable), Swedish tenor Jussi Bjoerling [YOOS-see bih-EHR-ling] and Lauritz Melchior, a Danish tenor famed for his numerous Wagner roles, especially as Siegfried.

The Plots Are Straight Out of *Dallas*

The main difference between *Dallas* and most operas is that *Dallas* is in English and Larry Hagman doesn't sing a whole lot in his role as J.R. Ewing.

But if *Dallas were* set to music, with Hagman and all the rest of the cast busting a gut through all the plots and subplots, it would make a fine opera.

Operas are mostly about love and death. The very best ones have lots of both, especially death, because people in operas really know how to die with style. Only B-movie Western gunslingers who go down with guns blazing and with their boots on do a better job of dying than characters in an opera. But the guys in the movies aren't belting out one of their big musical numbers while going down for the count, either. Can you imagine John Wayne singing his way through a horde of hostile Indians?

Many operas tell sad tales about star-crossed lovers who never get to spend much time together — or, if they do it's only for a night or so at the Bide-a-Wee Motel on Route 89. Then they die, often at the hands of a rival or ex-lover in a jealous, passionate rage.

The love arrangements in operas can sometimes get quite confusing: A is in love with B, but B loves C, but B is married to D, who loves E, who is engaged to A, who is sleeping with F, who is engaged to marry C.

So don't go to the opera expecting a night of heavy drama. Although opera combines music, drama, and sometimes dance, and a good opera can be extremely dramatic, the emphasis is expected to be on the music, not the plot.

Movie snacks are a no-no at the opera

Eating, Humming, Stomping Your Feet and Other No-Nos

No one would ever think of doing any of these, of course, but these days — with lowered standards all around — it doesn't hurt to drop in a few don'ts: Never bring food to the opera. Bags of popcorn and a Hershey bar in your pocketbook may be fine for the local dollar movie, but you must remember that just because the original audiences of these musical masterpieces may have brought food from home, that doesn't mean that you can.

It's also considered impolite to tap your feet, slap your hands on your knees or sing along *sotto voce* as you might at a rock concert. And, please, don't wave a lighted Bic back and forth in the air during the love duet.

It's all right, however, if you become so moved by the perform-ance that a few tears trickle down your cheeks at appropriate

moments (such as in Verdi's *Rigoletto* when the hunchback, Rigoletto, realizes that Gilda, his daughter, has been murdered).

You don't have to tell your companion that you're crying because you spent all that money renting a tux that is two sizes too small and your new black shoes are killing your feet. Or that the new underwire bra that gives you the necessary uplift for your opera dress with the plunging décolletage is also putting a dent in your evening's comfort.

It's also permissible to laugh at the opera. But laugh along with the audience, not with the cast on stage. They're just about always laughing or crying over something.

After the fat lady sings, you might have the occasion to attend an after-opera party where you can gush — over wine and cheese — about the performance. If you really want to score points, compare the night's performance to one you've seen in New York, preferably at the Met. If you've been to Italy, you can drop in a reference to a performance at La Scala (the holy of holies in Milan — it's to opera what Cooperstown is to baseball). Other opera venues that produce envious feelings include performances by the National Opera at Covent Garden (yes, Covent, not Convent) in London and performances of the Vienna State Opera in Austria.

You'll hit high notes all around if you'll say how much you enjoy — especially the opera — at Spoleto (the fine arts festival founded by Italian-born American composer Gian-Carlo Menotti) in Charleston, South Carolina, every year. You can double your score if you're willing to go for the original Spoleto festival in Italy; and triple your score if you make the opera orgy in Salzburg, Austria. At Salzburg, the emphasis is on Mozart, but other composers are also performed. Likewise, Bayreuth, West Germany, puts on an annual Wagner shindig. Just don't confuse Bayreuth with Beirut, which is in Lebanon. The only music you hear in Beirut is the sound of mortar rockets whistling over your head when you try to cross the street.

Background Stuff It Won't Hurt To Know

Here Come the Italians

If this were the Scholastic Aptitute Test, the question would go something like this: Art is to France as opera is to (blank). And you would have to choose from (a) Antarctica (b) Zimbabwe (c) Italy or (d) None of the Above. You'd choose (c) Italy, and you'd be headed to Harvard or Yale, right?

Verdi and Rossini (hardly anybody tries to say his first name, which is Gioacchino) are two major names in Italian opera. They are to opera what Mantle and Mays are to baseball. Just try not to confuse them with Martini and Rossi, another popular Italian duet.

Verdi, whose full name was Giuseppe Verdi (that's Joe Green in English, by the way), composed *Aïda, Rigoletto, Il Trovatore* (*The Troubadour*), and *La Traviata*, among numerous others that consistently rank among the most popular in the operatic repertoire.

In addition to *The Barber of Seville* and *William Tell*, Rossini composed numerous other hits, including *L'Italiana in Algeri* (*The Italian Girl in Algiers*) and *Semiramide*.

Other top Italian composers include Gaetano Donizetti (*Lucia di Lammermoor* and *Anna Bolena*), Giacomo Puccini (*La Bohème* and *Tosca*), and Ruggiero Leoncavallo (*Pagliacci*, the one made famous by Enrico Caruso as the clown, crying and laughing before a mirror).

And Don't Forget the Germans

Whether you prefer Italian over German opera probably depends on whether you prefer pasta over schnitzel. Richard Wagner, Wolfgang Amadeus Mozart and Richard Strauss are Germany's and Austria's big names in the world of opera.

Springtime for Hitler is not one of Wagner's operas, but is the name of the play intended to be a flop that instead turns out to be a success in Mel Brooks's film *The Producers*. Hitler and his pals

did have a fondness for Wagner, though, perhaps because of his glorification of the nationalistic myths of Germanic greatness. He was also openly bigoted, speaking out against Jews as well as others who weren't German enough for his taste.

But true opera buffs are big on Wagner's *Der Ring des Nibelungen*, (just refer to them as the *Ring*). The four operas that make up the *Ring* are usually staged on successive nights as a sort of operatic endurance test — to separate the sopranos from the mezzo-sopranos, so to speak. Other well-known operas by Wagner include *The Flying Dutchman*, *Lohengrin* and *Tristan und Isolde*.

In addition to his symphonic compositions, Wolfgang Amadeus Mozart also wrote operas. Among his oft-performed works are *Le Nozze di Figaro* (*The Marriage of Figaro*), *Don Giovanni*, *The Magic Flute* and *Cosi Fan Tutte* (*Women Are Like That*).

Richard Strauss, another top German symphonic composer, also produced operas, including *Der Rosenkavalier* (*The Cavalier of the Rose*) and *Ariadne auf Naxos*.

Short List of Others You Might Encounter

Other composers (their nationalities) and operas you should know include: Alban Berg (Austrian) *Wozzeck*, Hector Berlioz (French) *Benvenuto Cellini*, Alexander Borodin (Russian) *Prince Igor*, Pietro Mascagni (Italian) *Cavalleria Rusticana*, Jules Massenet (French) *Manon*, Gian-Carlo Menotti (Italian/American) *Amahl and the Night Visitors*, Modest Mussorgsky (Russian) *Boris Godunov*, Maurice Ravel (French) *L'Heure Espagnole*, Arnold Schoenberg (American) *Moses und Aron*, Bedřich Smetana (Czech) *The Bartered Bride*, Johann Strauss (Austrian) *Die Fledermaus*, Peter Ilyich Tchaikovsky (Russian) *Eugene Onegin*, and Kurt Weill (American) *The Threepenny Opera*.

Closing Out With a Quartet of Opera Favorites

Here are capsule peeks at four operas that are guaranteed to be on almost any fan's list of favorites. There are hundreds of lperas, and any of the various collections of plot outlines will serve you well.

One of the best sources for acquainting yourself with opera story lines (as well as short biographies of the composers) is *The Metropolitan Opera Stories of the Great Operas*, by John W. Freeman (W.W. Norton, 1984), a handy, at-a-glance guide that summarizes the standard favorites of the operatic repertoire.

Carmen, by Georges Bizet: In early nineteenth-century Spain, Carmen, a gypsy who works in a tobacco factory, is your basic Fickle Young Woman destined to cause men grief. This she does throughout the opera, flitting back and forth among various men but, in particular, Don José, a corporal who deserts the dragoons to join her and a band of smugglers, and Escamillo, a dashing bullfighter. When Carmen dumps José for Escamillo, her fate is sealed. (Guess who is stabbed to death by her jealous ex-lover in the surprise finale?)

Don Giovanni, by Wolfgang Amadeus Mozart: Don Giovanni is Don Juan, the world's most infamous womanizer. Don Juan goes about eighteenth-century Seville seducing (or worse) any woman his mind takes a fancy to. Unfortunately, he has, in the course of his rakish ramblings, killed the father of one of his victims, and she sets out to avenge the death. However, the father's ghost — in the form of the statue from his tombstone — takes care of the job himself as Don Juan disappears in a swirl of smoke and flame.

Madama Butterfly, by Puccini: B. F. Pinkerton, an American naval officer in Japan at the turn of the century, cavalierly marries a Japanese girl known as Butterfly. Pinkerton returns to the United States, leaving behind Butterfly and any memories of their marriage. Upon his return three years later, she learns the reason

for his tardiness — while in the U.S. he has married an American woman, Kate. Learning Butterfly has given birth to a son by Pinkerton, the American couple implore Butterfly to let them take the boy and raise him in the States. Butterfly agrees, but before giving up the child, she slips behind a screen and kills herself with the same sword that her father used to commit hara-kiri. Other Puccini greats: *La Bohème*, *Tosca*, and *Turandot*.

La Traviata, by Verdi: Violetta, a young party girl of Paris in the mid-nineteenth century, celebrates life to the hilt, relying on wine and men to pull her through the rough spots. She leaves Lover A, the Baron, to live in the country with Lover B, the younger Alfredo. They are deliriously happy until Violetta is convinced by Alfredo's father that she must give up the young man. She leaves and Alfredo, not knowing of his father's actions, believes that she has rejected him for the Baron. One thing leads to another until Violetta is finally abandoned by both Alfredo and the Baron. Later, as she lies dying of tuberculosis, Alfredo, who has now learned the truth, returns to her bedside in time for the ill-fated couple to sing their love duet.

A Few Words Before the Curtain Falls

Everybody knows when to applaud at a rock concert or a high school graduation. But symphonies and operas tend to throw some of us a curve.

Applause is permitted during an opera (1) when a singer of star quality makes her or his entrance onto the stage and (2) at the conclusion of an aria or duet, (3) at the end of each act, and (4) at the end of the opera.

When the final curtain falls, there's nothing at all wrong with shouting your approval of a particularly sterling performance by rising to a standing ovation. In keeping with the European flavor of the opera, it's permissible to whistle (yes!) and shout "Bravo!" to show your appreciation for an outstanding performance.

Just remember that the whole idea is to have a good time. Do your homework ahead of time until you reach that point where the

classics have become common fare in your operatic repertoire. And keep in mind that, above all else, opera is entertainment. There's nothing grander than the beauty and the majesty of a full-blown performance with a cast of hundreds.

Sit back, relax, and enjoy the show. And when it's over, shout "Bravo!"

DANCE

Waltzing Your Way
Through the Hard Steps

*Dancing is the loftiest, the most moving, the most beautiful of
the arts, because it is no mere translation or abstraction from
life; it is life itself.*

— *Havelock Ellis*

Ballet, the classical form of the art of dance, is a relative
newcomer to the fine arts, a fact that makes life much easier for
anyone trying to become acquainted with it. You really don't have
to go back very far to cover the ballet's greatest years — many of
which fall in the modern era, especially in the United States (the
New York City Ballet was founded only in 1948). And, if you're
willing to glide back a few more years in Europe, you can be as
glib as the most ardent balletomane (one who loves ballet) when it
comes to chatting with authority about the legends of the game,
such as Anna Pavlova or Vaslav Nijinsky.

Despite its late arrival, ballet has gained immense popularity in
a short time. Most major American cities boast at least one ballet
or dance company (and many have several), and even smaller
communities are able to host any of the number of top profes-
sional groups that take to the road each year. Add to that

the number of hours of ballet and dance on television (through such outlets as the Public Broadcasting Service and the Arts & Entertainment Cable Network) as well as motion pictures with ballet or dance themes (*White Nights* and *The Turning Point*, to name a couple that featured Mikhail Baryshnikov), and there's plenty of programming to help the newcomer rapidly pick up the right steps.

All you really need at this stage is someone to point your feet in the right direction, waltz in with a few appropriate phrases and bits of relevant information, and lead you gently out into the footlights. So, if you're ready — music, Maestro, please!

Doing a Quick Two-Step Through Dance History

Dance has been a human activity almost as long as there have been humans. There is evidence (those cave paintings in France, remember?) of dance among primitive people. Such things as the friezes on Grecian urns (the sort that so entranced the English poet John Keats) and other pieces of ancient art show people caught in various dancing positions. The Bible reports that David "danced before the Lord" and that dancing was often connected with ancient customs and festivals. In North America, the native Indians danced to ensure the success of any number of ventures, from planting their crops to journeying out on hunting expeditions.

However, ballet is a relatively young form of dance. Although it's impossible to pinpoint exactly when ballet came into existence, most historians point to its origins in the sixteenth century court of Catherine de Médicis. She played a major role in providing what is now considered to be the first ballet, a performance of the *Ballet Comique de la Reine* given in Paris as an entertainment for a royal family marriage in 1581. This particular dance exhibition is credited with having been the most important attempt to that point at presenting an organized production that fits the definition of what we today call ballet.

During the seventeenth and eighteenth centuries, ballet as a form of court dancing grew in popularity as an entertainment for

the rich and famous. One of those who especially favored the form was France's Louis XIV (the Sun King), who even appeared as the sun in a ballet performed in 1653. He also set up the first ballet school, with Pierre Beauchamp as its master. The five basic foot positions that Beauchamp established are still a part of the beginning dancer's regimen.

By the early eighteenth century, ballet and opera had become closely linked in France. More importantly, ballet was being performed for the public, rather than merely as court entertainment. Around the middle of the century, the Frenchman Jean Georges Noverre had become noted as a choreographer (one who designs dance steps and movements) who took a "professional" approach to his calling and is credited with raising ballet to a serious art form through his close attention to all aspects of the performance, from the music to the stage settings to the choice of individual dancers and their movements.

Tripping Lightly Into the Early Years

From the charismatic Anna Pavlova (her signature piece was *The Dying Swan*, which some critics thought aptly described her technical ability, a handicap she overcame with tremendous stage presence) to the luminary Baryshnikov, the Russians have been tops for years. Fortunately for the rest of the world, the Russians have never been good at keeping their dancers at home.

International boundaries have meant little to ballet performers and promoters over the years. For this reason, ballet has seen a healthy dose of cross-pollination as the French went to Russia, the Russians went to France, and, ultimately, they both came to the United States.

In the early days, it was "How're you gonna keep 'em down on the farm after they've seen Paree?'' for such troupes as the Ballets Russes, which exported Russian ballet across Europe beginning in the early nineteenth century. Later, the lure of the West and the chance to cop a few capitalist coins lured defectors (Rudolf Nureyev and Baryshnikov, both from the prestigious Kirov Ballet of Leningrad) across the Iron Curtain.

Ballet is a relative newcomer to the arts

Although ballet originated in Renaissance Italy and then "grew up" in France, it did not fully flourish until it traveled to Mother Russia, where it has been the dominant art form — unless you count ice hockey — for the past century. *Swan Lake*, the *Nutcracker*, and *Sleeping Beauty*, three of the greatest classical ballets, all originated in Russia with music written by composer Peter Ilyich Tchaikovsky [Chai-KOF-skee]. Yet, it was a Frenchman who moved to Russia, Marius Petipa, who choreographed all three, as well as more than sixty other full-length ballets, including *Giselle*, a traditional favorite. And it was the Russian promoter Sergei Diaghilev, the founder of the Ballets Russes (which toured Western Europe, operating out of Paris and Monte Carlo), who is generally considered the father of modern ballet. And what children he had!

Among the choreographers who worked for Diaghilev were such giants as Michel Fokine (the classic *Les Sylphides*), Nijinsky (remembered for his ballet based on DeBussy's *Afternoon of a Faun*; more notable for his dancing ability), and the man credited with being the founder of modern American ballet, George Balanchine (for "purity of form" you compare him to painter Pablo Picasso; of such comparisons he was prone to respond: "Picasso's overrated"). And it was Diaghilev who commissioned Russian composer Igor Stravinsky to write his first ballet score, the famous *Firebird*. Stravinksy's next ballet, *Petrouchka*, featured Nijinksy, who set the standard for the classic with his portrayal of the pathetic clown puppet in love with the all-too-beautiful ballerina doll, Columbine (sort of like Mayberry's Barney Fife falling in love with the flashy dame from the big city).

American Feet Discover New Feats

American dance began coming into its own during the twentieth century. First, there was Isadora Duncan (a flower child before her time, she was the original "free spirit"), the turn-of-the-century eccentric prophetess of modern dance who had an affinity for loose, free-flowing clothing on and off stage. Trag-

ically, such dress was her undoing: She died in a bizarre accident when her scarf got caught in the spokes of a car wheel. With little formal training, Duncan shook up ballet with her free-form, barefooted approach to dance — and life — based not on the classical tradition, but on doing what came naturally. An expressionist who championed interpretive dance, she is often called the mother of modern dance.

A disciple of Duncan, Martha Graham made a major impact as a dancer and choreographer. Basing dance on "primal" movements (as in her *Primitive Mysteries*), Graham's ritualistic, abstract style has been referred to as the "open crotch school" by her detractors. But no one disputes her influence — for better or worse — on dance. You know her primarily because of her legendary temper (she was known to rip clothing from dancers in fits of rage) and her choreography of Aaron Copland's [COPE-land] *Appalachian Spring*.

About other pioneers of dance in the United States, Ted Shawn and his wife, Ruth St. Denis ("the first lady of American dance"), established the Denishawn school and dance company. Although both were popular on the dance stage, the idiosyncratic "Miss Ruth" is remembered more as a teacher than a dancer.

Remember too that the Tallchief sisters were not a female wrestling tag team, but the last names of two American Indian ballerinas, Maria and Marjorie. Maria Tallchief married Balanchine in 1946, but was granted an annulment five years later, citing their opposing views on whether she should have a child: she wanted one; Balanchine, known for liking his dancers bony and lean, did not.

You should be aware that more recently Jerome Robbins helped American ballet widen its appeal to new audiences through his work for Broadway musicals (*West Side Story* and *Fiddler on the Roof*), movies and television. He also put the pizazz in modern ballet, transforming jazz elements freely into dance. Other examples of those who have helped popularize dance are Gregory Hines and Baryshnikov in the movie *White Nights*.

Other names to drop include Merce Cunningham (he was a student of Graham's) who, together with avant-garde musician

John Cage, has choreographed a number of pieces that reside on the cutting edge of modern dance. Among Cunningham's somewhat quirky innovations was the use of chance composition, which involved flipping a coin to decide who danced where and for how long. In 1953, the avant-garde artist Andy Warhol designed plastic pillows that were used in the set of Cunningham's *Rain Forest*. And don't forget to mention Paul Taylor (*Esplanade*) and Twyla Tharp (*Push Comes to Shove*).

Father of American Ballet: George Balanchine

As Diaghilev's name is associated with the development of ballet in Europe, George Balanchine's [BAL-en-sheen] is synonymous with the rise of modern ballet in the United States. That the two Russians should have worked together — in France — should come as no surprise.

Balanchine's real importance lies not in Europe, but in the United States, where, in 1948 with Lincoln Kirsten, he founded the New York City Ballet. He promised a world-class ballet within three years. He kept his promise.

Seeking perfection through dance, Balanchine served as a tireless taskmaster (Mr. B to his students), who taught by demonstration, even in his final years when his body could have used a rest from such treatment. His vision defined forever what American dance could be — not a mere stepchild of the European form — but a brash, energic, self-confident youth that would eventually overshadow its entrenched forebears. Over the years, Balanchine shifted the balance of power in the world of ballet from Russia to the United States.

Known for his numerous collaborations with Igor Stravinsky, another Russian emigre, he nevertheless created ballets with a definitely American stamp. He said he wanted American dancers to be proud of who they were. Three of his ballets worth noting include *Serenade* (his first in America), *Agon* (perhaps his most well-known effort with Stravinsky), and *Pulcinella* (a collaboration with Jerome Robbins).

Baryshnikov: a great athlete, a great leaper

Among his lasting contributions to ballet was his definition of the physical form of the ideal ballerina. a form he imposed on those who wanted to be his stars. For Balanchine, the ideal ballerina was willowy, thin to the point of being bony, tall to the point of being lanky. Over the years he would marry four of his favorite ballerinas: Tamara Geva, Vera Zorina, Maria Tallchief and Tanaquil LeClercq.

All Hail the Modern Master, Mikhail

Mikhail Baryshnikov, along with Nureyev, has done more to popularize ballet in the United States than anyone since Nijinsky at the turn of the century. In addition to being one of the great dancers (his leaping ability is legendary) of all time, "Misha" is a hunk.

There are some, mostly jealous husbands and nervous boy-friends, who say there's nothing special about Baryshnikov, that he puts his tights on one leg at a time just like anybody else. But women will tell you — to a man — that they'd rather watch Baryshnikov leap powerfully across a stage than see the whole front line of the Los Angeles Rams football team parading around the locker room in towels and rope soap.

Since his defection in 1974, he has singlehandedly led much of the wave of enthusiasm for ballet in the West. His *bravura* style is always to push to the edge of danger, to seek to draw the most from each leap and turn.

Now serving as artistic director of the American Ballet The-atre, Baryshnikov continues to dance, but not at the gruelling pace of his younger days.

Keeping the Proper Kind of Company

As a full-fledged balletomane, you need to be familiar with the names of some of the top dance companies. Here's a quick rundown.

The Alvin Ailey Dance Company in New York City (modern, jazz and ethnic; its *Revelations* is a show-stopping tribute to the triumph of the black spirit); American Ballet Theater in New York City (Baryshnikov's company); Bolshoi Ballet (so named because of its home, the Bolshoi Theatre in Moscow); Dance Theater of Harlem (its founder, Arthur Mitchell, was the first black male to dance with a major U.S. ballet company); the Joffrey Company (a New York City ballet group that leans toward modern dance; Ron Reagan, Jr., performed with one of its troupes); Kirov Ballet (Leningrad); the Moiseyev Dance Company (emphasis on folk dance of the Soviet Union); and the Royal Ballet (England's official ballet; it boasted the popular combination of Margot Fonteyn and Nureyev in their heyday).

Talking About Dance, Especially Ballet

The language of dance is largely French because of the classical ballet forms. Here's a short course of words and phrases:

Arabesque: The position that winged Mercury used to take on automobile hood ornaments, one leg raised and pointed straight to the rear, one arm pointing forward, the other to the rear.

Benesh System: A method of dance notation that attempts to present dance movements in a written form, similar to standard musical notation. However, most choreographers, being former dancers themselves, instruct dancers the old-fashioned way — they show them the steps.

En pointe [ahn PWANT]: Refers to the practice of dancing on the toes. Originally, dancers did just that. The "toe shoes" that dancers use today — with blocks of wood in the toes for support — came later.

Jeté [zhe-TAY]: To leap in an arc from one foot to the other, with a kicking movement of the leg. When Tiny Tim goes tiptoeing through the tulips, he's attempting a series of jetés.

Labanotation: System of dance notation that uses a specialized set of symbols in vertical diagram form. From Rudolf von Laban, the German dance pioneer.

Pas de deux [PAH-day-deuh], **Pas de trois** [twa], **Pas de quatre** [quat]: All refer to different dance combinations, depending on whether two (*deux*), three (*trois*), or four (*quatre*) performers are involved. A famous *pas de deux* combination would be Suzanne Farrell and Peter Martins in Balanchine's *Chaconne*. Don't confuse *pas de trois* with a *ménage à trois*, which is a marriage bed in which three's not a crowd.

Pirouette [PIHR-uh-wet]: The spinning movement on tiptoe that you probably associate most readily with ballet. First made

popular in Stuttgart by ballerina Anna Heinel, under the watchful eye of choreographer Jean Georges Noverre, who was working under the patronage of the Duke of Württemberg.

Plié [plee-AY]: Bending the knees just before taking a leap. Ballets generally are full of pliés.

Port de Bras [POR-duh-bra]: Contrary to the way the word looks, this does not refer to a port of entry for ladies' undergarments made in Hong Kong and Singapore. Rather, it's a reference to the classical ballet arm positions.

Positions: The positioning of the feet of the dancer. There are five basic positions, referred to as first position, second position and so on. The missionary position is not a classical ballet form.

Prima ballerina: The leading female dancer in a company. The male equivalent is the *danseur noble*. Anna Pavlova, Margot Fonteyn (the greatest English ballerina of all time), Alicia Markova (the first great English ballerina), Natalia Makarova, Patricia McBride and Cynthia Gregory are all famous prima ballerinas.

Now That You're Well-Heeled, Take a Spin

Now that you're well-heeled in the subject of dance, especially ballet, why not take yourself out for a spin — go see the real thing. As with the other performing arts, what to wear should pose no problem. Unless you've planning to attend a command performance, your usual Sunday best should do the trick.

Once you get past the few French phrases on your dance program and learn to pronounce some Russian names, there's little about dance that can trip you up. Just take things one step at a time, and you'll have no trouble at all staying on your toes.

THEATRE

Avoiding Opening
Night Jitters

To see sad sights moves more than hear them told.
— William Shakespeare

Serving as a backdrop to any conversation about theatre is the implied notion that somewhere along the line you have picked up a cue or two about the ancient Greeks. Without prompting, you should always be able to project the impression that you're well aware they are the people generally credited with giving us drama as one of the fine arts.

In tribute to Thespis, a poet who is the first known to have presented carefully thought-out productions of tragedies (from the Greek words for "goat song," a description that has to do with the goat skins worn by the performers), actors and actresses are still known today as thespians.

Among the elements of Greek theatre (you must always spell it that way for true snob appeal; a theater is a place where you go to watch Arnold Schwarzenegger movies) that you should be familiar with are the dithyramb, a dance to the god of wine and revelry

Dionysus (perhaps what got theatre started in the first place) and the chorus. However, the chorus in Greek tragedy is not a choir. Rather, it was a group of people (fifty in the early days, the size dwindling over the years as dramatists moved toward more independence) whose purpose was to offer commentary (socially accepted viewpoints, hence, the party line) upon the events being presented.

Any discussion of Greek drama will at some point come to rest upon four names: Aeschylus, Sophocles, Euripides and Aristophanes. The first of these in chronological order, Aeschylus [ES-kuh-lus], is sometimes called the father of tragedy. Only seven of his plays remain, but three of them in particular, the *Oresteia* [ORES-teeyuh] form a trilogy still able to reach out across the centuries: In 1931, American playwright Eugene O'Neill shifted the ancient story to Civil War times in his *Mourning Becomes Electra*.

Sophocles is remembered for such plays as *Oedipus Rex* and *Antigone* [an-TIG-uh-nee] while Euripides' legacy includes *Medea* and *The Trojan Women*. Aristophanes was the comic genius of the four, noted for his sharp satire in such works as *The Frogs* (which made fun of Euripides) and *The Clouds* (which laughed at Socrates). His *Lysistrata* — which suggested that women could end war by withholding certain favors from their men — was revived as a pacifist statement during the Vietnam War.

Compared to the Greeks, the Romans contributed little to theatre since, after borrowing the form, Roman theatre degenerated into spectacle, opting for elaborate productions full of sound and fury, but all too often signifying nothing.

After the fall of Rome, theatre developed slowly. Mystery plays, miracle plays and morality plays were popular during the Middle Ages. In the case of mystery plays, the mystery is not a whodunit, but a reference to the New Testament meaning of the Latin word *mysterium*, which has to do with the supernatural. Hence, all three types of plays tend to deal with Biblical themes, but mystery and miracle plays focus especially on events surrounding the life of Christ.

By the end of the sixteenth century, a form of street theatre known as *commedia dell'arte* [kom-MAY-dyuh delLAR-tay] had risen to popularity in Italy. Thriving on interplay between actors and spectators, the *commedia* made liberal use of improvisation, allowing its casts to go with the flow in order best to please the audience (and fatten their purses). *Commedia dell'arte* also put to use a whole grab bag of theatrical devices, including music, dance, mime, juggling and so forth.

He Who Needs No Introduction: William Shakespeare

Shakespeare is to theatre what God is to religion: a key figure whose presence continues to be strongly felt although it's been years since he's put in a personal appearance. He's truly the *great one* of theatre, perhaps because, as poet-playwright T. S. Eliot put it, he was able to cover "the greatest width of human passion." Whether it was history or comedy or tragedy, Shakespeare brought it to the stage in a manner that no one since has been able to match.

You should be aware that Shakespeare's plays (thirty-nine in all) are usually divided into the three previously mentioned categories: histories (such as *Henry IV*, Parts I and II), comedies (such as *Much Ado About Nothing*, *All's Well That Ends Well*, *The Taming of the Shrew*), and tragedies (such as *Julius Caesar*, *Romeo and Juliet*, *Macbeth*, *Othello* and *Hamlet*). Short of listing all the plays, it's practically impossible to talk about Shakespeare's "best." There was something good in everything he wrote and even his worst (some would argue for *Titus Andronicus* [An-druh-NEYE-kus], a play filled with murder, rape, blood, gore and mutilation) is better than many.

Also, it's impossible to list even a representative sampling of Shakespeare's famous (and infamous) characters (Hamlet, Lady Macbeth, Romeo, Juliet, Falstaff, Othello, Shylock, etc.) or even to make a dent in all the great lines from Shakespeare's works (Bartlett includes sixty-five pages of the quotable Bard, for example; the Bible musters only forty-eight). Any number of books

No matter how you spell it, Shakespeare is tops

dealing with Shakespeare can be found at most public libraries.

But you should at least know that the Globe was the theatre where Shakespeare's plays were performed in London, not the name of his favorite newspaper. And, of course, that he was born and reared at Stratford-upon-Avon and died there, living in London during the years of his adult theatrical career. (By the way, his wife's name was Anne Hathaway, an *older* woman, eight years his senior).

Although most people are content to take in a Shakespeare play and discuss its finer points afterwards, there are some malcontents who continue to insist that what's really important is whether the Bard of Avon actually penned everything he's been given credit for. From such troublemakers comes the Baconian Theory, which is not the idea that Shakespeare preferred bacon to sausage for his morning meal. Rather, this theory (and it *is* only a theory) holds that, based on alleged internal evidence such as cryptograms (coded words) found in the plays, Francis Bacon actually wrote much of Shakespeare's material.

Part of the problem, however, may also have to do with the fact that Shakespeare never seemed to get the hang of spelling his name correctly. If you go by the different ways he signed his name then there were at least eight Shakespeares. Some detractors feel that this also points to a "second Shakespeare" theory. Opponents of the Baconian Theory point out that (1) Shakespeare is much harder to spell than Bacon and (2) nobody paid much attention to orthography (the science of spelling) in the sixteenth century.

Other playwrights working in England during Shakespeare's time were his chief rival Thomas Kyd and a group known as the University Wits, composed of Robert Greene, Thomas Nash (sometimes spelled Nashe; perhaps Shakespeare wrote some of his stuff, too), George Peele, Christopher Marlowe and John Lyly. Marlowe is credited with writing the first of the great Elizabethan plays, *Tamburlaine the Great*, Part I.

A seventeenth century French playwright worth knowing is Molière [mol-YER], whose *Tartuffe* is a bawdy farce still popular with modern audiences. He doesn't have a first name because

Molière is his stage name. His real name, which hardly anybody knows, is Jean Baptiste Poquelin.

Thoroughly Modern Henrik Leads the Way

Modern drama begins in the second half of the nineteenth century with the plays of Norwegian playwright Henrik Ibsen. Among his important works are *Peer Gynt*, *The Wild Duck*, *Hedda Gabler* and *A Doll's House* (if someone calls it *A Doll House*, they haven't goofed, but are merely referring to the most recent translation — which some consider the best).

Among other early pioneers of modern drama are the Swede, August Strindberg, known for his "dream plays" (*The Ghost Sonata*), and the great Russian genius of the stage, Anton Chekhov (*The Sea Gull* and *The Cherry Orchard*).

Somewhere along the line, it helps if you doff your hat to the likes of George Bernard Shaw, who lived from the mid-nineteenth to mid-twentieth century. His fans, known as Shavians (the correct form of his name when used as an adjective; not to be confused with the Fabians, members of a socialist group he associated with) are big on *Man and Superman* (not *that* Superman), *Pygmalion* (later reincarnated as *My Fair Lady*), and *Saint Joan*.

In the twentieth century, the certified giant of the American stage is Eugene O'Neill. With such plays as *Mourning Becomes Electra* (all fourteen acts!), *The Iceman Cometh* (the refrain was "pipe-dreams"), and *Long Day's Journey Into Night*, he established himself as the standard against which all other American claims to greatness must be measured.

The century also saw the rise of the musical as a truly American form of stage entertainment. Pioneering the form were Richard Rodgers and Lorenz Hart (Rodgers and Hart) with such winners as *A Connecticut Yankee*, *On Your Toes* (with dance numbers by George Balanchine) and their finest effort, *Pal Joey*. Plagued by drinking problems, Hart died shortly after urging Rodgers to find himself a new partner. The man Rodgers next

Musicals, an American art form on stage

collaborated with was Oscar Hammerstein, and their first joint effort was the benchmark musical *Oklahoma!*. Numerous other hits followed, including *The King and I*, *South Pacific* and *The Sound of Music*. Another pair, Alan Jay Lerner and Frederic Lowe (Lerner and Lowe) teamed up for the likes of *My Fair Lady*, *Brigadoon*, and *Camelot*.

It's also handy to know about Thornton Wilder, whose *Our Town* shocked its first audiences with its lack of sets and scenery in addition to a stage manager who served as a key member of the cast. An Italian turn-of-the-century playwright, Luigi Pirandello, draws rave reviews as a precursor of existential drama with such plays as *Henry IV* and *Six Characters in Search of an Author* (setting the stage with its plotless questioning of reality for what has come to be known as "anti-theatre"). Other twentieth-century playwrights worth knowing include Jean Cocteau (*Orphée*),

Federico García Lorca (*Blood Wedding*) and Jean Anouilh (an updated *Antigone*).

Absurdly Waiting in the Wings With No Place To Go

Samuel Beckett, generally considered the master of the modern stage, long ago stopped being merely a literary trivia answer ("What playwright was once James Joyce's secretary?") and, with *Waiting for Godot* in 1952, became He Who Must Be Reckoned With. *Waiting for Godot* established Beckett's reputation. In *Godot*, two tramps wait for something (we don't know what) to happen (it never does). Such, Beckett says, is life.

Beckett is champion of the Theatre of the Absurd, a movement that attempts to confront audiences with the basic *absurdity*, or lack of meaning, in life. Theatre of the Absurd could also be described as ultraminimalist. What could be more minimalist, more absurd than Beckett's play *Breath*, which lasts forty-five seconds, features no onstage cast and has only a couple of off-stage voices portray a baby's cry and an old person's last gasp?

Among Beckett's other works, you should be familiar with *Endgame*, which places its two main characters onstage in garbage cans (his plays are heavy with this sort of symbolism), and *Krapp's Last Tape*, about an old man listening to a tape recording of his life.

The other absurdist you know is the Romanian Eugene Ionesco (*The Bald Soprano* and *The Rhinoceros*). It's nice, too, to remember their cousins, the existentialists Jean-Paul Sartre (*No Exit*) and Albert Camus (*Caligula*). Some consider Sartre an absurdist, others don't.

Often discussed in connection with the Theatre of the Absurd is the Theatre of Cruelty, a movement based on the writings of Antonin Artaud, a man who spent nine of his last ten years in an insane asylum. But you don't have to worry about being beaten up if you attend a performance of this type of drama: cruelty is meant in the sense of shock. The classic production of the Theatre of Cruelty is the German playwright Peter Weiss's *The Persecu-*

tion and Assassination of Jean-Paul Marat as Performed by the Inmates of the Asylum at Charenton Under the Direction of the Marquis de Sade. Being an insider, you refer to it simply as Marat/Sade.

Curtain's Up on Five Easy Pieces

Here's a quick look at five modern playwrights worth knowing and their most well-known creations.

Harold Pinter — Harold (pause) Pinter is a (pause) British playwright noted (pause) for his abuse of the (pause) pause. When not taking a pause, he found time to write *The Birthday Party*, *The Caretaker*, and *The Homecoming*, considered classics of the minimalist style. His use of the pause is based on his contention that what is unsaid is often as important or more important than the words actually spoken. As a dramatic device, the pauses tend to add a sense of mystery and unease to his plays, which usually deal with ordinary people speaking ordinary words, often to the point of cliché.

Bertolt Brecht — Unfortunately, German "epic" playwright Bertolt Brecht is heavy stuff, in a brooding, schoolmarmish sort of way. He's almost as heavy as the wagonload of provisions the character Mother Courage must lug all over Europe during the Thirty Years' War (*Mother Courage and Her Children*). Given your druthers, you're better off choosing to see the musical, *The Threepenny Opera* (with music by Kurt Weill and featuring the song "Mack the Knife"), especially if performed by the Berliner Ensemble. Brecht sought to use the theatre to teach people how to live, attempting to draw intellectual rather than emotional responses from the audience.

Arthur Miller — Show your appreciation of Arthur (yes, he was once married to Marilyn Monroe) Miller's *Death of a Salesman* (a classic of the American stage) by commenting that although Dustin Hoffman "wasn't bad" in his stage revival (as

well as television production) of the story of a salesman on a losing streak, you still consider Lee J. Cobb — who first played the role — the quintessential Willy Loman. Given a choice between *Death* and *The Crucible*, a play with a heavy-handed message set in Puritan New England that serves as an allegory for the McCarthy-era witch hunts, always choose *Death*. His *After the Fall* is based on his relationship with Monroe, so if you are interested in her, that's the ticket for you.

Tennessee Williams — Serving up sleaze and slime with all the ease of a Southern plantation owner offering "just one more little old mint julep, Miss Daisy," Tennessee Williams holds sway over the sensual stage with such carnally delicious classics as *Sweet Bird of Youth*, *The Night of the Iguana*, and *A Streetcar Named Desire*, in addition to the sensitive and touching *The Glass Menagerie*.

Alan Ayckbourn — British playwright Alan Ayckbourn is an absurdly funny writer of comedies that often satirize the middle class. His *Absurd Person Singular* charts the rise and fall of three couples over a series of New Year's Eve disasters (mostly of the domestic kind). In *The Norman Conquests*, Ayckbourn jabs his sharpened pen at the male-female relationship with a trilogy that follows the life and loves of one completely hopeless houseguest, Norman, and his attempts to link himself romantically (in the most intimate sense) with any woman in sight (except his wife). Each play of the trilogy reveals to the audience what is going on in a different part of the household during the same weekend in July.

Knocking 'em Dead in Peoria

The next time you want to steal the show, here are some lines guaranteed to help you upstage the other would-be leading ladies or gentlemen. Just remember to enunciate well and project your voice clearly when you declare:
You know that the theatre is not dead, it's just sleeping. Of

course, when you say "theatre," you're referring to serious drama, not the Neil Simon fluff that audiences flock to see simply because they have to have something to do after they've taken in a fancy meal at an expensive restaurant.

Of recent Broadway fare, you think James Earl Jones is at the top of his form in *Fences* and ultimately may be remembered as much for his portrayal of the former athlete Troy Maxson, a black man battered by the white man's system, as for his classic rendition of the boxer Jack Johnson in *The Great White Hope*.

Also mention that you preferred the Negro Ensemble Company's stage production of the 1982 Pulitzer Prize-winning drama by Charles Fuller, *A Soldier's Play*, over the film version. And you know that the title of the movie was *A Soldier's Story*.

It's okay to opine that South African playwright Athol Fugard (most recently, *A Place With the Pigs*) may not be a household name, but he's still one of the best at his craft in the twentieth century.

Once considered an underground maverick, Sam Shepard (with such titles as *Fool for Love*, *True West* and *Geography of a Horse Dreamer*) has become one of the contemporary theatre's most widely produced American playwrights. But you're probably as likely to know him as the guy who hangs around with Jessica Lange and worked with her in *Country* as well as picking up an Oscar nomination for his performance in *The Right Stuff*. His fans see him as "brutally powerful," while his detractors prefer to say that he's "obscure and undisciplined." In either case, he's the theatrical world's wunderkind of the Eighties. Shepard's plays often project a certain "slice-of-life" quality that means they're short on beginning, middle and end and, therefore, a long way from the traditional "well-made play."

Among his themes are the death of the American dream, the erosion of our national myths, and our search, probably because of these losses, for roots. One of Shepard's basic tacks is to calf-rope that true American hero (and myth), the cowboy, yank him out of his natural setting and deposit him in some strange place where he can't cope (sort of like Crocodile Dundee taking on New

York, but with much less success).

Though Shepard won the 1979 Pulitzer Prize for *Buried Child*, his most popular work is probably *Fool for Love*, which explores a somewhat tawdry romance between a worn-out cowpoke and a woman who needs a man.

Other contemporary playwrights you're keeping an eye on include Beth Henley (*Crimes of the Heart*), Marsha Norman (*'night, Mother*), David Mamet (*Glengarry Glen Ross*) and Lanford Wilson (*Talley's Folly*).

Upstaging Your Rivals When You "Hit the Boards"

When anyone with theatrical pretensions wishes you good luck, it'll be in the form of "Break a leg," the traditional backstage sendoff before a performance ("hitting the boards"). You never, therefore, wish anyone in the theatre "Good luck," unless you want your leg broken for having done the verbal equivalent of sending a black cat across their path just before a performance.

You can spend hours studying diagrams depicting a stage as seen from an actor's perspective. Frankly, unless you're an actor you don't need to know such trivia.

Just remember that directions on a stage seem backwards, but they're not. In the old days, stages often rose toward the back, hence the term "upstage" for that portion away from the audience. So, when you wanted to upstage your rival, you moved toward the back of the stage, forcing the other actor to turn to face you (and turn away from the audience). "Downstage" is that part of the stage closest to the audience.

"Stage right" and "stage left" refer to the actor's right and left, not the audience's (it's the old "your left is my right" routine). "Offstage," or "waiting in the wings," is where many would-be performers spend much of their time, often as stage-hands or doorkeepers.

The stage itself is called the boards, and those large canvas backdrops used as scenery are called flats. And sitting in the audience makes you a member of the house. The fourth wall is an imaginary wall that in traditional realistic or naturalistic theatre separates you from the action on the stage: supposedly, you're

looking through the fourth wall. Breaking down the fourth wall refers to the intentional disregard of this artifice, especially by modern playwrights, who see it as a restrictive contrivance.

Lastly, "the method" has nothing to do with the rhythm method (a form of birth control) or the Lamaze method (what you move on to if you ain't got no rhythm), but refers to the Stanislavski method, named after its originator, the Russian actor and director Konstantin Stanislavski.

The method requires the actor to study the life of the character, trying to get "inside" the role, delving into the psyche of the character. A method actor, then, is one who follows the Stanislavski method. Some method actors of stage and film fame include James Dean, Marlon Brando, Robert DeNiro and Dustin Hoffman.

Broadway, Off-Broadway, Off-Off-Broadway

If friends invite you to see an off-Broadway play, that doesn't necessarily mean you'll have to sit through their kid's third-grade production of *Hansel and Gretel* in Topeka. Off-Broadway plays can take place in theatres on Broadway, in fact. Likewise, many "Broadway" theatres are actually on side streets near Broadway, not actually on the street whose name has become known as the Main Street of American theatre.

What the off-Broadway tag signifies is that the play is not taking place in one of the major New York City theatres. It also means the actors are probably working at less than union pay scale, but with the union's blessing. Off-off-Broadway productions take the whole thing a step further, and the term usually refers to plays being produced in the smallest theatres (or not in a theatre at all). At worst, you could wind up viewing an off-off-Broadway play in the producer's master bedroom or den. What everybody hopes for is that their play gets from off-off-Broadway to off-Broadway to Broadway, going from the smaller theatres to bigger ones.

Real theatre buffs are also familiar with some of the shows that

have had the longest runs on Broadway, which includes the likes of *A Chorus Line* (the current champ and record-holder; it's been on Broadway more than a decade, with over five thousand performances), the revival of *Oh! Calcutta!*, *42nd Street* and *Cats* (based on T. S. Eliot poems; it completed its fifth year in September 1987).

It helps if you can drop the names of a few of the bygone greats of the stage, such as David Garrick (he ruled the eighteenth-century stage; noted especially for his Shakespearean roles), Edwin Booth (remembered for his Hamlet as well as for being the brother of John Wilkes Booth), the Barrymores (Ethel, John and Lionel), Dame Edith Evans and Sarah Bernhardt.

Some of the other classics performances worth a mention are Julie Andrews as Guinevere (and Richard Burton as Arthur) in *Camelot*, Lee J. Cobb as Willy Loman in *Death of a Salesman*, Claire Bloom as Hedda in *Hedda Gabbler* and Nora in *A Doll's House*, and Marlon Brando as Stanley Kowalski in *A Streetcar Named Desire*.

You should also be familiar with the Tony awards (actually the Antoinette Perry Awards), the theatre's equivalent of the Oscars. Recent Tony winners include such dramas as August Wilson's *Fences* (1987) and *I'm Not Rappaport* (1986) and musicals such as *Les Misérables* (1987) and *The Mystery of Edwin Drood* (1986). Other top theatre awards include the New York Drama Critics Circle Awards (*Fences* won the 1987 drama award; *Les Miserables* was chosen as the best musical) and induction into the Theater Hall of Fame by the American Theater Critics Association. Recent inductees include Geraldine Fitzgerald and George C. Scott.

Dinner Theatre: Don't Ask the Actors to Pass the Potatoes

What better way to top off a meal than with a play as the ultimate unfattening dessert?

Although the popularity of dinner theatre seems to have peaked, the idea is still a great one. Rather than rushing to eat in

Dinner theatres offer a diverse menu

one part of town and then scrambling elsewhere to make it to your seats on time, you pay one price, which includes your meal, then sit back at your table and enjoy the show.

Generally, dinner theatre productions run to lighter fare, such as musicals and comedies. Because of the setting, shows chosen for dinner theatre also tend to be those with smaller casts. With dinner theatre, you know you've gone off-off-Broadway when a member of the cast slips over to your table during the play and politely inquires whether you want the rest of the pineapple upside-down cake you couldn't quite finish off.

Another form of theatre that you might hear about is summer stock. Many Hollywood actors and actresses enjoy summer stock as a break from the routine of filmmaking (and as a way of keeping in touch with the "legitimate theatre"). And, summer stock is popular with theatre-goers who want to see big names without having to travel to the Great White Way.

Summer stock productions typically take place in out-of-the way locations, such as the Pennsylvania Poconos or bucolic arts centers located near major metropolitan areas.

Typically, summer stock runs to the lighter side — Neil Simon comedies (*The Odd Couple*, *The Last of the Red-Hot Lovers*) or Rodgers and Hammerstein musicals (*South Pacific* or *Flower Drum Song*): Nobody, it seems, cares to go on vacation to sit through a production of Edward Albee's intense *Who's Afraid of Virginia Woolf?* (Beware: It's not about British author Virginia Woolf!)

Curtain Call on a Cast of Thousands

Don't believe for a minute that "The play's the thing."

The "thing" with the theatre is the box office, which means selling tickets, and living or dying on the strength of opening-night reviews. A "one-night stand" is exactly that in the theatre, a play that closes after only one night — victim of poor ticket sales and scathing — or worse, lukewarm — reviews.

When a play "bombs," you know that means it was so bad it never even made it to opening night in New York, but died during a trial run on the road, where plays sometimes are tested on smaller audiences to work out the rough spots before going to Broadway. That's not always the end of the line, though. *Everybody Goes to Rick's* didn't make it to Broadway, but that didn't hurt it at all when it came out in celluloid as *Casablanca*.

Finally, a bit of coaching when it comes to bluffing your way through the dramatic arts. You should have no problem at all, but if you ever do, just stay calm and remember your lines. And if all else fails, do what the professionals do — improvise, juggle, dance or sing. In any case, break a leg!

Plotting Your Course Is No Mystery

Some books are to be tasted, others to be swallowed, and some few to be chewed and digested.
— *Francis Bacon*

A good book is the precious lifeblood of a master spirit, embalmed and treasured up on purpose to a life beyond life.
— *John Milton*

Discussing literature is a snap. Don't worry that it's assumed you're thoroughly familiar with the classics: Chaucer, Dickens, Shelley, Keats, and so forth.

Fact is, they've been talked over so much, hardly anyone ever discusses them anymore unless you happen to land yourself among a nest of graduate students trying to impress each other. There's also the fact that hardly anybody reads anymore. (Reading *DOT-TO-DOT* puts you one up on them!)

But, should some of those names pop up, you want at least to be able to go with the flow. Hence, a quick primer in literature.

'Who Ya Gonna Call?' How About Beowulf?

If you'll think of *Beowulf* in terms of the movie *Ghostbusters*, you've got the basic idea. *Beowulf* is your basic heroic legend,

Beowulf was trouble for English monsters

written as a poem in Ye Olde English, a form of the language that looks funny and sounds even funnier. A phrase roughly translated as "Hey, don't look at me, I just work here" goes something like "Wyrd gaep swa hit sceal" and is pronounced the way a Swedish waiter would call out an order of blackened swordfish with baked potato and salad.

Beowulf tells of a hero, whose name happens to be Beowulf, who comes to help out his uncle, who has problems with a monster, Grendel, who keeps gobbling up all the uncle's men as if they were so many Buffalo chicken wings.

Beowulf and his buddies hit town, sit around the old castle and drink flagons of mead (mugs filled with a sort of Olde English wine cooler) and lustily sing of brave deeds before dozing off to drunken sleep.

Grendel, smelling fresh meat, breaks in and during a fight with

Beowulf, is disarmed, literally. He then slinks off to his lair (a place where monsters live) and whines to his Momma that Beowulf has mortally wounded him ("Look, Ma, no hand").

Beowulf winds up slugging it out with Grendel's mom, who nearly kills him, but Beowulf, being the hero, chops off her head and everybody — except the monsters and the scores of warriors they have already done in — lives happily ever after.

John Gardner, a contemporary author, wrote a book called *Grendel*, which took up for the bad guy, telling the story from the monster's point of view. Gardner claimed Grendel got a bad rap, that he was just a misunderstood member of a disadvantaged minority group (human flesh-devouring monsters) who was driven to a life of crime by social and psychological forces beyond his control.

Poor widdle monster.

Geoffrey Chaucer and the *Canterbury Tales*

These fourteenth-century stories were originally written in Middle English, which comes after the Old English of *Beowulf* and before Modern English. If you'll imagine an overfed and sleepy William F. Buckley, Jr., expounding in his thick Anglo-Teutonic accent on the meaning of the first Constitutional Convention to an overly unimpressed group of bored college students, you've got a feel for the way Middle English sounds.

In *The Canterbury Tales*, a group of pilgrims (not the Thanksgiving kind, just a collection of travelers) sets out to visit the holy shrine at Canterbury. On the way, they stop at an inn for supper and a night's rest. After supper, the host explains that the cable with free HBO is not working and proposes they swap yarns around the table and offers a free meal — but this is the fine print: "On the return trip, at participating restaurants, void where prohibited" — to the person who produces the best tale.

Although there were thirty-one pilgrims and each was supposed to tell four tales apiece, only twenty-three stories ever got told. English literature students have been eternally grateful Geoffrey [JEFF-ry] Chaucer fell short of the mark.

Although (or because) the group included a nun, three priests, a friar and a monk, several of the tales are notoriously risque. "The Miller's Tale," in particular, is noted for its bawdiness and the Wife of Bath, who has seen five husbands come (and go), is the member of the group whose bedroom was probably the most popular later that night.

We Have Met Defoe and He's a Sonuvabutcher

Daniel Defoe, a butcher's son (his family name was simply Foe) and early eighteenth-century writer, suffers the indignity visited on many a Great Writer of being known by the general populace not for his "important" works (*Moll Flanders* and *A Journal of the Plague Year*, to name a couple) but for an adventure novel, *Robinson Crusoe* (please, not Caruso; that's Enrico, the Italian operatic tenor; and yes, Crusoe's right-hand man's name was Friday).

Another author of the period, Jonathan Swift, arguably the greatest of all English satirical writers (from Ireland, naturally) is known today mostly for *Gulliver's Travels*. The tale of Gulliver among the Lilliputians (sort of forerunners of Oz's Munchkins) and others has come to be thought of by the general public as a children's tale, since most modern readers miss the satirical points and allusions.

Richardson, Fielding & Sterne, Ltd.

Samuel Richardson, Henry Fielding, and Laurence Sterne were not members of a prestigious English law firm. Along with Defoe, they are considered to be among the earliest practitioners of the English novel.

Richardson showed an early understanding for the necessities of the writing trade: He was, by profession, a printer, which helped immeasurably with his ability to find a publisher for his first work, *Pamela*. When your literary friends speak of *Clarissa*, you know they mean his *Clarissa Harlowe*.

Jane Austen, never far from love and marriage

Although Fielding studied law, he made his living by writing for the stage (not epic drama, but comedies and farces). In 1749, his ribald classic novel *Tom Jones* was published. It was made into a movie, winning the Oscar for Best Picture in 1963, but without popular singer Tom Jones in the title role (Albert Finney got the job, but lost out in the Oscar voting for Best Actor to Sidney Poitier in *Lilies of the Field*. The movie's Diane Cilento, Joyce Redman and Dame Edith Evans were all nominated for Oscars as Best Supporting Actress, but Margaret Rutherford, at seventy-two, was awarded the statuette for her performance in *The V.I.P.'s*).

Sterne, an Anglican churchman by trade, is remembered for *The Life and Opinions of Tristram Shandy*, which tells us little, if anything, about said life beyond the first few years. We are given, however, an abundant insight into the opinions of Shandy (therefore, of Sterne) on every conceivable topic.

The Prime-Time Humor of Miss Jane Austen

You just can't get enough of the late eighteenth- and early nineteenth-century writer Jane Austen (*Pride and Prejudice*, *Sense and Sensibility*, and *Emma*). What you admire most is her clear-eyed view of reality; that she presents such insights with a dash of humor adds to your pleasure. Her works nearly always deal with young women, usually middle-class or better, on the road to love and marriage. If you want to come across as a devoted Austen fan, swear you reread all of her works every year. Women especially like these stories because the heroines not only get their men, but they get to stay smart and a little sassy, too.

What the Dickens, or, Down and Out in Dirty Old London

Charles Dickens wrote novels back in the nineteenth century when people bought books to read during long, cold English winter nights. He was a blockbuster novelist, the Sidney Sheldon of his day.

Just remember that *Oliver Twist* is the one where the little boy (Oliver) asks for another bowl of gruel and *David Copperfield* (not a magician) is the one where little David joins a band of thieves headed up by a hood named Fagin and including a pick-pocket called the Artful Dodger (not Tommy Lasorda). It's sort of a Patty Hearst story set in Victorian (during the reign of Queen Victoria) England.

Dickens had a gigantic soft spot for the downtrodden, hence the rap that his novels are "sentimental." This is most evident in *A Christmas Carol*, that monument to all that is wonderful about a snowy English Christmas, complete with the original Tiny Tim ("God bless us every one!"; not to be confused with the sixties ukulele player whose line was "Tiptoe through the tulips"), his father, Bob Cratchit, and the consummate capitalist, Ebenezer Scrooge, who takes a turn for the better after a harrowing night with ghostly visitors.

Charles Dickens championed the downtrodden

Did Somebody Say Boy George Eliot?

If someone raves about George Eliot's *Middlemarch* (1871; which is one of those highly touted books that hardly anybody reads; in a nutshell, it's the story of a woman who finds fulfillment in the cause of medical reform rather than in marriage and of a man who sells out the cause of medical reform, opting instead for a wealthy practice), don't pop in with "Oh, yes, he's one of my favorites." He's not, because he's not a he, he's a she. George Eliot (who lived about the same time as Dickens) was actually Mary Ann Evans Cross (the Cross often being dropped in referring to her since she married in May, died in December, giving new meaning to the notion of a May-December marriage).

Another of her novels, *The Mill on the Floss* (1860), has absolutely nothing to do with dental hygiene, but refers to a flour mill on a river named the Floss.

How About a Blind Date With the Bronte Sisters?

Even before the Andrews Sisters or the Pointer Sisters, there were the nineteenth-century Bronte Sisters — or were they actually the Bell Brothers?

Anne wrote *Agnes Grey* (1847) under the pen name of Acton Bell, and Charlotte wrote *Jane Eyre* (1847) under the *nom de plume* of Currer Bell while Emily produced *Wuthering Heights* (1847; remember why you never wanted to name a child Heathcliff?) under the pseudonym of Ellis Bell. A brother, Branwell Bronte, went by his own blessed name, but he never amounted to much of anything, dying of consumption, alcohol and opium addiction.

Thomas Hardy: Hey, Jude, Don't Be So Obscure

When talk turns to Thomas Hardy, remember that it's *Far From the Madding Crowd* (1874), not "maddening crowd." Also, that he had nothing to do with the comedy team of Laurel and Hardy.

It also helps to remember that Wessex, which is known as

"Hardy country," is actually southwest England, particularly the county of Dorset.

Among Hardy's memorable works are *Jude the Obscure* (1895), *The Mayor of Casterbridge* (1886), and *Tess of the D'Urbervilles* (1891; remember Nastassia Kinski in the marvelously beautiful 1979 Roman Polanski film version, *Tess*?). A central theme in much of Hardy's works (he's also well-respected as a poet) is the human struggle against the neutral and indifferent forces that govern the world. He describes these forces as "purblind doomsters" in his poem "Hap," and his writing is often described as fatalistic.

Little Jimmy Joyce and the Bloomsday Boys

The most famous English novel of the twentieth century has to be *Ulysses* (1922), by James Joyce. Okay, in addition to *Lady Chatterly's Lover* (1928), by D. H. Lawrence (you know, Frieda's husband and the subject of the film *The Priest of Love*, with Ian McKellen and Janet Suzman in the leading roles).

Ulysses retells the events of June 16, 1904, which is known as "Bloomsday" (bonus points with the literati if you can remember the date) in honor of the book's main character, Leopold Bloom, an Irish Jew married to an adulterous Catholic wife, Molly.

During his wanderings about Dublin, Bloom meets up with young Stephen Dedalus, a typically mixed-up young man in search of a father figure, and the two wind up roaring drunk by book's end.

You like *Ulysses* for its generous humanity and its comic vision of life's little tragedies. Molly Bloom's soliloquy at the end of the book (a textbook example of "stream-of-consciousness" technique, which is the literary equivalent of psychological free association) is sheer, sensual, seductive poetry.

Joyce's *Finnegans Wake* (1939) is similar to *Beowulf* in that it's written in a form of English that is largely indecipherable to the average human being. If someone wants to talk about *Finnegans Wake*, it's best to suddenly develop appendicitis.

Who's Hot, Who's Not on the Recent British Scene

The complicated and cerebral ("enigmatic") British writer John Fowles (*The French Lieutenant's Woman*) is definitely your cup of tea, even if he does give his books quirky titles like *A Maggot*, which is not a reference to a slimy creature you'd rather not think about, but is used in the old-fashioned sense of "a notion or a whimsy."

College professors and intellectuals lap up John Fowles. He's a thinking man's thinking man who deals in ultimate questions ("Why are doughnuts round? Who invented air? If an atomic bomb falls in the middle of a forest and nobody hears it, will the radiation still make your hair fall out twenty years later?).

You consider *Daniel Martin* to be a disappointment, but, among his earlier works, you rank the disturbingly complex *The Magus* (you prefer the 1977 rewritten version and eagerly hope there'll be others) over *The Collector*.

Among other recent writers, you like David Lodge (*Small World*), Alan Sillitoe (*The Loneliness of the Long Distance Runner*), Muriel Spark (*The Prime of Miss Jean Brodie*), and Angus Wilson (*Anglo-Saxon Attitudes*).

Of writers within the last century or so, you like E. M. Forster (*A Passage to India, A Room With a View*; both made into movies in the eighties), D. H. Lawrence (*Sons and Lovers, Women in Love*; you can see what *he* was preoccupied with), Evelyn Waugh (*Brideshead Revisited*, a big Public Broadcasting Service hit in the eighties), and Virginia Woolf (*To the Lighthouse*).

You think Firbank's biography of Forster was superb, and you know Evelyn [E-velyn, not EV-elyn] Waugh is a man despite his name. And you've never, ever, ever thought about reading Barbara Cartland.

In the Colonies, a Revoltin' Development: American Literature

The early American literary scene was dominated more by poetry and essays (including collections of sermons, histories) than by the novel.

Early writers include Anne Bradstreet (poet, *The Tenth Muse Lately Sprung Up in America*, 1650), Edward Taylor (poet, *Preparatory Meditations*, written 1682 to 1725), Cotton Mather (theological essayist, *The Wonders of the Invisible World*, 1693), and Ebenezer Cook (poet, *The Sot-Weed Factor*, 1708; in 1960 writer John Barth borrowed the title for his novel based on Cook's life). Among early American novels are *Charlotte Temple* (first published in England in 1791, in America in 1794) by Susannah Rowson and *Wieland* (1798) by Charles Brockden Brown.

Otherwise, you know that the next significant event to come along in American literature was the publication of *The Spy* (1821), by James Fenimore Cooper. Although *The Spy* was Cooper's first commercial success, the most well-known of Cooper's works is *The Last of the Mohicans* (1826), which features the great white hunter Natty Bumppo and the Indian Chingachgook. You know that the Natty Bumppo novels collectively (there are five; *Mohicans* was the second) are known as the *Leatherstocking Tales*.

In Nathaniel Hawthorne's *The Scarlet Letter* (1850), the letter is an *A* and it stands for adultery (don't confuse it with the *T* that stands for trouble, which is what they had in River City in the Broadway play, later movie, *The Music Man*). The novel tells of a young minister who commits adultery with a parishioner and then allows her to face the music on her own (you know, sort of a Jim Bakker sex scandal set in Puritan New England).

Moby Dick: The Great American Novel?

While some people wait for Godot and others wait for the Messiah, the American literati are waiting for the Great American Novel, a largely mythical work which somehow, in one volume, could capture the breadth and depth and width and scope and range of the U.S. of A.

Generally, it's conceded no one has written such a book. But many would say that Herman Melville's *Moby Dick* (1851; "Call me Ishmael" is the opening sentence of the book's first chapter,

Great American novel: a whale of a debate

Ishmael being the sole survivor of the search for the great white whale and the book's narrator; just remember that the next line isn't "Call me irresponsible") came close. Some would argue so did Margaret Mitchell's *Gone With the Wind* (1936). The Great American Novel, perhaps, would combine the two, with elements of other great works.

You should know that *Moby Dick* deals with the blind pursuit of Moby Dick, the White Whale, by Captain Ahab, who winds up insane — as well as dead — as a result of his compulsion. Like all great works, it also has something to do with good and evil.

Another candidate for Great American Novel honors is *The Adventures of Huckleberry Finn* (1884), by Mark Twain. Ostensibly the story of a boy's adventures on the Mississippi River, the book ultimately deals with questions of human worth and dignity. Huck's relationship with Jim, a runaway slave, forms the central focus of the novel. "All modern American literature comes from one book by Mark Twain called *Huckleberry Finn*," said Ernest Hemingway.

Oink If You Earnestly Like Hemingway

Now that liberated men are doing such things as cooking their own TV dinners, taking their own shirts to the laundry, and making sure the baby's diapers are picked up by the diaper service, is it any wonder that America's greatest male chauvinist pig of a writer is taking a beating at the hands of revisionist critics?

Before you go sailing off into uncharted seas by blabbing how much you like *For Whom the Bell Tolls* (1940) or *A Farewell to Arms* (1929), remember that you like Hemingway, but not as much as you like William Faulkner (*The Sound and the Fury*, 1929), who, despite being a Southerner, is generally regarded as the great American writer of the twentieth century.

What you *do* like about Hemingway is that underneath that gruff, macho exterior that was always running the bulls at Pamplona, drinking till all hours of the day and night, and generally

Hemingway: Mr. Macho with an artist's heart

chasing any skirt in sight, there beat a sensitive heart that some-how could never overcome its physical and psychic makeup.

Your favorite Hemingway book is *The Old Man and the Sea*, a whale of a tale about one that got away. An old man hauls in a beaut of a marlin (probably using twenty-pound test line, using a Honolulu swivel-hipped hula hugger in muddy water off the coast of Cuba), only to lose it to Jaws's granddaddy on the way back to shore.

The story is an allegory, which means it's about an old man and the sea and a fish, but it's also about life, death, infinity and the universe. You can probably throw in references to good and evil as well.

Wild Bill Faulkner's Yoknapatawpha County

Like Shakespeare, William Faulkner had problems spelling his name, being born without a "u" in his last name. For this reason, references to the rest of his family (the Falkners) all look like typographical mistakes.

When discussing Faulkner, remember that a running theme in his Yoknapatawpha (an imaginary county in Mississippi) works is the decline of the Compson family, the rise and decline of the Sartoris family, and the rise and shenanigans of the Snopeses (they liked to set fires).

You also know that the "Faulknerian sentence" could run unrelieved for pages, weaving in memories, dreams and halluci-nations with the dialogue of the character speaking/thinking at the time (mention *Absalom, Absalom!* as an example). Because of this, Faulkner's name is often linked with those of James Joyce and Marcel Proust as experimenters with a form of writing known as "stream of consciousness."

The J. D. Salinger Cult

There's probably only one American author who could produce a frenzy at bookstores, should he decide to come out of hiding.

William Faulkner's sentences were long-winded

J. D. Salinger (*The Catcher in the Rye*, 1951) has lived a secluded and private life in New Hampshire and hasn't published a book in years. ("What's the latest on Salinger?" is always a good line. Salinger sightings are reported in the literary press with the fervor of birdwatchers' reports on rare or endangered species.)

Salinger's works (other than *Catcher*, whose protagonist is Holden Caulfield, a smug young twerp, who is personally offended by all the "phonies" in the world, even though he never knew Richard Nixon in his prime) are inhabited by members of the multifaceted Les and Bessie Glass family, a Jewish-Catholic union whose egocentric offspring can be introspective to the point of tears.

To really strut your stuff, it's nice to know a few intimate details. For example:

Buddy Glass, the narrator of the various stories, was born in 1919, the same year as the author. The other members of the family are Boo-Boo, twins Walt ("killed in a freakish explosion while he was with the Army of Occupation in Japan" in 1945) and Walker, Franny and Zooey (stars of two longish short stories published together as *Franny and Zooey*). The oldest brother, Seymour, commits suicide in *A Perfect Day for Bananafish*.

And, if you want to come across as a true Salinger aficionado, you know that the family cat is named Bloomberg and that the J. D. stands for Jerome David.

Other American authors you admire include Maya Angelou (*I Know Why the Caged Bird Sings*), James Baldwin (*The Fire Next Time*), Saul Bellow (*Humboldt's Gift*), John Gardner (*October Light*), Thomas McGuane (*Ninety-Two in the Shade*), Flannery O'Connor (*Wise Blood*), Walker Percy (*The Moviegoer*), William Styron (*Sophie's Choice*), Alice Walker (*The Color Purple*) and Eudora Welty (*The Robber Bridegroom*).

You don't particularly care for John Irving (*The World According to Garp* — "pornography parading as literature") or Philip Roth (*Portnoy's Complaint* — ditto). You wonder if Norman Mailer (*The Executioner's Song*, *The Naked and the Dead*) will ever write another good novel. You wouldn't be caught dead in a

bookstore that harbors such fugitives from literary justice as Danielle Steel, Jacqueline Susann, or Harold Robbins.

The Rooskies are Coming, the Rooskies...

Tell them you're reading *War and Peace*.

It doesn't matter that you're really reading Elmore Leonard's latest south Florida potboiler: Lie through your teeth. Few people are going to call your bluff on *War and Peace*.

Fact is, not many people have read *War and Peace* cover to cover. If you're in a particularly literate setting (the local pub where young poets read their works), any mention of *War and Peace* will prompt someone to trot out the obligatory reference to the Russians.

They're not referring to Lenin and Marx.

Rather, the Russians include, in addition to Leo Tolstoy (*War and Peace)*, such top names as Fyodor Dostoevsky (*Crime and Punishment*; it's not about the KGB), Nikolai Gogol (*Dead Souls*), Mikhail Sholokhov (*Quiet Flows the Don*), Ivan Turgenev (*Fathers and Sons*) and, more recently, Boris Pasternak (*Doctor Zhivago*) and Alexander Solzhenitsyn (*One Day in the Life of Ivan Denisovich*).

Reading the Russians is something everyone over the age of sixteen should do at least once in a lifetime. Try to look dark and solemn, as if you had just swallowed a mouthful of moldy caviar, at any mention of "Russian dominance."

Recent Foreign Authors of Note

You are fascinated by the "imaginative vigor" of South American writers, especially Gabriel García Márquez, the Colombian Nobel Prize winner, whose *One Hundred Years of Solitude* has developed a cult following. The Argentine surrealist Jorge Luis Borges also rates high on your list. And Isak Dinesen (*Out of Africa*; the movie with Meryl Streep and Robert Redford won seven Oscars in 1985) was the pen name of Karen Blixen, a Danish baroness who also wrote *Seven Gothic Tales*.

Poetry: I Think That I Shall Never See a Poem

It's also permissible to say that you like to dabble in poetry. This is because dabbling is all you can do since you can't make a living writing poetry, unless, perhaps, for greeting-card companies. But you should at least have some vague inkling who some of the name-brand poets of Western literature are, even if you never get around to reading a line of what they've written.

It's always good form to tip your hat to Shakespeare's sonnets. Learning a couple of bits such as "Shall I compare thee to a summer's day?" or "Let me not to the marriage of true minds / Admit impediments" will speed you through many a conversation. Two contemporaries of Shakespeare who should be accorded due respect are Christopher Marlowe and John Donne. Marlowe wrote the line oft repeated (but rarely attributed to him) in singles bars: "Come live with me and be my love" while Donne is remembered more for a stretch of poetic prose that includes the phrase "No man is an island."

John Milton, author of *Paradise Lost*, should always be accorded a place of special honor. Though blind and in declining health, he wrote what is considered one of the poetic masterpieces of the English tongue, *Paradise Lost* ("Better to reign in hell than serve in heav'n") in 1667, only seven years before his death.

Lord Byron, Percy Bysshe Shelley and John Keats are known as romantic poets, which had nothing at all to do with their love lives, although such did prove interesting at times. Lord Byron was perhaps the most dashing of the threesome, continually laboring at love, while at the same time — perhaps because of that fact — being the worst poet of the lot. His unfinished masterpiece *Don Juan* [always pronounced Don JEW-ahn] related the adventures of the master Spanish lover. Lord Byron died rather ignobly of a fever at Missolonghi during the struggle for Greek independence, but was accorded full hero's treatment by the Greeks.

Shelley, whose wife Mary Wollstonecraft Shelley wrote *Frankenstein or the Modern Prometheus*, drowned at thirty with a friend in a sailing accident. The bodies were washed ashore on an Italian

island where Lord Byron and Leigh Hunt, a poet and essayist, watched as the bodies were burned in a funeral ritual. Although *Prometheus Unbound* is probably his greatest work, he is best remembered perhaps for the short poem "Ozymandias," with its haunting lines: "My name is Ozymandias, king of kings: / Look on my works, ye Mighty, and despair!"

Other British poets of note include Elizabeth Barrett (Browning), William Blake, Robert Browning, Samuel Taylor Coleridge, Dylan Thomas, and William Butler Yeats.

Some groups and movements connected with poetry you should be aware of include:

The Transcendentalists — A group of New England writers whose works emphasized feelings and sensations over pure intellect and reason. Ralph Waldo Emerson, a poet better known as an essayist ("I hate quotations. Tell me what you know"), was a leader of the movement.

The Boston Brahmins — Because they were members of high society, these writers received the tag Brahmins, from the name given the highest caste in Hindu society. Among the Brahmins were Henry Wadsworth Longfellow, James Russell Lowell and Oliver Wendell Holmes (his son, of the same name, was the famous U.S. Supreme Court justice).

Agrarians — Writers who believed the South should pursue development along agricultural rather than industrial lines. These writers included Allen Tate, John Crowe Ransom and Robert Penn Warren (the only American writer to win Pulitzer Prizes for poetry and fiction, he was also the nation's first poet laureate).

Beat Movement — Convinced that America was going down the tubes morally and artistically, the beat poets spoke out against middle-class values. Among their leaders were Allen Ginsberg (*Howl, and Other Poems*) and Lawrence Ferlinghetti (*A Coney Island of the Mind*).

Other American poets worth knowing include Hart Crane, e. e. cummings (that's the way he did his name; he also liked to play with the way his poems were set in type), Emily Dickinson, Robert Frost, H.D. (her pen name; Hilda Doolittle), Denise Levertov, Robert Lowell, Marianne Moore, Sylvia Plath, Ezra Pound, Carl Sandburg, Wallace Stevens, and William Carlos Williams.

Just remember that *Leaves of Grass*, by Walt Whitman, is a celebration of the freedom of the human spirit, not a paean (a song of praise) to marijuana. And you know that Joyce Kilmer ("I think that I shall never see / a poem lovely as a tree'') is a man, not a woman.

Little Magazines and Small Presses

You know that most short stories and poems are published in little magazines (meaning little in size and circulation) and by small presses (size of list and total sales). Many of these are connected with colleges and universities, which subsidize their operation. Some of the little magazines whose names you drop are the *Paris Review* (George Plimpton and the *Writers at Work* series), the *Antioch Review,* the *Southern Review*, the *Kenyon Review*, and *Prairie Schooner*.

You know that the only major contemporary magazine that publishes poetry and fiction every week is the *New Yorker*. With a sigh, you mourn the passing of the days when most of the major magazines (especially *Saturday Evening Post*) in the country were ready markets for young writers out to make their mark in the world.

Arm-Wrestling With the Literati

The *literati* are those men and women of letters who have achieved a certain elevated (elitist?) status as keepers of the torch of knowledge. They are scholarly, well-read, and often self-appointed guardians of What Is Good and What Is Not. In other words, literary snobs.

In England shortly after the beginning of the twentieth century, a group of the *literati* who often gathered to discuss Art, Literature and Other Works of Beauty came to be known as "the Bloomsbury Group" (after the section of London where their gatherings were usually held; don't confuse Bloomsbury with Joyce's Bloomsday!).

Members of the Bloomsbury Group included the writers Virginia Woolf, E. M. Forster and Lytton Strachey (*Eminent Victorians*, a classic in biography).

Opposing the *literati* are those "anti-intellectuals" referred to by essayist and poet Matthew Arnold as "Philistines" because of their inability to enjoy the finer things in life.

In the United States, the *literati* and would-be *literati* worship such shrines as the Algonquin Club in New York or Bread Loaf, a writers' workshop in Vermont, or Yaddo, a writer's colony in upstate New York. And, of course, when you can break away from your $50,000-a-year job, you plan to spend a year at the Iowa Writers' Workshop, knocking off the Great American Novel.

A Phrase for All Seasons

You need some stock literary phrases to drop into your conversation. The following have worked well for years. You can update by substituting the appropriate titles from current works.

• "(*Going After Cacciato* or any other Vietnam-era book) is good — and I mean damned good — but still it doesn't quite hit the mark. Sooner or later, somebody's going to write a great novel about Vietnam."

• "James Michener (or John Steinbeck or Graham Greene or any writer who actually earns or earned a living by selling books and achieves any sort of popular, off-campus following) is such a hack."

• "Whatever happened to (J. D. Salinger, Norman Mailer)? He had so much potential, so much promise. Then ..."

• "Hollywood ruined (*The French Lieutenant's Woman*, or the name of any book that has been made into a movie)."

• "(*Moby Dick*, *The Godfather*, *Gone With the Wind*, or the title of your favorite epic) could have been the great American novel. If only …"

• "The last great American writer was (take your pick: William Faulkner, Ernest Hemingway, F. Scott Fitzgerald [*The Great Gatsby*])." Don't say G. Gordon Liddy or John Madden.

Six Excuses for Why You Don't Read More

Hardly anybody reads as much as they should. It helps if you have a good rationalization for not doing so. Try these:

• "I read the first few pages of *War and Peace* three years ago, but there's been so much action in the commodities market lately, I just haven't had time to get back to it."

• "I'm tired of reading novels written by college professors about college professors writing novels about college professors writing novels."

• "Nobody reads anymore."

• "If you read the book before you see the movie, it ruins the movie."

• "My analyst told me to stay away from fiction."

• "I asked for a good novel at the bookstore the other day and the clerk showed me a nouvelle cuisine cookbook instead.

A Writer by Any Other Name Still Lies the Same

Writers, dealing mostly in made-up stuff that happens in an unreal world in a nonexistent universe (and therefore being about as dishonest a lot as you can come across) naturally are not inclined to put their real names on the deceptions they churn out.

What's slick is that writers even have fake names for this business of a fake name. They call it a pseudonym, or in certain circles, a *nom de plume*.

As for why writers hide behind phony names, there are various other reasons, but one is that they're afraid their Momma might find out they've written a sleazy little sex novel. After having hocked the family heirlooms so young Sneddington could rub sensitive shoulders with the Other Great Minds of His Generation at Harvard, Princeton or Yale, Momma might disinherit the insensitive gerbil if she were to discover that he had written *Sixty-five Lust Poems for Sexually Starved Sorority Sisters*.

You can score major points with the literary crowd by knowing that Anthony Burgess (*A Clockwork Orange*) is really John Burgess; Lewis Carroll (*Alice in Wonderland*) is really Charles Dodgson; Joseph Conrad (*Lord Jim*) is really Josef Korzeniowski; George Eliot (*Silas Marner*) is really Mary Ann Evans Cross; O. Henry ("Gift of the Magi") is really William Sydney Porter; George Orwell (*1984*) is really Eric Blair; and Mark Twain (*Tom Sawyer*) is really Samuel Langhorne (not Longhorn!) Clemens.

You don't really care whether Stephen King is Richard Bachman or vice versa. And you know that Penelope Ashe was the collective pseudonym used by a group of newspaper writers for *Naked Came the Stranger*, a 1960s erotic hoax.

No Mystery About It

On vacation or just before dozing off to bed at night, it's perfectly fine for you to curl up with a thumping good mystery. Your favorite British tales range from the classic Sherlock Holmes stories (you've read and reread them all), by Arthur Conan Doyle, to the contemporary P. D. James (a woman, by the way; *Cover Her Face* and *Death of An Expert Witness*) whose Inspector Dalgleish is urbane and sensitive (a published poet), but ever in pursuit of the guilty party. Or, if you prefer a romp through the horse-racing scene with its paddocks and hay, there's Dick Francis, whose *Bonecrack* and *Flying Finish* are among his best.

Though there's nothing wrong with Agatha Christie, her Hercule Poirot and Jane Marple books enjoy too widespread an audience to give you much of an advantage. To seize the upper hand, drop in Dorothy Leigh Sayers's name instead. Her Lord Peter Wimsey is the epitome of the sophisticated private detective. *The Nine Tailors*, which is a delightful short course in the old English custom of bell-ringing, is a marvelous mystery set in the East Anglian fen country. To score major points, mention that you also like her translation of Dante's *Divine Comedy*. (You won't even need to discuss her interest in incunabula, early printed books.)

For a change of pace, you like to cross the channel and spend time with Maigret in Paris, where Georges Simenon's idiosyncratic police inspector is famed for his ability to wade through any school of red herrings. Typically, he forces a confession from his suspect while munching on sandwiches and beer (brought in from a nearby *brasserie*) in his office after a night of exhaustive questioning that resembles a prolonged session on a psychoanalyst's couch.

Back in the States, you like Amanda Cross for such literate works as *The James Joyce Murder*, although you find heroine Kate Fansler a bit overbearing at times. James Cain's "social realism" (*The Postman Always Rings Twice*) is just the ticket when you feel like slumming on the West Coast. But for pure, raw power, nobody can beat Elmore "Dutch" Leonard (*LaBrava*, *Glitz*, and *Stick*) for the hard-boiled detective potboiler.

Remembrance of Things You'd Rather Forget

Remember when you were in the eighth-grade and Mrs. Quimby, that evil-eyed hag of an English teacher who could pop a ruler down on your knuckles faster than you could say *Wuthering Heights*, gave you a list of the Great Works of Literature?

And she told you in no uncertain terms that by the time you finished high school you should have read every single blessed one of those books if you expected to be considered anywhere close to what could be called literate?

Great works of literature aren't always heavy

You carried that list around the rest of the year, finally checking off *Silas Marner* because you *had* to read that to get out of eighth-grade English.

By the time you got your diploma you had about five or maybe six of those books checked off.

Then one night about two and one-fourteenth months after you graduated you got feelthy steenking drunk and yanked that list out of your wallet or purse and tore it into itty-bitty shreds and sailed them like confetti out the car window while you were weaving your way home after an all-night binge at somebody's lake cabin.

Then you went to college and got a degree and graduated and got a job and maybe even a cat or a family. But you could never forget that list.

Like the albatross in Samuel Taylor Coleridge's "The Rime of the Ancient Mariner," it has hung around your psyche all these

years. Occasionally you'll check one of the titles out of the library, and it will gather dust on the nightstand beside your bed for a month and a half until you get an overdue notice and return it to the library. Unopened, unread.

It's time to get that list — and Mrs. Quimby — off your mind.

Instant Plot Outlines of the Great Works of Literature

These books are the "givens" of literature. Their greatness is indisputable. Most of them have not been read voluntarily anywhere in the Free World for years. They are kept in print largely because high school and college teachers force their students to plod through them annually in some perverted ritual of torture based on the premise that "I had to read this when I was your age, so you will too."

War and Peace, Leo Tolstoy (Russian) — By the end, you can't remember who anybody is (all these Russians have about half a dozen different names) and you don't really care. You just want them to defeat Napoleon (they do) and get the war over so you can peacefully close the book. What you admire about this enormous novel is its epic scope, its vast portrayal of the human condition.

You have to make a commitment when you undertake *War and Peace*. It also helps to have several years of free time, like if you're serving ten to twenty at Leavenworth for diversion of funds.

The Mayor of Casterbridge, Thomas Hardy (British) — The basis for comedian Henny Youngman's "Take my wife" joke. A drunk loses his wife and child to a sailor while gambling. When he sobers up, he swears off booze but good. Eighteen years later when he's the town big shot and mayor, the discarded woman returns, causing a whole series of sticky wickets. In the end, he dies a lonely, broken man, but you can't help but feel sorry for him.

Don Quixote, Miguel de Cervantes (Spanish) — Don Quixote, wearing a wash basin for a helmet, riding a fleabiscuit of a hayburner named Rocinante, accompanied by his sidekick, Sancho Panza, rips it up, tears it up, gives 'em hell all over Spain, jousting with windmills, among other things. He adopts a young woman (Dulcinea) from a nearby village as his maiden fair. Don't get Rocinante and Dulcinea mixed up. The musical *Man of La Mancha* covers the high points in about the same time it would take for you to read a couple of chapters.

Remembrance of Things Past, Marcel Proust (French) — Only about one-thousandth of one percent of the world's literate population has ever read *Remembrance of Things Past* from start to finish. That's because it's not one book, it's seven novels that can be read independently but form a single narrative. For years the English-speaking world has relied on the translation of *Recherche* (from the French, which is *A la recherche du temps perdu*) by C. K. Scott-Moncrieff. But you — and all your literate friends — have never read a word of it in either language.

Recherche looks impressive in your bookcase. Usually, people say something along the lines of "Ah, yes, Proust." And you reply, "Yes, Proust." Try to hold the line on the conversation there.

Building a Repertoire of Amusing Literary Anecdotes

It's helpful to develop an appreciation for the amusing literary anecdote, a short, witty story involving some Great Literary Figure. Preferably, the humor turns on some obscure literary point that only a Rhodes scholar with a background in the Postnatal Depression Novel would be able to appreciate. You get bonus points if your anecdote concerns Samuel Johnson, as told by his biographer, James Boswell. Be sure to refer to Johnson as "the good Dr. Johnson" and Boswell simply by his last name.

If you're told an amusing literary anecdote, you don't have to laugh (and for God's sake, don't guffaw). Simply give an amused,

knowing grin, letting everyone know that you're in on the joke.

Then, of course, you'll probably be expected to try to top the other person's amusing literary anecdote. You have two choices. One is to thumb through *The Oxford Book of Amusing Literary Anecdotes* beforehand and memorize a tale or two. But, if caught off-guard, try this tactic: "Oh, this will absolutely crack you up. That reminds me of the time that Dickens was invited by his publisher to ... oh, I'm sorry, but first will you excuse me while I go call (the sitter, the kennel) and check on my (son, daughter, cat, dog)? (He, she, it) has been running a fever, and I'm a bit worried." Stay away long enough for the conversation to have moved on into other realms, such as Freudian psychology or pork-belly futures.

ARCHITECTURE

Building Expertise
One Story at a Time

A man that has a taste of music, painting, or achitecture, is like one that has another sense, when compared with such as have no relish of those arts.

— *Joseph Addison*

Towered cities please us then.

— *John Milton*

In the beginning, architecture was purely functional. As such, it generally isn't thought of as art. But once people began designing structures that combined the elements of function *and* style, the notion of architecture was born.

You don't need a great deal of architectural knowledge to get by in most social settings. While the older forms are admired (the Parthenon in Athens will always be considered a thing of beauty), architectural talk is generally going to focus on the here and now. And the discussions will center on (1) what's going up, that is, the new structures being designed and built and (2) what's coming down (with an emphasis on trying to preserve examples of older architecture endangered by the wrecker's ball).

So, you need to know some of the highlights of the here-and-now and a few relevant bits of information from the past. Perhaps the best place to begin, then, is with an express-elevator tour of the background stuff.

Starting Out on a Firm Foundation

There have been architects almost since Day One. After Egypt ("See the pyramids along the Nile"), Rome and Greece are the high points of ancient architecture.

The Greeks preferred graceful forms, such as the perfection of the Parthenon, which was completed in the fifth century B.C. Classical Greek architecture was built around a desire for pure, clean lines and simplicity. The Greeks also gave the world the three basic types of columns that nearly everybody had to learn at some point in high school. In case you've forgotten (or were busy writing epic poetry), they're Doric (no frills; just a good, simple generic column), Ionic (slightly ornamental scrolls at the top) and Corinthian (ornate; looks like fancy wedding cake decoration).

The Romans, however, went for the "bigger is better" approach. The Colosseum, built in the first century, was where Romans liked to go for sport. Apparently, there was nothing quite like a Saturday afternoon spent munching on pizza, sipping a little wine, and watching the lions chew the heads off their victims. Because the Romans discovered ways to do things with arches and vaults that permitted bigger, taller buildings, their architecture tends to be massive (built along the lines of the big, fat Pantheon; the Romans would have loved the Louisiana Superdome).

From the tenth through the thirteenth centuries there was a renewal of interest in architecture based on the Roman style — therefore called Romanesque — characterized by use of a round arch and vault as well as thick, massive walls for support. Examples of Romanesque architecture include the Italian Cathedral of Pisa (the Leaning Tower is right next door) and the Eglise Sainte Croix in the French wine capital of Bordeaux. A relatively recent example of the Romanesque style is the Castle — the old red brick building across from the carrousel in the summer — at the Smithsonian Institution in Washington.

A style popular from the twelfth through the fifteenth centuries in Europe was slapped with the worst possible adjective its critics could muster: gothic. They thought these buildings looked like something the barbaric Goths would do. The description stuck,

although nowadays Gothic is considered an improvement over the Romanesque style it replaced.

Its primary advantage was that it allowed huge portions of walls to be used for window space, rather than support, thus opening the way for the glorious stained-glass windows that are the trademark of the Gothic cathedral. The great cathedrals in Paris (Notre Dame), Chartres and Cologne are prime examples of the Gothic style.

During the Renaissance, Michelangelo, famed for his work as a poet, painter and sculptor, would add to the architectural splendor of Rome by designing the world's largest (remember, bigger is better) church, St. Peter's Basilica.

In seventeenth-century England after the great London fire, Christopher Wren was given the job of rebuilding the city. Though his master plan was ignored (aren't they usually?), his impact on the city is to be found in the restored St. Paul's Cathedral (the one that survived the German blitz during World War II, its dome miraculously rising above the surrounding rubble; the façade is baroque) and numerous other public buildings. Wren's churches were his specialty and he is credited with more than fifty in London — each one different, distinctive and exhibiting the style that was his signature. Wren is generally thought of as England's greatest architect.

An Italian, Giovanni Battista Piranesi is remembered not so much for what he built — there just wasn't much work for an architect to do in impoverished mid-eighteenth-century Rome — but for his etchings, which are valued more for their worth as art than their architectural merits. But, as an architectural aficionado, you drop his name in the same breath with rave reviews of his *Views of Rome* and his wildly imaginative *Prisons* series of drawings.

During the nineteenth century, generally the period in the United States between the War of 1812 and the Civil War, there was a renewal of interest in the Greek style. A primary proponent of this movement was Benjamin Latrobe, architect for the U.S. Capitol under Thomas Jefferson (also a fine architect; remember his home, Monticello [MON-tee-CHEL-o] and his designs for

Frank Lloyd Wright: Boy Scout in a Superman cape

the campus of the University of Virginia). The architecture of this period that harkened back to ancient Athens is known as Greek Revival.

Modern Architecture: Knowing the Right Stuff

In the United States, Frank Lloyd Wright had the right stuff long before anybody thought about setting foot on the moon. It's a given he is America's greatest home-grown architect.

Idiosyncratic and individualistic, he was fond of wearing capes, boots and berets and of living life as he damned well pleased. He often resembled an overgrown Boy Scout with a Superman cape. For such quirks, the more staid public sometimes thought him slightly off-base.

The studio-homes where he lived and worked were given the unusual names of Taliesin I and II in Wisconsin and later, Taliesin West, in Arizona. He charged students, whom he generally treated like dogs, for the privilege of working for The Master.

The novelist Ayn Rand thought so much of Wright that she patterned a ruggedly individualistic architect-up-against-the-world after him in her massive work *The Fountainhead*. And musicians Simon and Garfunkel paid tribute to him on their *Bridge Over Troubled Water* album with the tune, "So Long, Frank Lloyd Wright."

Among his most well-known designs: the Johnson's Wax company headquarters (it gleams like it's perpetually buffed in Glo-Coat), Racine, Wisconsin; the Guggenheim Museum in New York (it resembles a pregnant marshmallow; he had to fight the city for the zoning approval); *Fallingwater,* a private residence in Pennsylvania (rocks, trees, falling water); the H. C. Price Tower in Oklahoma (rocks, trees, falling water on top of an office building); and the Marin County Civic Center, California (it looks like a futuristic rocketport from the twenty-second century).

In his early days, he designed residences called "prairie houses." These weren't mud huts for suburbanites, but a series of homes designed in the early 1900s in a style that emphasized the relationship of the indoors to the outside world.

European Voices: Reach for the Sky, Mein Pardner

International style is the dominant form of twentieth-century skyscrapers: glass and steel surrounded by more glass and more steel. Functional, no-frills, just-the-facts-ma'am architecture.

The names most often connected with the International style are Walter Gropius, the father of the Bauhaus [BOUGH-house] movement in Germany; his disciple, Mies ("Less is More") van der Rohe [MEES van der ROW]; and cohort, Le Corbusier.

The next time you wake up in a strange city and can't figure out where you are, thank Mies (that's how he's known in the business, not as van der Rohe), the German architect who is father of the glass and steel skyscraper in the United States. Or, at least, thank all the Miesian copycats.

The Seagram Building in New York (appropriately in whiskey-colored glass) is one of the country's first boxy buildings designed by Mies. Show off your depth of knowledge by remarking that Philip Johnson was an assistant on the project.

Mies's other notable contribution to Western civilization is the design of the Barcelona chair, which looks like it's made out of a set of dual chromium tailpipes with old rubber inner tubes stretched between them.

Le Corbusier, a Swiss-born architect and one of the founders of the International Style, called the houses he designed "machines for living." But what happened when people tried to live in his "machines" is perhaps best exemplified by the Pruitt-Igoe Housing Project in St. Louis, a seventeen-year experiment with Corbusian worker housing, which was dynamited to smithereens in one fell kaboom after proving a dismal failure.

Tom Wolfe, the puckish American journalist/iconoclast, doesn't care at all for the Bauhaus/Miesian style and said as much in his hilariously blistering assault on the movement, *From Bauhaus to Our House*. If you ignore the obvious bias, it's as good (quick-read) an introduction as you'd want to the style that has shaped most American cities in the twentieth century.

Other Moderns You Should Know

An ardent student of the Miesian style, Philip Johnson is sometimes referred to as "Mies van der Johnson" by his critics. But, more recently, he shocked the architectural community by placing arches (the Chippendale pediment atop the AT&T Building in New York, for example) on the tops of his glass and steel skyscrapers.

Earlier, however, he had let nothing stand in the way of having a room with a view. Glass to the left, glass to the right, Johnson's glass house is considered one of American architecture's great shrines. Enclosed in glass, it resembles a modernistic gas station without pumps — definitely not the thing for anyone who doesn't like life in a goldfish bowl.

When not busy with buildings, Princeton professor Michael Graves dabbles in designing shopping bags, boutiques, and furniture. Known as the prince of post-modernism, he once designed a New Jersey state park complex that resembles a three-year-old's efforts with wooden building blocks.

Don't confuse I. M. Pei with Mario Pei. The former is from China and one of America's foremost contemporary architects (the John Hancock Tower in Boston and the trapezoidal East Wing of the National Gallery of Art in Washington). The latter is from Italy and is a linguist (one who studies the science of language) of renown.

If you want to show you know your stuff, remark that you've always been impressed by Kenzo Tange, winner of the 1987 Pritzker Prize ($100,000, tax-free) in architecture. In fact, you've liked him ever since 1964 when he designed the Olympic stadiums in Tokyo. Say something architecturally deep, such as you're "impressed by his impact on the shape and philosophy of Japanese design."

Likewise, your admiration of the work of Richard Meier (in 1984, the youngest winner of a Pritzker) was confirmed when he was selected to design the J. Paul Getty Fine Arts Center in Los Angeles. And you adore his High Museum in Atlanta, which has drawn him praise for his ability to balance light, space and form (key architectural concepts, by the way).

When it comes to architectural firms, you should be familiar with Skidmore, Owings and Merrill. They've left their imprint on everything from the Sears Tower in Chicago to the Hirshhorn Museum in Washington to the Air Force Academy in Colorado. Unquestionably, the great architectural firm of the twentieth century.

Two Who Walk to a Different Drummer

Every field must have its visionaries. For architecture, they are Paolo Soleri and Buckminster Fuller.

Out in the Arizona desert, Soleri's grand scheme rises: Arcosanti, a solar-powered desert metropolis. Soleri's visions include cities that rise vertically, stacked high like huge space-age anthills. For now, though, he settles for the cold, hard facts of the reality of Arcosanti, a slowly evolving structure that has been under construction — with a good bit of volunteer labor — since 1970 and may never be completed.

In the sixties and seventies, Buckminster Fuller ("Bucky"), father of the geodesic dome (a structure that looks like a prefabricated igloo) became a guru to the environmental movement with his concept of "spaceship Earth." The U.S. exhibit at Expo '67 in Montreal was a geodesic dome.

It's All a Matter of Style, Period

Architecture, like art, has its periods and styles. Here's a quick rundown of some of the important ones not covered elsewhere.

Baroque — Lavish, ornamental seventeenth- and eighteenth-century style (the palace at Versailles with its Hall of Mirrors, all that gold leaf and the rich tapestries) that tends to gaudiness. The Italian Lorenzo Bernini is credited with starting the movement, filling Rome with his elaborate fountains and sculptures.

Brutalism — Has nothing to do with architects' sexual perver-

Brutalism would be Hulk Hogan's style

sions ("Whip me with a steel girder, you big brute"). It's a style based on massiveness, on being overpowering. With its pure form (lots of plain concrete) and clean lines, it lacks even the saving graces of the Romanesque. If wrestlers Hulk Hogan and Big John Bundy designed buildings, brutalism is probably what they would come up with.

The small town of Columbus in Indiana has become a living exhibition of modern architecture, especially in the Brutal style. It all started when a local company set up a foundation to pay fees for new schools — if a noted architect did the work. What followed was a number of new schools and eventually other buildings designed by top architects caught up in the Columbus experiment.

In Oklahoma City, the Mummer's Theater is an example of the New Brutalism. (Could it be that the architects' drawings for a

Federal style, popular for state capitols

flour mill got shipped to Oklahoma City by mistake and wound up as that town's arts center? And somewhere out in South Dakota there is a flour mill that looks like an arts center?)

Federal — Prevalent during the early years of the United States. Among its characteristics: slender, fluted columns and large, freestanding porticoes (porches or walkways). As developed by Bostonian Charles Bulfinch, the Federal style became a popular form for state capitols.

An excellent quick-as-a-wink guide to American architecture is *Master Builders: A Guide to Famous American Architects* (Diane Maddex, editor; The Preservation Press, The National Trust for Historic Preservation, 1985).

Georgian — Don't confuse this eighteenth-century style with Tobacco Road Chic, a tarpaper-and-tin-roof style popular in the South during the Depression. Nor was Billy Carter's gas station in Plains, Georgia, a prime example of Georgian architecture.

In fact, the style has nothing to do with the state of Georgia, other than the coincidence that both words come from the name of the kings of England (there were three in a row, with George III taking the rap for losing the war with the Colonies) who reigned during the period the formal, elegant style was popular. In England, the Georgian period covers the period from 1714 to 1820, while in the United States, it runs from about 1700 to the time of the Revolution. Independence Hall in Philadelphia is a familiar example of Georgian architecture.

Landscape Architecture — Frederick Law Olmsted is considered America's greatest landscape architect for his many urban parks. He is most well-known for Central Park in New York City. His original design did not include muggers and thieves, however. These were added later.

Finishing Up: Topping Things Off

Architecture also has a language all its own.

To an architect, a lintel is a weight-bearing beam, such as the crosspiece over a window or a door. It's not a bean, which is a lentil. So when an architect talks about using lintels, don't envision a doorway fashioned out of gigantic lima or pinto beans (remember those you decorated cigar boxes with when you had to make a jewelry box for Mom at summer camp?).

Likewise, buttresses are brick or stone supports used to prop up buildings. Don't gaze skyward or pop out your field glasses if someone mentions a flying buttress. Like a buttress (which, for some reason, is not called a standing buttress), the flying buttress serves the same purpose except that it's a support placed farther from the wall and is connected to the wall by an arch. Notre Dame Cathedral in Paris is supported by flying buttresses.

A pediment, in the classic Greek style, was a low-pitched gable on the front of the building. Nowadays, it's usually a similar triangular piece used ornamentally over a doorway, fireplace, etc. (or atop Philip Johnson's AT&T building in New York). Pediments serve to create a focal point. However, a pediment can focus on an impediment if the door is locked and you can't remember where you left the key. It's nice too if you can sprinkle in references to arches, apses, cornices, colonnades and façades.

Now that you've mastered the basic styles and picked up a few names to drop, you can fly your buttresses with the best of them. Just remember to always build your expertise from the ground floor up, one story at a time. And, don't expect to become an architectural know-it-all overnight. Rome, remember, wasn't built in a day.

MOVIES

Putting the Right Names
Up in Lights

If my film makes one more person feel miserable, I'll feel I've done my job.

— Woody Allen

The advantage to being a movie buff is obvious: You're an expert on a relatively young art form. You don't have to spend four years in college studying Restoration Cinema or Italian High Renaissance Movies. In film, the classics are less than a hundred years old.

Fortunately for non-movie buffs, you're already familiar with many of the classics, simply from years of going to the movies as an innocent bystander and from half-watching old movies on the late show (film is one art form where osmosis works).

But what you need to know is why film buffs like certain movies, actors, directors, etc., and why they show a disdain for others. As a bluffer, the key is to mention the right movie, the right director or the right actor.

So, even if your best boy has run off with the key grip and left you on location with the second unit, here are some names and

faces guaranteed to produce results.

Lights, camera, action!

Birth of an Art Form: Milestones in Silent Moviemaking

As you shine the arc lights on the masters of the past, speak fondly of *The Great Train Robbery* (1903, directed by Edwin S. Porter) as the first movie that told a coherent story from start to finish. (Earlier movie efforts had concentrated on vignettes or favorite scenes from stage plays, such as the infamous — and risqué for the times — May Irwin-John C. Rice kiss scene from their *Widow Jones*. It's known among film buffs simply as *The Kiss*.) *Train Robbery* is also considered the first of that venerable genre [ZHOHN-ruh] (a type or variety of film): the Western, complete with good guys (in the white hats) and bad guys (black hats, natch), chase scenes and so forth.

Birth of a Nation (1915, directed by D. W. Griffith) is considered a benchmark of early filmmaking. Not only was it a smash box-office success, but it was a consummate statement of the filmmaking art to that point. The epic tale of the Civil War and Reconstruction eras uses numerous movie techniques (fadeouts, flashbacks, dissolves, cross-cutting, split screen) in ways never before attempted on such a grand scale.

Griffith himself is considered the father of American film, producing and directing nearly five hundred movies during his Hollywood career, including his masterpiece, *Intolerance*, the 1916 historical epic that would foreshadow Cecil B. DeMille's later biblical masterpieces (such as the story of Moses, complete with the parting of the Red Sea in his last effort, *The Ten Commandments*). In one scene alone, Griffith used sixteen thousand "extras" (anonymous actors and actresses whose role is to be part of a crowd scene: you know, "Lights, camera, mingle!'') in his commentary on the evils of intolerance from the time of ancient Babylon to the modern day.

Elsewhere, *Battleship Potemkin* (1925, directed by Sergei M. Eisenstein), is considered a silent classic for its use of montage

(also pioneered by Griffith). And the massacre scene on the Odessa steps has been called the most influential six minutes in the history of filmmaking. (To really strut your stuff, remark that Brian DePalma invoked the memory of Eisenstein in *The Untouchables* [1987], his version of the Eliot Ness/Al Capone story, when he borrowed the baby carriage scene from the Odessa steps for a shootout sequence in a Chicago train station.)

Well, Hush My Mouth and Tickle My Funny Bone

Among movie buffs' favorite silent comedy classics are *Safety Last* (1923), in which Harold Lloyd (the innocent-looking chap in the horn-rimmed glasses) winds up dangling precariously high above the street while hanging from the hand of a giant clock; *The Gold Rush* (1925), in which Charlie Chaplin as "The Little Tramp" falls in love with a dance-hall girl who tends to give him the bum's rush; and *The General* (1927), which features a poker-faced Buster Keaton in the role of a Civil War train engine-chaser on the trail of Union soldiers who have made off with, most importantly, his locomotive ... and, oh yes, his woman.

And you know that Mack Sennett was the director-producer responsible for so many of the classic comedies of the silent era. In addition to discovering the likes of Charlie Chaplin, W. C. Fields, Harold Lloyd, Ben Turpin, Fatty Arbuckle and Buster Keaton, he brought the Keystone Kops, slapstick, and custard pies in the face to the screen.

Putting It All Down in Black and White

There are scores of black-and-white movie favorites. What you need is a quick rundown of the *creme de la creme*. Here goes:

It's hard to say whether *Citizen Kane* (1941) or *Casablanca* (1942) is considered *the* black-and-white movie of all time. If you vote only with your heart, the sentimental favorite has to be the warmly romantic *Casablanca* with Humphrey Bogart, Ingrid Bergman, Sydney Greenstreet, Peter Lorre, Paul Henreid, Claude Rains, and so on.

But as a true movie connoisseur, voting with your head as well as your heart, you're likely to go with *Citizen Kane*, which not only tells a great story (a man's life wasted in the pursuit of the wrong things: money, power, etc.) but also serves as a textbook example of how to tell a story on film. Orson Welles not only directed the movie, he also played the role of newspaper publisher Charles Foster Kane (whose resemblance to William Randolph Hearst was purely coincidental), who uttered the most famous deathbed line in the movies: "Rosebud" (the name of the sled he loved as a boy before setting out on the path to power and greed). Cinema *cognoscenti* (those "in the know") simply say "Rosebud" whenever *Citizen Kane* is mentioned.

Other black-and-white favorites in your repertoire include: *King Kong* (1933), the original, the one and only, with Fay Wray as the object of Kong's affection; *My Little Chickadee* (1940), with W. C. Fields and Mae West as "husband and wife"; *Woman of the Year* (1942) with Spencer Tracy and Katharine Hepburn as the oddest couple of the year — a pair married to each other and to newspaper careers; *The Big Sleep* (1946) with Humphrey Bogart and Lauren Bacall in the Raymond Chandler classic detective story; *The Third Man* (1949), the Graham Greene story of the search for Harry Lime (played by Orson Welles) with its tone of intrigue heightened by eerie zither music; *Psycho* (1960), Alfred Hitchcock's masterpiece of sex and horror at the friendly Bates Motel; and *Dr. Strangelove, or: How I Learned to Stop Worrying and Love the Bomb* (1964), Stanley Kubrick's cult favorite with Peter Sellers (in several roles), George C. Scott (as a general; a warmup for *Patton*?) and Slim Pickens (who rides an atomic bomb to movie immortality).

Colorful Classics of the Silver Screen

Become a *Gone With the Wind* expert, and you cover a lot of the territory. Long the box-office draw of all time (before inflation sent the price of tickets past the five-buck threshhold), *GWTW* won ten Oscars (the movie equivalent of a Nobel prize or the congressional Medal of Honor) in 1939, capturing statuettes in the

categories of Best Picture, Best Actress (Vivien Leigh as Scarlett O'Hara), Best Supporting Actress (Hattie McDaniel as Mammy — the first Oscar for a black performer), Best Director (Victor Fleming), and Best Editing (David O. Selznick), among others. But Clark Gable (Rhett "Frankly, my dear, I don't give a damn" Butler) lost out in the running for Best Actor honors to Robert Donat, who played the lovable English schoolmaster in *Goodbye Mr. Chips.*

When it comes to winning Oscars, *Ben-Hur* (1959) was no slouch, picking up twelve of the famous figurines for its epic (almost four hours) tale of Ben-Hur (Charlton Heston, who took the Oscar for Best Actor) and the Roman Empire. The picture's trademark scene is the chariot race, which took three months to film and seems to last almost as long on the screen.

For the musically inclined, it's hard to beat director Vincente Minnelli's *An American in Paris* (1951, with Gene Kelly and Leslie Caron stepping out to the Gershwin music), *Singin' in the Rain* (1952, with Gene Kelly and Donald O'Connor; the memorable scene is — what else — Kelly singin' and dancin' on rain-soaked city streets) or the story of the Trapp Family Singers, *The Sound of Music* (1965, with Julie Andrews, Christopher Plummer and a wonderful Rodgers and Hammerstein score — you know, "Doe, a deer, a female deer..."). And, you can't go wrong by mentioning Bob Fosse's *Cabaret* (1972), with Liza Minnelli (the singer), Michael York (the friend and lover) and Joel Grey (the emcee) in the pre-WWII decadence that was Berlin.

Among baby boomers, *The Graduate* (1967, with Dustin Hoffman: "What do we want to be when we grow up?") and *The Big Chill*, (1983, "How did we turn out like this?") serve as bookends to enclose the passage from youth to adulthood. Somewhere in between is *American Graffiti* (1973), with its nostalgic look back at more innocent times. Generally, Republican baby boomers probably identify with *Chill* ("realistic portrayal of the natural progression from youthful radicalism to the mature mainstream") while Democrats probably prefer *Return of the Secaucus Seven*, a low-budget treatment with the reunion motif of *Chill*, but lacking its cynical notion that all student activists have

Woody Allen: writer, director and actor

"sold out." *Return* is the work of writer-director-actor (hence, in filmese, *auteur*) John Sayles, sort of the Sam Shepard of those even more in the know than those who know Shepard. Sayles has never been involved with Jessica Lange, but he has received a genius grant from the MacArthur Foundation, the ultimate cultural Lombardi Trophy.

Other classics of the color screen include (by genre):

Comedy — *A Shot in the Dark* (1964) was not the first of Blake Edwards's *Pink Panther* movies, but it was probably the best. With Peter Sellers as the accident-prone Inspector Clouseau (he always pronounces "bump" as "bimp"), French law enforcement sinks to new levels of inefficiency.

Likewise, you consider Mel Brooks's *The Producers* (1968) a marvelous spoof on the notion that sometimes the best way to succeed is to try to fail. Producers Zero Mostel and Gene Wilder attempt to make off with their backers' money by producing a sure-fire flop in the form of a musical titled *Springtime for Hitler*. Naturally, the play becomes a smash hit, and the fun and games are on.

As a movie buff, you like any of writer-director-actor Woody Allen's efforts, but feel a particular fondness for *Play It Again, Sam* (1972), evoking, as it does, pleasant memories of Humphrey Bogart and *Casablanca*. Woody is so in-the-know himself that he skipped attending the Oscar ceremony during which he won the Best Director award in 1977 for *Annie Hall*, his autobiographical film about his relationship with Diane Keaton (she won and showed up to accept the Best Actress award that year). Woody played clarinet at Michael's Pub, his usual Academy Awards night hangout in New York City, instead.

Science Fiction — *The War of the Worlds* (1953), an updated version of H. G. Wells's story of a Martian invasion of Earth (famous because of the panic it caused when broadcast over radio in 1938. Many people actually thought the Earth — or, at least the United States — had been invaded).

More recently, director Stanley Kubrick's *2001: A Space Odyssey* (1968) featured HAL, the talking (and thinking) computer while writer-director George Lucas's *Star Wars* (1977) populated whole new galaxies with the likes of Luke Skywalker (Mark Hamill), Obi-Wan Kenobi (Alec Guinness), Darth Vader (the body is David Prowse; James Earl Jones provides the memorable voice), Princess Leia (Carrie Fisher, who went on to become a "serious" novelist — *Postcards From the Edge* [1987]), R2-D2 (Kenny Baker), C-3PO (Anthony Daniels) and all the rest.

War — It's Alec Guinness (the captured British officer) versus Sessue Hayakawa (the Japanese POW camp commander) in a test of wills and philosophies (the by-the-book West against the inscrutable East) in director David Lean's *The Bridge Over the River Kwai* (1957). As a true film buff, you can whistle the movie's signature song, "The Colonel Bogey March," while sipping a glass of your host's best Lafite-Rothschild (an expensive wine, my dear, and not one to joke around with unless you're doing some serious bluffing).

Less cerebral, but a classic of the more traditional macho war movie genre (of which they don't make many these days) is *The Dirty Dozen* (1967) with Lee Marvin and a cast that includes Charles Bronson (in 1974 he played the consummate vigilante in *Death Wish*), John Cassavetes (Gena Rowlands's husband; he played opposite Mia Farrow in *Rosemary's Baby* (1968), Telly Savalas (remember TV's *Kojak*?), Jim Brown (the former professional football star; he was never as good off the field as he was on), Clint Walker and George Kennedy (Oscar winner for Best Supporting Actor in *Cool Hand Luke*, released the same year as *Dozen*). The story revolves around the dozen, who are all thugs and goons being held in a military prison. In exchange for undertaking a dangerous mission behind enemy lines, they are promised their freedom. And it never hurts to mention *Patton* (1970) with George C. Scott as "Blood and Guts" Patton. Scott won an Oscar for the role, but snubbed the Academy by rejecting it.

Anti-war — The quintessential anti-war movie of the Vietnam era is Robert Altman's *M*A*S*H* (1970, with Donald Sutherland as Hawkeye and Elliott Gould as Trapper John), the absurd comedy about a different war (the Korean), a different time (the fifties), but the same old story (during war, craziness is the only way to keep your sanity).

Not receiving as much popular notice, perhaps because it was more outspoken, was *Johnny Got His Gun* (1970), written and directed by Dalton Trumbo, which tells the story of a young man trapped inside a useless body because of an explosion in World War I.

Others worth knowing include *How I Won the War* (1967), largely because it featured John Lennon in the role of a soldier, and *Slaughterhouse Five* (1972), which was based on the popular Kurt Vonnegut novel of the same title (the refrain in both was "So it goes").

To show your depth of knowledge, it's good to drop in references to two black-and-white classics: *La Grande Illusion* (1937) by Jean Renoir, and *All Quiet on the Western Front* (1930), considered by some to be the most powerful anti-war film of them all.

Western — *High Noon* (1952), with Gary Cooper and Grace Kelly, has become known over the years as one of the classics of the genre. The movie tells of a lawman who has married and plans to hang up his gun. Only problem is that a man he sent to prison is returning — on the noon train — with three of his pals and the notion of paying the marshal back. Cooper can either stay in town and face the music — or leave with his new bride and settle elsewhere (but always know that *they* are out there, tracking him down). Cooper decides to stay and fight it out like a man, even though Kelly abandons him and none of the townspeople agree to join him in facing down the bully bandits. In the end, noon arrives and the fateful shoot-out occurs. If you can't figure out who wins, a clue: Cooper, in 1941, played Sergeant Alvin York in the movie by the same name. In that movie (directed by Howard Hawks) about the real-life World War I hero, Cooper

wiped out a German machine-gun unit, killing twenty-five and capturing more than a hundred and thirty *singlehandedly.*

Any discussion of the Western must include at least one reference to "The Duke," that quintessential American movie hero, John Wayne. Although he appeared in any number of Westerns, his work in three movies directed by Howard Hawks deserves special notice. In *Rio Bravo* (1959), Wayne plays a sheriff who must keep a killer jailed until the marshal arrives to pick up the prisoner. Knowing the killer's buddies will try to spring him, Wayne enlists the aid of three professional gunmen, played by Dean Martin (a drunkard), Ricky Nelson and Walter Brennan. Reportedly, *Rio Bravo* was Hawks's response to *High Noon*, which irked him with its presentation of a lawman who was reduced to begging civilians for help rather than simply taking matters in hand. Thanks to the success of *Rio Bravo*, Hawks followed up with *Rio Lobo* (with George Plimpton in the cast) and *El Dorado*, all based on roughly the same good-guys-versus-bad-guys theme.

Based on the Japanese film *Seven Samurai*, the American version *The Magnificent Seven* (1960) follows the exploits of a group of seven outlaws who are hired to defend a town against bandits. The stellar cast includes Yul Brynner, Steve McQueen, Charles Bronson and James Coburn as the good guys and Eli Wallach as the leader of the bad guys.

You also like *Butch Cassidy and the Sundance Kid* (1969), not so much for the story (Butch and Sundance are on the run) but for the chemistry between actors Robert Redford and Paul Newman, who deadpan their way to, well, death.

Any mention of Westerns probably should include some reference to Clint Eastwood for such efforts as *Fistful of Dollars* (1964), *For a Few Dollars More* (1965) and *The Good, the Bad and the Ugly* (1966), in which Eastwood plays a mythical nameless gunman who brings death and destruction to the bad guys. Knowing that Eastwood directed and starred in *High Plains Drifter* (1972) places you ahead of the pack.

And nobody could ever fool you into thinking that Mel Brooks's *Blazing Saddles* (1974) is anything but a parody of the real thing.

Taking Another Shot at It: The Remake

A remake is a new version of an old movie. The first remakes were sound versions of silent movies, such as the 1939 remake of the Foreign Legion adventure *Beau Geste*. Then came color remakes of black-and-white films. Lastly, there are remakes to introduce a new generation of audience to an old story updated with contemporary cast (the 1976 color version of the 1933 black-and-white classic *King Kong*).

The biggest risk faced in remaking a movie is the obvious comparison that will be drawn with the original. Therefore, neither the 1946 (Paul Henreid and Eleanor Parker) nor 1964 (Laurence Harvey and Kim Novak) remake of *Of Human Bondage* is considered as successful as the original featuring Leslie Howard and Bette Davis. Likewise, the 1956 version of *Invasion of the Body Snatchers* is considered superior to the 1978 remake.

Some films are so hallowed that no one so far has had the chutzpah (Yiddish for nerve) to attempt remakes: *Citizen Kane, Gone With the Wind*. But that doesn't mean they're not fair game for parody. In *Irreconcilable Differences* (Ryan O'Neal, Shelley Long, Drew Barrymore — of *the* Barrymores), O'Neal's character, a filmmaker, does a musical *GWTW* spoof called *Atlanta*.

Giving Credit Where Credit's Due: Directors, Producers, etc.

Movie buffs can hold forth for hours about directors, producers, cinematographers, and so forth. All you really need to know are the names of the greats of the game. In addition to producers and directors mentioned elsewhere, it's good to know about the following.

When discussing "serious" films, you surely must be talking about Ingmar Bergman (not Ingrid, and she's *not* his daughter), the Swedish director whose movies include his classics, *The Seventh Seal* (1956) and *Wild Strawberries* (1957). Bergman's movies are heavy on symbolism (images of death) and deal with "big" (that is, philosophical) problems facing modern man. If

you don't think you can handle that much heaviness, then try Woody Allen instead. Allen, an admitted Bergman fan, lifts heavily from the master.

Almost in the same breath, you should bring up the names of Federico Fellini (Italian, *La Dolce Vita*), Michelangelo Antonioni (Italian, *Zabriskie Point* and *Blow-Up*), Luis Buñuel (Mexican, *Los Olvidados/The Young and the Damned*), Akira Kurosawa (Japanese, *Seven Samurai* and *Kagemusha*), Kenji Mizoguchi (Japanese, *Ugetsu*) and Francois Truffaut (French, *Jules and Jim*). You will notice these are all foreign directors. Most American directors are "serious" about only one thing: making money.

Among American and British directors, you like to drop the names of Robert Altman (*Nashville*), Francis Ford Coppola (*The Godfather*), Martin Scorsese (*Taxi Driver*), John Huston (*The Maltese Falcon*), David Lean (*Lawrence of Arabia*), John Ford (four Oscars for directing the likes of *The Informer, The Grapes of Wrath, How Green Was My Valley,* and *The Quiet Man*), Billy Wilder (*Some Like It Hot*), and Frank Capra (*It Happened One Night*). Steven Spielberg (*Jaws, E.T.: The Extraterrestrial*), you've heard of, in the same way literature buffs have heard of — but would never admit reading — John Irving (*The World According to Garp*).

Who Is This Fat Man and Why Is He Smiling?

Alfred Hitchcock is the funny little fat man whose silhouette became famous thanks to his television show, *Alfred Hitchcock Presents*.

A man of few words, Hitchcock spoke in a slow, deliberate British drawl as he berated his commercial sponsors and apologized to his viewers for having to impose such messages on them. He also liked to stick his fat little silhouette into his movies, making brief appearances. A true Hitchcock fan (such as moviemaker Brian DePalma, whose admiration is suitable for framing, as in *Body Double* and *Dressed to Kill*) can cite you the scene in which the Master appears.

Among Hitch's (which is what his friends called him) movies,

Alfred Hitchcock, the man and the silhouette

Psycho is the undisputed classic. All anybody ever wants to talk about in *Psycho* is the shower scene. Out of all his movies and all his efforts, this is what people remember.

The shower scene goes like this: There's a woman (Janet Leigh) taking a shower. You see the water coming out of the shower head. You see and hear the water splashing. The killer (Anthony Perkins) slips in, you see a knife flash, you see blood running in the drain.

You never want to take a shower again.

Favorite Children's Movies of All Times, No Kiddin'

Every good film buff's repertoire includes a few choice "children's" movies. You know *The Wizard of Oz* with Judy ("Somewhere Over the Rainbow") Garland, but do you know who starred in *National Velvet*? How about a young Elizabeth Taylor and Mickey Rooney?

And no discussion of the genre would be complete without mention of the Walt Disney classics. Take your pick from *Snow White and the Seven Dwarfs* (his first feature-length cartoon, in 1937), *Cinderella, Bambi, Dumbo, Lady and the Tramp, Pinocchio, Mary Poppins* (with Julie Andrews and Dick Van Dyke), or if you want to show your appreciation for the classiest — from a cultural point of view — *Fantasia* (with music conducted by Leopold Stokowski, its vivid images became a cult favorite with the druggie crowd of the sixties).

Famous Film Combos That Double Your Pleasure

Certain film combinations involve teams that seemed to go together just right (the Marx Brothers, Laurel and Hardy, Abbott and Costello, Martin and Lewis before their breakup). However, other film combos double your pleasure because they bring together actors and actresses whose reputations stand on their own but who find new life and vigor when playing opposite certain others.

Here are some of filmdom's famous duets, which, as an expert, you simply refer to by their last names:

Spencer Tracy and Katharine Hepburn — Their first movie together was *Woman of the Year* in 1942. In all, there would be nine, with *Guess Who's Coming to Dinner* (it was Sidney Poitier in the 1967 reply to the question "But would you want your daughter to marry one?") being completed shortly before Tracy's death in 1967.

Humphrey Bogart and Lauren Bacall — Although "Bogey" was paired with a number of top leading ladies (Ingrid Bergman in *Casablanca,* Katharine Hepburn in *The African Queen*), his off-screen romance and marriage to Miss Bacall inextricably linked their names. Together they made such classics as *To Have and Have Not* in 1944 (their first together; it contains the memorable Bacall line: "You know how to whistle, don't you? You just put your lips together and blow") and *The Big Sleep* in 1946.

Tony Curtis and Jack Lemmon — Their *Some Like It Hot* (1959, directed by Billy Wilder) with Marilyn Monroe still ranks as the classic comedy about two men who learn the true meaning of "Life's a drag." On the run from mobsters, Curtis and Lemmon pose as women to make their escape. As the consummate bluffer, you know Joe E. Brown's immortal closing line, when Jack Lemmon reveals he's not really a woman: "Well, nobody's perfect!"

Fred Astaire and Ginger Rogers — First teaming up in *Flying Down to Rio* (1933), the classy, sexy dancing team of Fred Astaire and Ginger Rogers would make a total of ten movies together before looking elsewhere for partners. You think *Top Hat* (1935, with music by Irving Berlin), their third film together, may have been their best, especially the dance numbers done to "Top Hat, White Tie and Tails" and "Cheek to Cheek."

Bob Hope and Bing Crosby — They started out on *The Road to Singapore* (1940) with Dorothy Lamour, following with *The Road to Zanzibar* (1941), then *The Road to Morocco* (1942) and, well, you get the idea.

Popcorn and Coke — No film fan would consider a trip to the movies complete without popcorn and a Coke. Eating at the movies is so *de rigueur* (in good form, fashionable) that it doesn't matter that you just knocked off a seven-course feast. Most people don't feel at ease in a dark theatre unless accompanied by their favorite foodstuffs. Film buffs also like to discuss their favorite childhood cinema candies, arguing over whether Ju-Ju Bees (an earlier form of today's gummi bears) or malted milk balls are superior accompaniments for the silver screen. It's best, however, to stay away from statements that give away your age, such as "When I was a kid, you could go to the movies and get popcorn and a drink for fifty cents." Everybody knows that was a looooong time ago.

And Solo Acts You'd Never Miss

In addition to actors and actresses mentioned elsewhere, some names you should be familiar with (and some of their more well-known roles) include:

Female — Ellen Burstyn (*Alice Doesn't Live Here Anymore*), Cher (*Silkwood*), Glenn Close (*The Big Chill*), Faye Dunaway (*Bonnie and Clyde*), Sally Field (*Norma Rae*), Diane Keaton (*Annie Hall*), Amy Irving (*Yentl*), Glenda Jackson (*Stevie*), Jessica Lange (*Frances*), Shirley MacLaine (*Sweet Charity, Irma La Douce*), Sissy Spacek (*The River*), Meryl Streep (*Sophie's Choice*), Barbra Streisand (*Yentl, The Way We Were*) and Kathleen Turner (*Body Heat*).

Male — Warren Beatty (*Reds*), Michael Caine (*Educating Rita*), Robert Duvall (*The Great Santini*), Albert Finney (*The*

Dresser), Harrison Ford (*Raiders of the Lost Ark*), Gene Hackman (*Hoosiers, The French Connection*), John Hurt (*The Elephant Man*), William Hurt (*The Kiss of the Spider Woman*), Ben Kingsley (*Gandhi*), Eddie Murphy (*Beverly Hills Cop*), Paul Newman (*The Verdict, Cool Hand Luke*), Jack Nicholson (*Terms of Endearment, Chinatown*), Robert Redford (*The Natural, The Way We Were*) and Sam Waterston (*The Killing Fields*).

And, in the moviegoers' Hall of Fame, there are always fond memories for the likes of Jimmy Cagney, Claudette Colbert, Joan Crawford, Bette Davis, Doris Day, Errol Flynn, Henry Fonda, Cary Grant, Jean Harlow, Katherine Hepburn, Rock Hudson, Steve McQueen, Laurence Olivier, Robert Preston, Barbara Stanwyck, Rod Steiger, Jimmy Stewart and Spencer Tracy.

Terms of Endearment

Here's a short list of some movie words and phrases you might run across.

Ars Gratia Artis — "Art for art's sake," the Latin motto of Metro-Goldwyn-Mayer Studios (the one with the lion that roars).

Art film — Genre that generally refers to films with an artistic intent or philosophical statement (Ingmar Bergman, Michelangelo Antonioni and that crowd); in the broadest sense, however, the term has been used to cover everything from amateur movies to porno flicks (which are sometimes amateur as well).

B-Movie — Generally denoting a movie of lesser artistic standing; where the *B* comes from is a matter of conjecture; some say it's because B-movies played on the bottom half of a double-feature bill while others feel that the *B* simply indicated it wasn't Grade A. In any case, B-movies have developed their own cult following — the best B-movies are fun because they lack all pretense of being anything other than entertaining.

Blue Movie — Not a full-length feature starring the Smurfs; a term for a movie containing explicit sexual material.

Cannes — Site of *the* film festival. Others have attempted to step into the spotlight, but still Cannes (KAHN, in France) is the tops. Film festivals, the cinema's equivalent of trade shows or conventions, give moviemakers a chance to show off their latest productions (the business side) as well as see and be seen (the pleasure). Top film festivals in the United States are held in New York and Los Angeles.

Cinema Verite — Form of documentary filmmaking which seeks to give as true-to-life images as possible by using small, hand-held cameras and relatively simple technology. *Gimme Shelter* (1970), Albert and David Maysles's story of the Rolling Stones' concert tour that ends in a spectator's death at Altamont Speedway, is a classic of the genre.

Cinemascope — Like Cinerama, a form of wide-screen projection developed in the 1950s as a way to show viewers just how small their home television screens were by comparison. *The Robe* (1953) and *The Ten Commandments* (1956) were two movies filmed in Cinemascope.

Colorization — Computerized process of color enhancement for black-and-white movies. A process thoroughly detested ("destruction of artistic integrity") by the cinephile crowd who can't stand Ted Turner's colorization of old black-and-white movies to which he owns the rights. For the film aficionado, the idea of a possible color version of *Citizen Kane* or *Casablanca* is sickening; makes you want to barf all over Captain Teddy's SuperStation.

Credits — The Whodunits listed at the end (usually) of most films. For true buffs, the movie's never over until they've "rolled the credits" and every minute bit of information has been gleaned, such as who did the special effects, what locations were

used, who was the dance and/or song coach, who was in charge of the camera crews, and so forth.

Cult Films — Movies that don't necessarily do well at the box office when first released, but, usually by word of mouth, become favorites and develop devoted followings. Some examples: *The Rocky Horror Picture Show*, *Invasion of the Body Snatchers*, *King of Hearts*, *A Thousand Clowns*, and *Harold and Maude*.

Dolby Sound — Some movies are "better in Dolby," the latest in a long line of aural improvements. You haven't really experienced *Star Wars* (which won a special Oscar for sound effects) unless you've seen it (and heard it) in a theatre equipped for Dolby sound.

Gaffer — He's not the guy responsible for editing out the cast's gaffes; rather, he's the head electrician on a movie set.

Hollywood — Despite some slippage, still the center of the U.S. film industry; one of those words, like *Coke* and *okay* that you can say anywhere in the world and gain instant recognition as being an American.

Klieg Lights — The bright, hot lights used on motion picture sets; named after their inventors, the Kliegl brothers.

Oscar — A thirteen-and-one-half-inch statuette that is the film industry's equivalent of the congressional Medal of Honor. The annually televised (live!) broadcast of the awards presentation of the Academy of Motion Picture Arts and Sciences is too long and too silly at times, but for film buffs, it's one of those primal experiences that defines your existence. You like to make your own list of winners once the nominees are announced and then sit back and feel either (a) brilliant because the Academy agrees with you or (b) smugly superior because the Academy disagrees (It's all just too "political," with the awards sometimes being nothing

but a "popularity contest.") Either way, you win. An Oscar is also called an Academy Award.

Rushes — Have nothing to do with the term as used for the euphoric feeling induced by certain drugs. In fact, film rushes can often be real bummers if things are going awry on the set. Rushes are the first available daily footage (they're "rushed" to the director, producer, etc., for viewing) that movie moguls look over to see how a film is progressing.

Sequel — Hollywood's favorite formula: If it works, try it again. Thus, the 1933 *King Kong* was followed immediately (the same year!) by *Son of Kong*. And, after the 1940 *Road to Singapore,* all roads led to Bob Hope and Bing Crosby in the numerous sequels to the original. Only recently, however, has the trend of simply reusing the original title come into vogue: hence, *Rocky, Rocky II, Rocky III,* etc. For once, the movies may actually be credited with saving — rather than destroying — a bit of a culture, that is, the use of Roman numerals.

Serials — Weekly episodic films that told a story a little bit at a time. Once a weekly staple on the Saturday afternoon double feature (two movies for the price of one!), along with a cartoon, and, sometimes, a newsreel.

Slice and Dice — Genre that includes such all-time greats as *Texas Chainsaw Massacre* and *Halloween.* Knowing that much, you should be able to guess the rest.

Smell-O-Vision — An aberration of the fifties. Various smells were actually sprayed into the theater. A great idea as long as the smells were pleasant, but would anyone ever want to experience *The Exorcist* in Smell-O-Vision?

Spaghetti Western — So named not because Chef Boy-ar-Dee rides to the rescue with a plateful of ravioli for hungry trailhands, but because they're Westerns filmed on the cheap in Italy. Perhaps

the most famous of the genre is director Sergio Leone's *A Fistful of Dollars*, which starred a relatively obscure (to American audiences at the time) actor by the name of Clint Eastwood.

Telluride [TELL-ya-ride] — Idyllic mountain town in southwestern Colorado, which has been home to the summer Telluride Film Festival since 1973. For film buffs, a grand excuse for leaving the heat of summer behind for a trip to one of the loveliest little towns in the Rockies.

3-D — You were issued a pair of 3-D lenses (chic paper frames, one blue, one red lens) when you walked into the theatre. To the unaided eye, the image on the screen looked blurred. With your 3-D lenses, the images "leapt out" at you. Definitely scary stuff. A recent attempt to revive 3-D was *Amityville — The Demon*, a sequel to the original *Amityville Horror*.

Giving Yourself the Proper Note of Authority

Being a real movie buff also means one other thing: going to a lot of movies. Every week brings new releases. Even real movie buffs can't see them all. If you simply don't have time to be spending half your life at the movies, you need some way of keeping up with what's going on.

For starters, read the reviews in the local papers. This allows you the luxury of letting someone else sit through the really dreadful films while you go about your normal life — and spend your valuable time watching the good stuff. Find a local reviewer whose opinions you trust and follow her or him faithfully.

Reading Pauline Kael's reviews in *The New Yorker* will only add to your credibility when you explain why you haven't seen a particular film. Very authoritatively quote a line from the review or words to the effect that "Pauline said an evening watching monkeys eat bananas at the zoo would be more interesting." This provides you with the chance to place the full weight of authority on your side. It also shows that you keep up with movies on a

higher plane. Of course, if Miss Kael raves about a movie, that makes it a must-see. Another print reviewer you should be aware of is Vincent Canby of *The New York Times*. Other reviewers you can count on include Roger Ebert and Gene Siskel, the former public broadcasting duo who have moved to the commercial TV airwaves. They're still the best of the several such twosomes that can now be found on the tube.

To fill in the gaps in your background, a good VCR and a well-stocked video rental store should do the trick. Any of the various books that provide thumbnail sketches of movies will prove valuable in helping you make your selections. Especially helpful are those books that not only list movies, but offer critical and background information, such as Danny Peary's *Guide for the Film Fanatic*. Several collections of Pauline Kael's reviews are also available, providing a handy way to slip back in time and see how she felt about certain movies when they were released — and how those opinions hold up a number of years later.

Now that you're armed with the basics, you should at least be able to hold your own should the topic of conversation be movies. And, if you decide to have a few friends over for a night of watching some classics on videotape, just remember to drop the right lines, and have plenty of popcorn — and Coke — on hand, please.

TELEVISION

Spotting Flowers in the Vast Wasteland

The history of an art is the history of masterwork, not of failures, or mediocrity.

— Ezra Pound

Being the connoisseur of fine arts that you are, it's not very likely that you would ever find time for something as *mundane* as television. Between nights at the symphony, the opera, the theatre and the ballet and trips to museums and galleries, there's simply not enough time in one's life to indulge in anything so pedestrian as the boob tube.

But the fact is that the idiot box has become a fixture of mass culture and doesn't seem to be in danger of being supplanted any time soon. Since it so permeates everyday life, you are far more likely to hear a business competitor described as being "just like J. R. Ewing'' of *Dallas* than as being Machiavellian.

Since these very people may also be the ones you need desperately to impress, if only long enough to get your name on an office door where you can quietly retire with your copies of *Connoisseur* and *The Paris Review*, you need at least a passing acquaintance with television.

Paying Tribute to the Early Days: TV's 'Golden Age'

It is perfectly acceptable, whenever discussing the sorry state of commercial television (and even people who are, as they are wont to say, *into* television admit that it's so), to bemoan sympathetically the passing of television's "Golden Age," a reference to the fifties, especially the days of live drama on the tube.

Although TV buffs concede there was a downside to the "Golden Age" — as evidenced by *I Love Lucy* reruns — they point to it as being a period when live television drama was at its peak. The "Golden Age" not only provided a vehicle for young writers and performers to gain valuable experience (and paychecks), but it showed that television could be a vehicle for dramatic presentations far beyond the scope of the bulk of the typical fifteen- and thirty-minute shows of the day.

Whenever discussing the "Golden Age," it's nice if you sprinkle in references to *Philco/Goodyear Television Playhouse*, which featured writing by the likes of Paddy Chayefsky (two decades later his screenplay for the highly acclaimed movie *Network* produced the memorable line: "I'm mad as hell and I'm not going to take it anymore") and Gore Vidal as well as performances by such actors as Julie Harris, Rod Steiger, Sidney Poitier, and E. G. Marshall; *Kraft Television Theatre* with scripts by the likes of Rod Serling and William Saroyan and performances by Lee Remick, Elizabeth Montgomery, Ossie Davis and James Whitmore, among others; and *Studio One* with writing by Paul Gallico and Reginald Rose and acting by Ralph Bellamy, Steve McQueen, Grace Kelly and Janet Swanson.

Other top live drama shows of the "Golden Age" include *Robert Montgomery Presents*, *Camera Three*, *Hallmark Hall of Fame*, *The U.S. Steel Hour*, *Playhouse 90* and *Omnibus*. To show your familiarity, store a few of these tidbits away for future reference:

• Among *Camera Three*'s undertakings was a six-part adaptation of Dostoevsky's *Crime and Punishment*.

• Before Andy Griffith took the role of Will Stockdale in *No*

Time for Sergeants to Broadway and Hollywood, he performed the Mac Hyman comedy live on *The U.S. Steel Hour*.

• Remember *Playhouse 90* as one of the heavyweights of the day, with such productions as *Days of Wine and Roses*, *For Whom the Bell Tolls*, *The Miracle Worker*, *Judgment at Nuremberg*, and *The Time of Your Life*.

• Shakespeare was popular, especially on *Hallmark Hall of Fame*, which produced versions of *Macbeth* and *Hamlet*, among others.

• Alistair Cooke (you watch him now as host of Public Broadcasting Service's *Masterpiece Theatre*) supplied the wry, urbane introductions and background notes for *Omnibus,* which provided not only drama, but appearances by composer/conductor Leonard Bernstein and architect Frank Lloyd Wright among others, discussing their fields of expertise.

It's also nice if you remember some of the filmed presentations of the day, notably, *General Electric Theater* (with Ronald Reagan as host and sometimes performer) and *Alfred Hitchcock Presents*.

The "Golden Age" was also prime time for newsman Edward R. Murrow, whose *See It Now* was the first news-documentary show on the medium. Murrow's attack on Sen. Joseph McCarthy, who was at that time conducting his hearings into "un-American" activities, is still remembered as a high point. (And his *Person to Person* set the pattern for close-up celebrity interviews.)

And, the *Today* show, a fixture after all these years, was a mere child when it was hosted by Dave Garroway (his farewell sign was the upright palm and the single word "Peace") during the "Golden Age."

Depending on how much of a "Golden Age" connoisseur you choose to become, you can also familiarize yourself with classics in other less elitist categories, such as comedy (*Your Show of Shows* with Carl Reiner, Sid Caesar and Imogene Coca), variety (*Toast of the Town* with Ed Sullivan), quiz (*The $64,000 Question*), educational (*Mr. Wizard* with Don Herbert), kids (*Ding Dong School* with Dr. Frances Horwich as "Miss Frances") and

Television: separating the waste from the land

so on. Numerous books are available exploring these areas in depth.

Looking for the Needles in the Haystack

Although for the most part television is the "vast wasteland" described a generation or so ago by FCC Commissioner Newton Minow (who, knowingly or not, echoed the image from T. S. Eliot's 1922 poem "The Waste Land"), there are some fine arts programs — as well as some network offerings — that would help you stake out the high ground if TV becomes the topic of conversation.

While it's okay to admit watching the news (you prefer the major networks — ABC, CBS, NBC, CNN — to the local

offerings, which tend to be mindless roundups of murders, muggings, rapes and traffic accidents, in addition to more than you could ever hope to want to know about the weather), you come across as more in the know if you show an appreciation of *The MacNeil/Lehrer Report*, which each weekday takes a close look at a topic of current interest, often from the day's breaking news, in addition to providing you with the headlines. As a faithful follower of the show, you know that it's Robert (called "Robin" by partner Lehrer) MacNeil and Jim Lehrer, who bring you events of great importance with all the deliberate calm and understatement of morticians announcing a year-end clearance on used caskets.

Of course, you have to watch *60 Minutes* each week (the boss will probably be talking about it at the Monday morning sales meeting) just to keep up with the competition, but if you want to stay a step ahead, start the day off with *Sunday Morning* with Charles Kuralt. Where *60 Minutes* has made a name for itself with its hard-hitting investigative (often confrontational) style, *Sunday Morning* offers a softer approach, focusing on the fine arts and on people who make a difference because of their concern for others. *Sunday Morning*'s closing segment, beautiful scenery usually accompanied by silence or natural sounds, has become a trademark.

Cable television has opened up vast new areas for the person interested in current affairs. While it's fine to admit you watch CSPAN (Congress around the clock) or CNN (news around the clock), keep in mind that you don't want to come across as simply a news junkie. It's always impressive, therefore, when you can put your comments about current events in some sort of historical and/or cultural context by alluding to the past.

Culture on the Half-Shell: British Imports, Home-Grown Treats

Masterpiece Theatre, a stalwart of the Public Broadcasting Service, is presided over by the pithy Alistair Cooke, a British subject who long ago made the land of the greenback his homeland of choice. Yet, with his finger crooked ever so slightly over

his stiff upper lip, he manages to inject just the necessary amount of amused British reserve into the introductions to each show.

Longtime followers of *Masterpiece Theatre* have their own favorites from over the years, but one of the most popular with viewers was *Upstairs, Downstairs*, which chronicled the lives of the Bellamy household upstairs (where the upper-crust family lived) and downstairs (where the servants, notably the adroit butler, Hudson, and the indomitable cook, Mrs. Bridges, always seemed to know the real score). Others that *Masterpiece Theatre* brought to American audiences include *The Jewel in the Crown,* (adapted from the Paul Scott books about life in India during the last years of the British raj) and *I, Claudius* (based on Robert Graves's historical novel).

Public television is also filled with Britcoms, those British comedies that somehow manage to rise above the level of much American fare. Among the favorites: *Yes, Minister* (about a low-level politico who rises to his level of incompetence), *To The Manor Born* (poor little rich girl loses manor, regains it through feminine wiles) and *Rumpole of the Bailey* (with the curmudgeonly Leo McKern as the ultimate "Bailey hack," lawyer Horace Rumpole).

Science fiction buffs are faithful followers of public TV's *Dr. Who*, named for a scientist who is able to bounce around the centuries via time travel. The show has been running more than twenty years in England and has developed a cult following in the United States, as well as in other of the more than fifty countries where it is syndicated.

Dedicated fans of the doctor can name all six of the actors who have portrayed him in his struggles against the sinister Master. Therefore, you know they are William Hartnell, Patrick Troughton, Jon Pertwee, Tom Baker, Peter Davison, and Colin Baker.

Of the numerous cooking shows on public television, one of the longest-running favorites is that of Julia Child, a home-grown talent. When chef Child hits the kitchen, everything not bolted down starts flying. She attacks a slab of meat with all the intensity of a jujitsu black belt taking on a horde of armed invaders.

Julia Child: add just a drop of wine

A confirmed oenophile, she's also known for including wine in just about every recipe. So it's chocolate eclairs … add a drop of wine. Shrimp creole … add a drop of wine. Grits au gratin … add a bottle of wine.

It's also good if you're familiar with such public broadcasting staples as *This Old House* (home restoration and repair), *The Victory Garden* (gardening), *Firing Line* (the incomparable William F. Buckley Jr.), *All Creatures Great and Small* (the life of a small-town British veterinarian), *Nova* (scientific adventures), *American Playhouse* (dramatic stage and film) and *Great Performances* (the performing arts).

Although they skipped out on public television (*Sneak Previews*) for more lucrative contracts in commercial television, Gene Siskel (you know, the skinny one with bony fingers) and Roger Ebert (the, um, portly one with glasses) are still your

favorite movie reviewers. That's because they seem genuinely to disagree, not just for the sake of offering opposing viewpoints, but because they think the other guy's opinion is lousy.

Commercial Programs Worth Noting: For Better Or Worse

There are, of course, some exceptions to the general rule that most of what is on commercial TV is dreck. Each season, it seems, a few programs come along that a sensitive, intelligent adult could admit to watching without having to make disclaimers ("I watch tractor pulls on ESPN because that's my husband's favorite show and it's the only chance I get to spend time with him").

Recent examples include *LA Law*, *Moonlighting*, *St. Elsewhere*, *Hill Street Blues*, *Designing Women*, and *The Days and Nights of Molly Dodd*. It helps if you are acquainted with *Late Night With David Letterman*. You get bonus points if you liked it back when it was a daytime show (it didn't last long) or if you've ever performed a "stupid human trick" as a guest. Old-timers like to talk about the first TV shows that were willing to tackle touchy subjects, such as Norman Lear's *Archie Bunker*.

In addition to knowing what you should be familiar with on television, it's also helpful to be aware of which shows you should definitely never admit to knowing about — even if, in reality, you spend all of your spare time glued to the tube watching them.

Awards shows — Okay, if you're trying to pass yourself off as a movie buff, you're allowed to watch the Oscars simply so you can second-guess the actual winners in order to show off your superior judgment and taste. TV has become littered with dozens of vapid awards shows. One of the worst is the Emmy awards (especially the local-level imitations). As an elitist, you take the position that when everybody gets awards, everybody has been lowered to the same level.

Beauty pageants — They're "meat parades," even if the contestants are asked tough questions to show off their cranial

abilities ("If your boyfriend asks to kiss you on your first date, what color hat should you wear?") and have a chance to win big scholarships to their favorite modeling schools. Never admit to having even the faintest idea who won Miss America, Miss USA, Miss Forty-Eight Contiguous States, Miss World, Miss Universe, Little Miss Extraterrestrial Asteroid, etc.

Fund drives — The only time you watch the networks is when your local public television station is conducting a fund drive, during which time they prove that anyone who stands in front of a camera long enough can be as silly as the next guy.

Music videos — They're like potato chips; you watch one, then you watch another, then another. Before you know it, you've blown an hour you could have spent *improving* your mind rather than letting a few thousand more brain cells die of neglect.

Soap operas — Whether it's *The Edge of Night* or *General Hospital,* it's all mindless drivel aimed at the legions of couch potatoes watching TV during the daytime rather than doing something constructive like finding a cure for the common cold or developing a perpetual-motion machine.

Sports — You never should admit to watching routine sporting events. The sports events you do watch should be of a special once-a-season nature. You watch not out of any *need* to do so (you'd rather be writing poetry or painting or birdwatching or hiking the Appalachian Trail) but in order to stay conversant with friends and business associates who may not be as discriminating as you. It's okay, therefore, to watch the Wimbledon tennis championships, the Masters golf tournament's final round, the World Series (but not the league playoffs), the NBA championship round (ditto on the playoffs), the Rose Bowl and the Super Bowl. You absolutely never watch any of the pseudo-sports "Challenge of the Dallas Cowboy Cheerleaders" shows and would never admit to even knowing anyone who does.

And We'll Be Back After These Messages

The best thing about television is that nobody really expects you to be an expert about it. Especially the cultural cognoscenti, who tend to look down their noses at television as proletarian pablum for the masses: TV's for people who don't have anything better to do.

But that may not help you much when dealing with a boss who thinks *The Cosby Show* is the height of realistic drama. As long as you've got a vague notion of what the latest trends are, you'll probably be able to hold your own in most conversations. Fortunately, you can keep up with television fairly well just by reading the newspaper or magazine accounts of what's going on with TV celebrities and personalities. And you can always read *People* while waiting in the dentist's office.

However, trying to come across as a culturally literate person doesn't mean never again watching TV. It does mean being selective about what you watch — or, at least, being selective about what you admit you watch. If you can take in three hours of prime-time wrestling every Saturday afternoon and still make it through *War and Peace*, then more power to you. But it's probably best that you keep such secret passions to yourself.

Your best bet, though, is to spend your spare time with activities that stimulate rather than anesthetize the mind. Or, if you're simply bluffing your way, make it seem that that's what you do. The next time the urge strikes just to sit and mindlessly flip the remote control around the channels, read a good book (Woolf? Faulkner?) while listening to good music (Brahms? Beethoven?) in a room decorated with tasteful prints (Degas? Cassatt?) while thinking great thoughts ("Gee, I wonder what's on the tube tonight?"). And don't touch that dial!

SPORTS

Being in Season in Any League

When the One Great Scorer comes to write against your name —
He marks — not that you won or lost — but how you played the
game.

— Grantland Rice

There's no quicker way to feel out of your league than to dive into a conversation about some sport you know nothing at all about. But sports — whether you participate or not — is an area of expertise you just can't afford not to know something about. Nearly everybody, it seems, follows at least one spectator sport. And increasingly greater numbers of people have taken up sports as a way of staying fit.

So, if you heard the boss talking about organizing an office tennis ladder (players advance up the rungs) and almost said something about being afraid of heights or if you're a bit unsure what the difference is between the World Series and the World Cup or between baseball's DH and football's DL, it won't hurt to take a quick turn around the track.

Every sport has its own jargon, so at some point you might want to join the office softball team or take in a hockey game to

give yourself the proper background to really come across as a know-it-all. But the information given here should help you feel a bit more at ease in the company of the corporate auditor from St. Louis who manages to schedule her out-of-town trips around the Ladies Professional Golf Association tour.

World Series Versus the World Cup

Nearly every professional sport has its annual holy event. The regular season in most of the major spectator sports is simply a warmup for the real thing, a playoff series leading to a championship game.

In baseball, it's called the World Series, in football it's the Super Bowl, in soccer it's the World Cup.

Baseball's World Series is not truly a world competition. Only teams from the United States and suburban Canada take part. Baseball leagues abound in Central and South America as well as in Japan, but none of these teams takes part in the World Series. Most fans don't really consider the sport as played outside North America to be big-league caliber. Purists cringe at the idea of using metal bats, common among the Latin American teams.

The World Cup is soccer's holy of holies. It is truly an international event. But teams don't compete for it every year. The World Cup matches are played every four years after a series of preliminaries leading up to the main event. World Cup fans have been known to get so worked up over the event that they have rioted in the stands.

Hockey teams go after the Stanley Cup while Canadian football teams try to win the Grey Cup, which is not gray at all, but named after Governor-General Earl Grey, who donated it in 1909. It's acceptable not to think a whole lot of Canadian football because it is played on a field that is longer and wider than the American version and the teams are allowed only three downs instead of four. Arena football, a high-scoring, indoor mutation found on cable television, is "highly offensive," you quip, smugly reveling in your pun.

Now, to give you the home field advantage, here's a sport-by-sport rundown of some information that might come in handy the next time you're called on to step up to the plate.

Baseball

Baseball fans know that life begins on opening day, which is usually in April, and that the best time to take a vacation is in March, to Arizona or Florida to watch the teams during the exhibition season (spring training) in either Arizona's Cactus League or Florida's Grapefruit League.

Although it's a long season (162 games), baseball fans can't help but get worried about their favorite team's status at that most critical juncture, the All-Star Break, which is a short holiday the teams take in July, built around the annual All-Star Game. Fans vote to select the players to the All-Star Game, a notion that strikes baseball elitists as absurd, noting that it turns the selection process into a popularity contest.

Depending on whether baseball fans are pessimists or optimists (or perhaps whether they're Republicans or Democrats), they think it's either a good sign or bad luck for their favorite team to be leading its division at the Break.

Baseball, being a game of streaks, means that fans hope their favorite team goes into a winning streak right after the All-Star Break and can stay at least near the division leader until mid-August or early September, which is generally when the various division races start being decided.

These races are the competition for the pennant, or division championship, so named because of the triangular flags that teams once won for finishing first in their division. The pennants are now usually rectangular instead of triangular, but still fly over the stadiums of the successful teams.

Looking for a Diamond in the Rough

Baseball is the quintessential American sport. Steeped in tradi-

Baseball is tops with American sports fans

tion and downright pure corn, there's no other game that fits so neatly the American psyche. It's often called the national pastime.

Nobody knows exactly how the sport got started, but it probably is a descendant of the English game of cricket. The American usually credited with fathering the sport as we know it today is Abner Doubleday, hence references to Doubleday's game.

Baseball is played on a diamond, so called because of the shape described by the chalk used in marking off the infield. The diamond is actually a square, each side exactly ninety feet, turned on its side. There are nine players on a team and games last nine innings or go into extra innings if tied. Theoretically, a game could go on forever until one team wins.

Perhaps the easiest way to break the ice with a baseball fan is to bring up the DH rule. As a way of keeping gimpy-legged aging sluggers in the lineup, the American League allows one player on each team to be a hitter (batter) only. He doesn't have to play in the field, and he's called the designated hitter. On most teams, he bats for the pitcher, who traditionally is the poorest batter on the team. Since the National League (the senior circuit because it's older), doesn't allow the DH, the great debate rages.

It's also a traditional baseball conversation topic to deplore the lack of a baseball team in the nation's capital, Washington, D.C. You should equate this to London without a soccer squad or Moscow without a hockey team or Madrid without bullfighting. Just don't mention the former Washington Senators baseball team — they were so lousy they had to sell their souls to the devil in the Broadway musical, later a movie, *Damn Yankees* in order to win the pennant — it gives the opposite side too much ammunition for arguing against the need for a team there.

Recent players who have become known as stars of the game include Roger Clemens (Boston Red Sox), Andre Dawson (Chicago Cubs), Paul Molitor (Milwaukee Brewers), Dale Murphy (Atlanta Braves), Darryl Strawberry (New York Mets) and Fernando Valenzuela (Los Angeles Dodgers). Among managers, Pete Rose (a.k.a "Charley Hustle") of the Cincinnati Reds generally draws rave reviews.

George Steinbrenner, the owner of the New York Yankees, is

one of those people fans either love or hate. Known for his lack of
tact — and lack of patience with losing — he's an owner who
definitely believes in sticking his finger in the pie, which means
firing managers as often as he thinks necessary.

And true fans know that baseball's national shrine is the Hall of
Fame in Cooperstown, New York. This is where you can see
memorabilia of such greats as Babe Ruth, Ty Cobb, Hank Aaron,
Yogi Berra, Mickey Mantle, Dizzy Dean, Lou Gehrig, Joe
DiMaggio, Willie Mays, Stan Musial, Jackie Robinson, Cy
Young, and others.

Basketball

Basketball, a supremely American sport, was invented by Dr.
James Naismith in Springfield, Massachusetts. The first game
was played in 1891, using peach baskets (hence, basketball)
instead of hoops. The basic idea of the game is still the same: put
the ball through the hoop.

The professional game is dominated by the National Basketball
Association. Typically, NBA games are high-scoring affairs in
which the outcome is not determined until the last few minutes of
play. Thanks to rules that emphasize scoring (teams have to shoot
within 24 seconds of getting the ball; a shot from a certain
distance earns three points instead of two) even a team trailing by
fifteen points with a couple of minutes to go can sneak back into
the game. And if that team can manage a tie, the game will go
into as many overtimes as necessary to determine a winner.

Larry Bird ("gangly, awkward, but ice-cold efficient," and no
kin to Big Bird) of the Boston Celtics and "Magic" Johnson
("poetry in motion") of the Los Angeles Lakers are two of the
most well-known players. Among veterans, you admire Kareem
Abdul-Jabbar ("the master of the skyhook") of the Lakers. Leg-
ends of the game enshrined in the Basketball Hall of Fame at
Springfield, Massachusetts, include Elgin Baylor, Wilt Cham-
berlain, Bob Cousy, John Havlicek, Jerry Lucas, Bob Pettit,
Oscar Robertson, Bill Russell and Jerry West.

You know that Air Jordan is not the name of the government-

Spud Webb is short but long on talent

owned airline in some dusty, dry-as-a-bone Middle Eastern camel kingdom, but the nickname given Michael Jordan (known for his curious habit of sticking his tongue out while playing) of the Chicago Bulls. And that the Atlanta Hawks' five-foot-six Spud Webb is no small potatoes when it comes to holding his own against the bigger, taller men of the NBA.

In the NBA, it seems that all the teams except those with bad breath and poor dental checkups get to take part in the playoffs, which begin about two months before the championship series is played. Over the past few seasons, the Los Angeles Lakers and the Boston Celtics (they play in the creaky old Garden [GAHD-un] with the parquet floor) have had a virtual lock on the title, capturing the crown seven of the last eight years.

Playing the College Game Isn't Kids' Stuff

Each year, the National Collegiate Athletic Association throws a tournament at the end of the season and invites sixty-four teams. As the tournament progresses, the number of teams is pared down to sixteen teams (called the Sweet Sixteen), then the Round of Eight, and finally, the Final Four.

Over the years, the greatest dynasty of all time belonged to the UCLA Bruins of 1964 to 1975. During that period, the Bruins, under Coach John Wooden (the Wizard of Westwood), won ten of twelve national championships, including seven in a row between 1967 and 1973, thanks to the likes of Lew Alcindor (who changed his name to Kareem Abdul-Jabbar) and Bill Walton (who now plays for the Celtics in the NBA).

Traditional college basketball powerhouses include members of the Atlantic Coast Conference (North Carolina, Duke, North Carolina State) and the Big East Conference (Georgetown, St. John's, Villanova). In women's college basketball, a rapidly growing sport, Southern Cal and Louisiana Tech have been teams to watch.

John Wooden, the Wizard of Westwood

Football

In professional football each year, the American Football Conference champion and the National Football Conference champion meet on the field of battle for the Game to End All Games. Also known as The Greatest Sporting Event in Western Civilization, the Super Bowl carries hyperbole to the extreme. Super Sunday is probably the only day of the year that World War III could be started and ended and nobody would notice the difference.

Vince Lombardi ("St. Vincent"), the late coach of the Green Bay Packers, epitomizes what the National Football League is all about. He was rough, tough, he didn't take prisoners, and he wouldn't tolerate crybabies. His teams, quarterbacked by Bart Starr, won the first two Super Bowls in 1967 and 1968.

Although there have been any number of exposés about the sordid lives of pro football stars (*North Dallas Forty*, etc.), you'll get a bigger kick out of George Plimpton's *Paper Lion*, which described the writer's life and hard times as a member of the Detroit Lions. Plimpton's credentials include being a founder of *The Paris Review* and first editor of the Writers at Work series of interviews in that publication.

Among the greats enshrined in the Football Hall of Fame in Canton, Ohio (the building shaped, appropriately, like a football) are Sammy Baugh, Raymond Berry, George Blanda, Jim Brown, Frank Gifford (he calls the Monday night games now), Red Grange, Paul Hornung, Sam Huff, Sonny Jurgensen, Dick "Night Train" Lane, Joe Namath, Ray Nitschke, Merlin Olson (he's been an actor, announcer, and petal pusher in those TV commercials for florists), Gale Sayers, O.J. Simpson (the one you've seen running through airports in the famous commercials for a car-rental company), Roger Staubach (he sells life insurance on TV), Fran Tarkenton and Johnny Unitas. Apparently, old football players don't die, they just go into television work.

Top recent NFL players whose names should ring a bell include Marcus Allen (Los Angeles Raiders), Joe Montana (San Francisco), Walter Payton (Chicago Bears), William "Refrigerator" Perry (Chicago Bears), Phil Simms (New York Giants) and

Herschel Walker (Dallas Cowboys). Coaches' names worth remembering include Mike Ditka (Chicago Bears), Tom Flores (Los Angeles Raiders), Tom Landry (Dallas Cowboys), Don Shula (Miami Dolphins) and Bill Walsh (San Francisco 49ers). And when it comes to announcing the games on television, former Oakland Raiders coach John Madden is as good as they come.

College: Fight, Fight for Old Alma Mater

There is no college playoff system to determine a national champion. You either think this is as God meant it to be or is a travesty of justice that should be corrected by the U.S. Supreme Court.

College football has to settle for a "mythical champion" as selected in the polls by the two wire services. Some years, The Associated Press and United Press International don't agree on who should be No. 1 after the season and all the bowls are over (in 1978, one picked Alabama, the other picked Southern Cal).

In recent years, there has been a proliferation of bowls. It seems that almost every city of over five thousand population now hosts a bowl of some sort. This produces bowls with pretentious names that sound like the Eli Whitney Cotton Gin and Sanforized Starched Shirt Bowl or the All-American Transcontinental I Pledge Allegiance to the Super-Patriot's Bowl.

The major bowls, however, are the Rose, the Sugar, the Orange, the Cotton, and the Fiesta. Purists refrain from mentioning any of the corporate sponsors who have recently attached their names to the events (the USF&G Sugar Bowl, for example). And they're not that crazy about the Fiesta Bowl, which only recently bought its way into the major bowl category by throwing big bucks around to lure the top teams.

College football fans either love Notre Dame or hate Notre Dame, depending on their views on the universe, divine ordinance, evolution, creation science, premarital sex and primogeniture.

Major conferences and some of their traditional powerhouses

include the Big Eight (Nebraska, Oklahoma), Big Ten (Michigan, Ohio State), Southeastern (Alabama, Georgia), Southwestern (Texas, Arkansas), Atlantic Coast (Clemson, Maryland), the Western Athletic (Brigham Young) and the PAC-10 (UCLA, USC). The Ivy League (Harvard, Yale) is also in Division I (the top grouping of colleges and universities), but, like the Southern Conference (Furman) and the Missouri Valley (Tulsa), its teams have trouble gaining the respect of the "big boys." Among independents (those not affiliated with a conference), Notre Dame, Penn State and Miami are among the teams that traditionally rank high.

Fans of the game also like coach Joe Paterno of Penn State because he looks like he could sell a used car with a bad motor and slick tires to a Mafia don ... and live to tell about it. His team was voted tops in both polls in 1987 (the last poll always comes after the bowl games), winning the national championship outright.

Getting a Grip on the Heisman Trophy

The Heisman, named after college coach John W. Heisman, is presented each year to the top college football player. Sometimes it seems the award is based on whose sports information department is able to mount the most extensive media blitz and hype campaign. Usually, this means a running back or quarterback wins because they're more photogenic than the hairy-naveled grunts who man the offensive lines or play defense. A lineman has never won the Heisman.

Followers of the game like to second-guess the Heisman balloting by talking about players who won the trophy but never could seem to get their games on track as pros, such as Auburn's Pat Sullivan or Oklahoma's Billy Sims. They also know that Archie Griffin, an Ohio State running back, was the only player to win the Heisman twice, in 1974 and 1975.

Because of the apparent bias in the awarding of the Heisman, the true cognoscenti know about the Outland Trophy, which is awarded to the outstanding interior lineman (center, tackle or

Football is war, on offense and defense

guard). Dave Rimington of Nebraska won back-to-back Outlands
in 1981 and 1982.

Any Resemblance to War Is Purely Intentional

Football is a lot like war. Consider:

The quarterback is often referred to as a field general. If he's
got a strong arm, he rifles the ball to the receiver. If he throws a
long pass downfield, it's a bomb.

On the field, the players wear helmets and line up in forma-
tions. Each team wears its own particular uniform so that players
can recognize who's friend and who's foe.

Teams operate on offense and defense. When the defense sends
everybody after the quarterback, it's called a blitz.

Teams are said to march down the field, often on a long drive deep into enemy territory. On the sidelines, the marching bands play, the pretty young women cheer, and the old men tell themselves they'd be able to play, if only.

If college players are good enough, they're drafted into the pros.

Golf

Knowing that golf originated in Scotland, fans always speak reverently of the golf course at St. Andrews, especially when it is the site of the British Open. The golf club at St. Andrews was among the early promoters of the game.

Although the professional golf circuit is in action year-round, interest heightens each spring as the quest for a Grand Slam winner begins. Golfing's modern Grand Slam is made up of the U.S. Open, the Masters, the British Open, and the PGA Championship. Bobby Jones is the only golfer to have won the Grand Slam, doing so in 1930 (the four major tournaments were not the same ones as today's).

Besides Jones, other golfing legends include Julius Boros, Jimmy Demaret, Ben Hogan, Gene Littler, Cary Middlecoff, Byron Nelson, Sam ("Slammin' Sammy") Snead, Arnold Palmer (his fans form "Arnie's Army"), Gary Player, Gene Sarazen, Louise Suggs, Betsy Rawls, Babe Didrikson Zaharias, Mickey Wright and Donna Caponi.

Among modern golfers, salute the names of Seve Ballesteros, Jack ("The Golden Bear") Nicklaus, Greg ("The Shark") Norman, Calvin Peete, Bernhard Langer, Lee Trevino, Tom Watson, Jan Stephenson, Hollis Stacy, Amy Alcott, Kathy Baker, JoAnne Carner, Jane Geddes, Betsy King, Nancy Lopez and Kathy Whitworth.

And speak with sympathy of Roberto de Vicenzo, who knocked himself out of a playoff shot at the green jacket (traditionally awarded the winner) in the 1968 Masters Tournament at Augusta, Georgia, when he wrote down and signed the wrong score (he gave himself a higher score than he had actually shot) and, by the rules of the game, was unable to change it.

Talking a Good Game On or Off the Links

Since golf is a game you might wind up playing for business as well as pleasure, it might be helpful if you know more details than would be needed for getting by in other sports.

Golfing fans know that par is what the game is all about. Making par means that you have played a particular course in the number of strokes allotted (say 72 for 18 holes, the typical number on a course). Since the golfer with the fewest strokes at the end of a match is the winner, going over par is bad, while playing under par is good.

Even a casual follower of the game knows that shooting a birdie has nothing to do with hunting quail, but means that the player has shot one under par on a particular hole. To shoot an eagle (as long as it's not a bald eagle) is even better, for that means shooting two strokes below par on a particular hole. Likewise, a double eagle means three shots under par.

The best you can do, of course, is to ace a hole by shooting a hole in one, which means you hit the ball from the tee into the hole in one swing of the club. And, yes, tee time to a golfer has nothing to do with tea and crumpets, but refers to a set time for that golfer to begin play.

On the other hand, not all golfers make par or under. Therefore, a bogey means that the golfer has shot one over par on a particular hole. And, a double bogey means two over par. Anything worse than a double bogey probably means the golfer has wrapped a club around a tree, and you don't want to talk about that.

As an insider, you know that even the golf clubs themselves have their own special names and properties. In addition to the putter (the one they use to tap the ball in the hole from short distances), there are woods (because of their wooden heads, the part that actually strikes the ball) and irons. Typically, a set of golf clubs might contain six woods and ten irons, in addition to various putters. In tournaments, golfers are limited to carrying fourteen clubs in their bags.

Both woods and irons are known by their numbers (an eight

iron for example, or a three wood). Real golfing buffs know that in the earlier days of the game, the clubs were known by such names as a mashie (the five iron) or a niblick (the nine iron). Of course, the No. 1 wood is still called the driver. Just remember that all the numbers are relatively low (one through six for woods, one through ten for irons), so don't try for one-upmanship by talking about acing the tenth hole at Sawgrass (a famous Florida course) with your thirty-two wood.

On the links (the golf course itself), golfers must contend with natural and man-made hazards (a sand trap or bunker, streams, trees, ponds and so forth) while trying to reach the green (the closely cut area where the hole is located, usually marked by a flag on a tall pole called the pin).

Between the tee and the green is the fairway, which may be relatively straight or may dogleg (change direction). On either side of the fairway is the rough. A golfer in the rough is not one who hasn't shaved for several days, but one who has landed in the woods or other rough terrain.

Golfers usually call the first nine holes of a course the front nine (also known as the out nine) and the final nine the back nine (the in nine).

Finally, be warned that the lie is not what golfers tell when they reach the nineteenth hole (the clubhouse, usually the bar) as opposed to what they actually shot, but is the position of the ball after each shot. Rules allow golfers to improve the lie of the ball in certain situations, but usually by paying the price of a penalty stroke added to their score.

Hockey

Don't start off a hockey conversation with the insufferable line that you "went to a fight the other night and a hockey game broke out." That phrase is now permanently enshrined — along with two hundred and fifty jokes having "Richard Nixon" as the punch line — in the Lame Joke Hall of Fame.

The main thing to remember about hockey (and please, don't call it ice hockey unless you're trying to convince everyone

Hockey: shake hands and come out fighting

you're from lower Hicksburg) is that you like a hard-fought contest with lots of checking (legally bumping another player away from the puck or using the stick to shove the puck away) and great goalie work between the pipes (in the goal or in the nets).

Hockey games (which last three twenty-minute periods) open with a faceoff, which means two opposing players square off as one of the officials throws the puck (a hard rubber disk) on the ice between them.

As the game progresses, penalties (major, lasting five minutes, and minor, lasting two minutes) may be called. When this happens, the offending player is forced to sit in the penalty box, which is like being forced to sit in the corner in grammar school. While thus imprisoned, his team must play shorthanded, giving the opponent a power play. The shorthanded team naturally attempts to kill the penalty by controlling the puck as long as

possible and using delaying tactics such as icing (shooting the puck from behind the red line at the center of the ice across the other team's goal line).

A hat trick has nothing to do with pulling a rabbit out of a top hat. Rather, it means that a player has scored three goals in a single game. If the three goals are in a row (an extremely rare occurrence), it's a pure hat trick.

Some of the great names of hockey's past include Phil Esposito and Bobby Orr (he won the Norris Trophy as best defenseman for eight straight years from 1968 to 1975) of the Boston Bruins, Gordie Howe of the Detroit Red Wings, Bobby Hull of the Chicago Black Hawks, and "Boom Boom" Geoffrion of the Montreal Canadiens. Among current players, Wayne "The Great" Gretzky of the Edmonton Oilers is usually rated as tops.

Horse Racing

In the United States the top horse-racing events make up the Triple Crown. In order to win the Triple Crown, a three-year-old must come in first in the Kentucky Derby, the Preakness and the Belmont Stakes. Triple Crown winners worth knowing include Whirlaway (1941), Citation (1948), Secretariat (1973) and Seattle Slew (1977). The last horse to win the Triple Crown was Affirmed, in 1978.

The Kentucky Derby is run at Churchill Downs in Louisville, Kentucky, each year. Fond memories always include the mint juleps and singing My Old Kentucky Home.

In England, one of the top events is the annual race at Ascot, which is also the name given a wimpy-looking necktie that picked up its name from the race. In addition to ascots, top hats and tails are the dress of the day at Ascot Heath in Berkshire. Doing it right means tailgating from your Jag on a course of champagne, caviar, fresh strawberries and cream.

While there is a certain amount of snob appeal connected with the big events in thoroughbred racing, such as the Derby, it's probably more faddish to be seen at one of the many steeplechase

The race at Ascot, complete with caviar

events around the country. These races involve riders who must take their mounts over a course of obstacles such as fences, hedges and ditches. In England, the most famous steeplechase is the Grand National (as in *National Velvet*, the Elizabeth Taylor-Mickey Rooney movie), held annually at Aintree, near Liverpool.

The Olympics

In the true spirit of international brotherhood and peaceful coexistence, the nations of the world get together and try to bash each other's brains out in a variety of sports every four years.

The first of the modern Olympics were held in 1896 in Athens. The Olympic Games have been held every four years since then, except in 1916, 1940 and 1944, because of war. The first of the Winter Games were held in 1924 in France. The Olympics always

Skiing is an exciting part of the Winter Olympics

are held in even-numbered years (1980, 1984, 1988, and so on).
Although technically there are no national teams and nobody
"wins" the Olympics, everyone keeps track of the gold, silver
and bronze medals awarded.

In addition to skiing (Alpine, or downhill, and Nordic, or
cross-country), the Winter Games include such events as bobsled-
ding and luge (tobogganing) competition. The Summer Games
include track and field, swimming, gymnastics, weightlifting,
boxing, wrestling, rowing, fencing, and equestrian events,
among others.

Notable Olympics include the 1936 games in Berlin, Germany,
when black American track and field great Jesse Owens pricked
Adolf Hitler's Aryan balloon by winning three individual and one
team gold medal, and the 1972 games in Munich, West Germany,
when eleven Israelis were massacred by terrorists. The United

States was among sixty-two countries that boycotted the 1980 Summer Games in Moscow to protest the Soviet Union's invasion of Afghanistan.

Polo

Known as the game of kings because only someone on a royal budget can afford the expenses involved, polo still retains its elitist mystique.

The game, which was imported by the British from India, requires two teams of four players each — on horseback. Each game is divided into from four to eight chukkers (an ancient Hindi word meaning a period of time) of seven and a half minutes each. Players wielding bamboo mallets try to hit the ball through the opponents' goal posts. Because of all the stops and shifts and turns, horses usually don't play successive chukkers.

Soccer

Only Americans call this sport soccer. Everyone else in the world refers to it as football and calls the sport played on the gridiron in the United States "American football." Soccer fans are fanatical about the sport, which is played by kicking a black-and-white checkered ball around on a playing field between two nets or goals.

Soccer games are usually low-scoring (3-2, etc.), and the true fan is more concerned with the skill of play than the lack of offense. Unusual fan customs include whistling (instead of or in addition to booing) to indicate displeasure with the officials or the pace of play and waving white hankies as makeshift pompons. Followers of the game speak in reverential tones of Pelé ("El Rey," "The Black Pearl"), the Brazilian who played for the Santos club while leading his national team to three World Cup titles. In his waning years, he jumped to the New York Cosmos of the North American Soccer League for a fat contract.

In soccer, the goalie (the one who guards the net or goal) is the only player on the field allowed to touch the ball with his hands.

Tennis

Because of its popularity with stressed-out executives (those who haven't advanced to racquetball), tennis is game you need to know on more than just a casual basis.

Tennis has been around for centuries, but the modern game has its roots in France and England. Basically, tennis is a simple game: Two players hit a ball back and forth across a net. The player who is the last to put the ball successfully across the net scores the point.

Scoring is another matter. First, there is the matter of game-set-match. In tennis, games make up sets which, in turn, make up a match. Typically, a male player must win three out of five sets to win the match; a female, two out of three.

Without getting into the details of game scoring — which are easier to understand by simply watching a few games — suffice it to say you should know that the server's score in each game is always given first (thirty-love) and that love is the tennis equivalent of zero. Love is thought to have come from the French *l'oeuf*, for egg, as in "goose-egg."

Winning in straight sets means that the opposing player didn't take a single set ("John McEnroe won in straight sets, 6-2, 7-5, 6-4").

You'll show an insider's understanding if you know that deuce is not an expletive, but a term that indicates that a game is tied after six points have been scored. Winner of the first point after deuce is said to have advantage (as in advantage McEnroe). If the opposing side wins the next point, the game is back at deuce. But if the side with advantage takes the next point (thereby winning two consecutive points), then the game is over.

Also, you know that a let is a serve that hits the top of the net but still falls fair and must be replayed. An ace is a serve that the opponent is unable to get the racket on. On the other hand, a fault has nothing to do with John McEnroe's temper, but refers to a serve that doesn't fall within the proper area of the court. A double fault results in the opponent's gaining a point.

You should also know that the Grand Slam in tennis means winning four major tournaments, the Australian Open, the British

National Open (better known as Wimbledon), the French Open, and the U.S. Open. Only four players have pulled off Grand Slams: American Don Budge in 1938, Australian Rod Laver in 1962 and 1969, American Maureen Connolly in 1953 and Australian Margaret Smith Court in 1970.

And remember that all courts are not the same and that the surface of a court can affect a player's ability. There are grass, clay, and synthetic courts, each having differing effects on the speed of the game. Traditionally, Wimbledon is played on a grass court while the French Open is on clay. The modern U.S. Open is usually played on the synthetic courts at Flushing Meadow, New York.

Wimbledon is probably the most snobbishly appealing of the four grand-slam events. Ideally, your tickets will be for Centre Court, the nearer to the Royal Box the better. In addition to snacking on the traditional strawberries and cream, you should try the Bath [BAHTH] buns. When not following the play on the courts, it's certainly proper to watch for celebrities.

Davis Cup competition is an annual international tournament involving national teams that take part in singles (individuals) and doubles (two on a side) play, with victories and losses going toward team standings. Since the end of World War II, Australia and the United States have dominated Davis Cup play. From 1950 to 1967, Australia won the cup fifteen times. In the period since 1968, the United States has taken nine Davis Cup titles, including five straight from 1968 to 1972.

When talking about the greats of the game, you should refer to such legends as:

Fifties — Lew Hoad (Australian), Frank Sedgman (Australian), Ken Rosewall (Australian), Maureen Connolly (U.S.), Althea Gibson (U.S.).

Sixties — Rod Laver (Australia), Fred Stolle (Australia), Arthur Ashe (U.S.), John Newcombe (Australia), Margaret Smith (Australia, later Margaret Smith Court).

Seventies — Bjorn Borg (the Swede who won five straight Wimbledon titles from 1976 to 1980 and four straight French

Opens from 1978 to 1981), Ilie "Nasty" Nastase (Romania), Chris
Evert (U.S., later Chris Evert Lloyd, she's now Chris Evert again;
she has won seven French Opens, six U.S. Opens and three
Wimbledon titles), Tracy Austin (U.S.), Margaret Court, Evonne
Goolagong (Australia), and Billie Jean King (U.S.).

Among recent top players, you always recognize the names of
Jimmy Connors (U.S.), John McEnroe (U.S.), Ivan Lendl [e-VON
LEND-ul] (Czechoslovakia), Stefan Edberg (Sweden), Christian
Bergstrom (Sweden), Mats Wilander (Sweden), Boris Becker
(West Germany), Yannick Noah (France), Pam Shriver (U.S.),
Chris Evert, Martina Navratilova (U.S.; the dominant women's
player of the current decade; she's won Wimbledon six years
in a row, eight times overall), Steffi Graf (West Germany; the
youthful challenger to Navratilova's supremacy) and Hana
Mandlikova (Czechoslovakia).

And, you know that one of the greatest hype jobs in tennis
history was pulled off in 1973 when fifty-seven-year-old Bobby
Riggs played Billie Jean King at the Houston Astrodome in a
nationally televised match that King won in straight sets (6-4,
6-3, 6-3) without working up a sweat. To come across as one who
really knows tennis, though, you need to remember that the
reason King was willing to take part (other than the obvious
financial rewards) was that Riggs had defeated Margaret Smith
Court a year earlier in a similar "battle of the sexes."

Yachting/Sailing

Yachting's premier event is the America's Cup, so named
because the trophy's first winner was the yacht *America*. It would
be a mistake to assume that it is called the America's Cup because
it resided in the United States for 132 years before being wrested
away in 1983 by the Australians. Being a true-blue American,
however, your chest swelled with pride when Dennis Conner and
the crew of *Stars & Stripes* won the cup back from the Aussies
in 1987.

Although the America's Cup is for twelve-meter yachts, twelve meters (about forty feet) is not the length of the boat, the figure instead being derived from a design formula that is more complicated than Einstein's theory of relativity. The yachts are more like sixty-five feet long and carry eleven-man crews.

In addition to the America's Cup, a boating event that annually carries a great deal of snob appeal is the Henley Regatta in England. Straw hats and striped blazers are the order of the day for the gentlemen, straw hats and diaphanous white summer dresses for the ladies, at this marvelously snobbish and old-fashioned series of boat races in Oxfordshire. Again, the emphasis is on being seen — with the right people, eating the right food, drinking the right wine, doing the right things. It almost seems as if the races are merely an excuse for gathering with the right people.

In any discussion dealing with yachting, you'll be expected to understand sailing terms, which means that port is left, starboard is right, fore is front (which is where the bow — as in bow-wow, not bow tie — of the boat is located), aft is back (where the stern can be found), and, oddly enough, midships is somewhere in the middle. The kitchen is the galley, and the bathroom is the head.

Should you really want to shine, you should act as if you know that jibs, mains, mizzens, genoas and spinnakers are all types of sails, and that tacking is a zigzag maneuver used when sailing against the wind. Crewing means being a member of the crew, an experience which has been described as being yelled at for fun. Further, if someone talks about rafting up, they're not talking about rafts at all, but about the sociable pastime of linking boats together in the water, generally for the purpose of socializing and having a good time.

It's handy if you know that the way to tell a sloop from a yawl or a ketch or a schooner is by the number of masts (the tall poles that support the sails), the position of the masts, and the types of sails on board. Just remember that most single-masted boats are sloops. Yawls, ketches, and schooners all have two masts. On a schooner, the shorter of the two masts is toward the front of the boat.

Likewise, if someone mentions a shroud, they're not referring to a corpse on board, but are talking about rigging that supports the mast. Sheets (short for sceatline, a rope attached to a lower corner of a sail) are ropes, not sails. Of course, if you're three sheets to the wind by the time you've taken in all this sailing talk, you might not really care one way or the other.

Relax, You Don't Have to Follow Them All

Only a certified sports nut follows every sport. These people spend so much time following sports they probably work in the shipping department so they can keep the Walkman tuned to the latest game. Obviously, they are not the sort of people who will be helpful in your climb to the top.

Chances are the person you need to impress with your sports knowledge is either a seasonal spectator (spring/summer: base-ball; fall: football; winter: hockey, basketball; spring: golf, tennis) or someone who participates in a sport such as tennis or golf.

Remember that the key to learning about any sport is to pick up as much of the jargon as you can (at least learn the teams' nicknames in spectator sports; if the boss mentions the New York Yankees you should immediately know he or she is talking about baseball, not football or hockey). Watching sports on TV is a quick way to learn the rules of the games; it takes only a few minutes to get the hang of scoring in tennis, and after you've watched a period or two of hockey, the meaning of icing becomes perfectly clear.

The main thing you want to be able to do is to know enough to be able to slip your way through a conversation without looking like you've been out of touch with civilization for the last twenty years. Just remember to keep your eye on the ball, one foot firmly planted on the ground, and always look for opportunities to show off your follow-through.

Separating the Junque
From the Junk

I love everything old: old friends, old times, old manners, old
books, old wines.

— *Oliver Goldsmith*

The first time somebody discovered there was more than one of
something and decided to have a matched set, collecting was
born. Can there be any doubt then that collecting is one of the
oldest professions?

Although almost anything you can collect can have monetary
value, collectibles from a cultural point of view tend to be those
objects that are connected in some fashion with an area of the fine
arts. Likewise, antiques are not merely those items that are old,
but those objects, such as fine furniture, tapestries, and table-
wear, that have intrinsic artistic value. They were created not just
to suit the mass taste of the day, but to bring artistic expression
to life.

Baseball trading cards, model airplanes, motel bath towels and
used beer cans, therefore, though all being collectibles, and some
perhaps being antiques, do not fall within these guidelines. Nor is

Collectibles can range from clocks to cloaks

there any need to go into art, music, movies, etc., as collectibles — any items connected with any of the names mentioned in those chapters as the tops in their fields obviously fall within the realm of being collectible.

Judging a Book Entirely by Its Cover

Let others read books if that is their wont. Some people collect them. And not necessarily first editions. As with all collectibles, being firstest is not necessarily being mostest.

First editions are not necessarily marked "first edition," especially with older books. Although many collectors go for first editions, a dedication copy (a copy personally given by the author to the person to whom it was dedicated) or a pre-publication limited edition may actually fetch a higher price.

When it comes to books, you've got to know the points of the trade. Points, you see, are those distinguishing marks that tell the expert which is a rare edition and which is not. In a particular rare edition, for example, a letter may be misshapen or broken. Or, there may be a typo (typographical error) or some other mistake that was corrected in later editions. The so-called Wicked Bible of 1652 was thus named because the Seventh Commandment (the one forbidding adultery) was left out.

Serious book collectors know about the history of printing, too. For example, they're aware that if someone offers to sell a copy of a Gutenberg Bible, they're probably being taken for a ride, especially if the book comes in only one volume. That's because Gutenbergs were usually printed in four and sometimes two volumes.

And they know that when someone talks about book "signatures," they're not referring to autographs, but to printed sections of pages or to letters or numbers at the bottom of the first page in such sections that show the order in which the book is to be bound. The points of a particular edition may be determined by checking its signatures.

Likewise, a printer's device is not a reference to a tool or piece of machinery, but is simply a term for a symbol used to identify a particular printer's work (also known as colophons and what are more commonly called logos today).

Age alone does not guarantee value as a collectible. Anyone who's ever been to a used book sale knows that you can buy old books by the pound almost anywhere. Generally, they aren't worth much. But, ah, the search for the rare edition of Flannery O'Connor's *Wise Blood* or James Joyce's *Ulysses*, there's the fun.

Nor does an expensive leather hand-tooled binding, although beautiful in its own right, guarantee that a book has value as a collectible. Of course, some collectors are more interested in the binding of the book than its contents. Fifteenth-century books bound by Aldus Manutius are considered rare treasures. The Kelmscott *Chaucer* of 1896 (which some collectors call the most beautiful book ever printed) and the Doves Bible (in five lavish volumes) of 1903 are examples of the finest work of noted binders

William Morris and Thomas Cobden-Sanderson.

A true connoisseur of books will probably also be interested in holographs, which are works in the handwriting of the author. This might be a draft of a novel or the actual finished manuscript, written in the era before typewriters or word processors. Whether a writer's computer floppy disks will be of any value to future collectors remains to be seen. A holographic copy of a manuscript, being a rare creature indeed, would therefore be extremely valuable. Don't confuse *holograph* with *hologram*, which is a photograph that produces a three-dimensional image.

A bibliophile (book lover) who has expensive tastes might be a collector (or at least a student) of *incunabula*, which are books printed before the year 1500. The English mystery writer Dorothy Leigh Sayers, author of the Lord Peter Wimsey series, was an ardent student of incunabula.

Be sure not to think that a *Book of Hours* is a date book. They are, instead, books of prayers to be said at certain hours during the day and were classic examples of the miniaturist's art. Among the most famous of these Middle Ages gems are the Rohan and the de Berry Hours.

The *Book of Kells*, an illuminated book (handpainted, with elaborate illustrations in silver and gold leaf), was produced by hand by Irish monks in the eighth century.

Book collectors enjoy visiting the Philip H. and A. S. W. Rosenbach Foundation Museum in Philadelphia, where more than 100,000 manuscripts have been collected (including James Joyce's *Ulysses*) along with books, porcelain, silver and so forth. Bibliophiles also know that the Folger Shakespeare Library in Washington and the Huntington Library in California are major storehouses of collectibles.

It's Lovely to Look at, But Would You Sit in It?

When talk turns to antiques, the conversation is usually about furniture. While you may have had trouble getting fifty dollars for that sleep sofa you paid six hundred for when it was new, part of the thrill of antique collecting is the search for the true rarity.

Of course, it helps if you simply enjoy old furniture, but true antique hunting can rapidly become an expensive — and rewarding — hobby.

As a connoisseur who keeps track of such things, you know that in 1986, Christie's (one of the two major auction houses; the other is Sotheby's) sold an eighteenth-century Philadelphia tea table for more than a million dollars. In the spring of 1987 a Townsend-Goddard secretary (a style of writing desk) sold at Christie's auction, setting a record for American furniture. An armchair, at the same auction, sold for 2.75 million dollars.

It's easy to be intimidated by the prices — as well as by the specialized language of antiques. But as long as you're talking antiques, not buying them, why not fill your vocabulary with a few bits of detail?

First, it's handy if you know some of the major periods of antique furniture.

William and Mary (named after the English king and queen; early eighteenth century) — Features walnut, maple and veneers (finer woods overlaid atop more common varieties) with elaborate scrollwork and the use of a Spanish foot (also called a paintbrush). Oriental influences are noted in japanning, the practice of lacquering and decorating objects in the Japanese style. The wing chair, once called an easy chair, was introduced during the William and Mary period.

Queen Anne (named after the last of the Stuart rulers of England; early eighteenth century) — Features cherry, maple and walnut in slim and delicate curving lines (especially the use of the cyma curve, which alternately turns in, then out) with subtle carved decorations and introduced the cabriole (CAB-ree-ole; a leg of a chair, table, etc., that curves out, then inward to a clawlike foot grasping a ball) leg.

Chippendale (named after furniture maker Thomas Chippendale; middle eighteenth century) — Furniture is generally made of mahogany and features elaborately carved broad and curving

parts with shells, scrolls, and acanthus leaves (therefore, is rococo, in the style of Louis XV or Louis Quinze). Rhode Island craftsmen Goddard and Townsend developed a massive, impressive style they used in chests, bureaus, dressers, desks and secretaries.

Federal (late eighteenth, early nineteenth century) — Features mahogany with contrasting woods for inlay and slender, delicate tapered legs, geometric shapes. Shield backs are popular on chairs and carved eagles show up everywhere. Duncan Phyfe, no relation to Barney Fife of Mayberry RFD, was the leading American designer of the Federal period. Other leading styles included Hepplewhite and Sheraton.

Empire (early nineteenth century) — Features walnut, cherry and mahogany with massive geometric shapes and bold carving. Also features marble tops, brass, glass or wooden knobs.

When not hunting for antique bargains, you like to read *Connoisseur*, *Art and Antiques*, and *Antique Monthly*.

Up on the Auction Block — Assorted Collectibles

Coins — Numismatists (coin collectors) know that proof sets have nothing to do with proving anything, other than that the coins in such a set are in mint condition. Typically, a proof set is struck from a highly polished die, and the coins are not intended for general circulation.

Collectors of American coins are also aware that the absence of a mint mark (an initial that tells which mint made the coin) means that the coin was produced at Philadelphia; other mints and their marks include *D* for Denver and *S* for San Francisco. You know that the valuable 1909 VDB *S* penny is so named because it includes not only a mint mark, but the initials of its designer.

Political Memorabilia — Political memorabilia of all sorts have been popular collectibles for years. Old posters, campaign buttons, convention memorabilia are all items worthy of the

Political memorabilia is highly collectible

collector's interest. Given enough time, there's nearly always a market for such items.

For the culturally inclined, collecting political cartoons is a nice way to combine an appreciation for drawn art with an appreciation for art as an investment. And it certainly doesn't take as much money as would be needed for investing in the latter.

Among contemporary cartoonists, you go for signed works by Pat Oliphant, Jules Feiffer, Herblock, Doug Marlette, Garry Trudeau (*Doonesbury*) and Jeff MacNelly. Among historical figures, you don't mind having a Thomas Nast or a Bill Mauldin among your collection.

The fun part is speculating, buying the works of relative unknowns in smaller newspaper markets on the hunch they'll eventually move up to the big time. Cartoonists at medium-sized papers have been known to give their works away to admiring strangers, but an offer of ten or twenty bucks is usually more than enough to pick up originals by a relative unknown.

One trick is to watch the major newsmagazines, and when a young unknown has a cartoon reproduced in *Time* or '*Newsweek*, take that as a signal the cartoonist has got potential.

With established big-time cartoonists, you probably have bought their works at a gallery, but you still enjoy telling the anecdote about the day you walked unannounced into the art department at the *Denver Post* and bought a Pat Oliphant in the early days.

Stamps — When someone talks about the Penny Black, they're discussing the first postage stamp ever issued (Great Britain, one cent, black ink; hence the name). However, the most prized stamp a collector can own is a one-cent British Guiana black on magenta. What makes it so valuable is that it was printed the wrong color. Also, it's rare. Since only one copy is known to exist (it last sold for $850,000 in 1980), beware of sidewalk con artists offering to sell you a block (an entire sheet, usually one hundred stamps).

Another famous and valuable stamp any philatelist (stamp collector) would know is the 1918 twenty-four-cent airmail with

inverted center (the airplane is flying upside down), of which one hundred were issued. In 1977, one of the stamps sold for $62,000.

You know that stamp collectors need to have a knowledge of watermarks (designs imbedded in the paper, which can be seen when the stamp is held up to a light or when it is dampened in a watermark detector with special chemicals) and perforations (the holes punched into a sheet of stamps to make them easy to tear apart; they can be measured with the help of a perforation gauge).

A pane is a section of stamps (anywhere from a group of four to an entire sheet or block).

Tapestries — Declining prices over the years have made these ripe targets for smart investors. The biggest problem with tapestries is simply their size; only the very rich have homes (castles?) with walls large enough to display the older specimens properly. However, if tapestries intrigue you, you probably prefer the French *verdure* (pastoral scenes, birds, flowers, etc.) or *millefleur* (thousand flower), as well as those with shorter drops (the more under ten feet, the better). You don't like battle scenes, decapitations, and other such blood and gore, and, unless you've got a temperature-controlled warehouse nearby, you don't care for tapestries the size of a football field.

Tiffany Lamps — The name has taken on a generic definition for a particular style, primarily a leaded glass shade that resembles wisteria flowers. However, a genuine Tiffany lamp will carry a mark which includes the name Tiffany, and it would have been made before 1933. You know that when it comes to glass, the other famous names are Baccarat, Steuben, and Waterford.

Keeping on Your Toes About Antiques, Collectibles

Trying to pass yourself off as an expert in any field of collectibles or antiques requires more knowledge than can be gained from simply reading a book. Knowing about such objects requires seeing them, touching them, holding them up to the light to look

for the various telltale signs that separate the junk from the junque. Once you've visited a few showrooms or sales, you can go back to the books with a better understanding of the information being provided there.

The key to appearing knowledgeable about collectibles is to be able to focus in on a particular field and become as knowing as possible about that one area. Given the nature of collectibles and antiques, that's a task that will always require a good bit of detail work.

Reading any of the periodical publications in the field, such as *Antique Monthly* or *Connoisseur*, is one way to keep yourself current as well as to find out where dealers and galleries are located that could provide you with more firsthand information.

But, armed with your newly acquired awareness of the subject, you can at least hold up your end of the conversation by knowing something about book collecting and antique furnishings, two of the older fields that especially appeal to the cognoscenti, who see such objects with a love and affection that goes beyond the sometimes cold eye of the mere investment collector.

WINE

Plucking the Right Year,
the Right Vine

And lately, by the tavern door agape,
Came shining through the dusk an angel shape
Bearing a vessel on his shoulder; and
He bid me taste of it; and 'twas — the grape!
 — Rubáiyát of Omar Khayyám

Entire books (nay, encyclopedias) have been written about wine, the favored European pastime which many Americans discovered in the late sixties with all the vengeance of pubescent teenagers caught up in the mysteries of love, lust and disgustingly heavy petting for the first time.

Fortunately, you don't need an encyclopedic knowledge of the subject to hold your own in the realm of wine connoisseurs.

Only in movies — or in their wildest imaginations — do wine aficionados sample a glass "blind" (that is, without so much as a clue as to what they're drinking) and then proclaim the innermost details of its vintage. (Imagine Humphrey Bogart gazing at a glass of wine. Instead of looking into Ingrid Bergman's eyes as he did in *Casablanca* and saying, "The Germans wore gray. You wore blue," he rattles off: "Ah, Cabernet Sauvignon ... yes, definitely from the Napa Valley ... the minty flavor probably

Wine talk is often just that . . . talk

means Chateau Montelena ... say, 1982.'') In their wildest fantasies, wine snobs then go on to tell you which side of the hill the grape was grown on, the details of the weather that year, and why the taste is slightly below five-star performance.

Suffice it to say that of such things are dreams made. All you really want to do, at the very least, is to handle the waiter or wine steward (the *sommelier* [sohm-el-YAY] without having to resort to sumo wrestling when he or she comes to your table. In any case, there's no reason for you to spend hours on the therapist's couch overcoming your fear of — gasp — choosing the wrong wine.

But you do want to protect yourself from the ignoble *faux pas*. If someone mentions "noble rot" (a condition in which certain grapes are left to rot on the vine before picking, actually enhancing the ultimate taste of the wine), you don't want to chime in with some foolish comment about such problems being the result

of years of intermarriage among the royal families of Europe. Alas, you need to know something about wine.

Rooting Around for the Basics

There are various ways of classifying wines.

By color, there are three basic types: red (such as Beaujolais [Beau-zhoh-LAY], red Burgundy), white (such as Sauterne, Chablis) and rose (the pinkish wines, such as Vin Rosé and Tavel). None of these descriptions is to be taken literally. There are red wines that are so dark they appear black and there are white wines that tend to appear green or yellow. Some wine buffs insist on classifying wine colors in further shadings, but that's really taking things too far. Red, white and rosé will get you through most social occasions just fine.

Branching out, it's handy to know that wines are also known by where they're produced. There are French wines, such as Beaujolais; German, such as Liebfraumilch [LEEB-frow-milkh]; Italian, Chianti [Key-AHN-tee]; Spanish, Amontillado [Ah-MON-tee-YAH-doh]; and American, Chardonnay [char-de-NAY], to name a few. Generally, when you think of wine, you think of France and, in the United States, California. And, with the boom in domestic wines, many states now boast home-grown varieties, which can make pleasant choices for dinner conversation when visiting other parts of the country.

Typically, wines are also known by the specific region (Burgundy and Bordeaux being areas of France, for example) in the country where they are produced. To really show your stuff, however, you also know that wines are known by the vineyards — Chateau Lafite [Sha-toe La-FEET] and Chateau d'Yquem [Sha-toe dah-KEHM] being two elite examples — that produce them.

And wines are known by the year (the vintage) in which they were bottled. Wine snobs know that there are "good" and "bad" years for all wines, especially French wines. Therefore, think nothing of it if a wine snob proclaims that 1968 was an absolutely dreadful year for red Burgundy while 1969 was one of the best

ever for the same wine. But if you want to play the wine snobs' game, all you have to do is bury your head in any of the numerous wine books and do a little memory work. By the way, the standard classic in the field is Frank Schoonmaker's *Encyclopedia of Wine*, which is loaded with charts, year-by-year ratings, and such minute information as the name of the mold that actually causes noble rot (botrytis cinera, if you're interested).

Therefore, wine connoisseurs rarely describe a wine simply as a red wine or a white wine. They are proud to detail a wine's lineage as if talking about the bloodlines of a fine race horse. So, when a wine snob tells you that you're being served a '59 Lafite-Rothschild [La-FEET roh-SHEELD], you know she or he means (1) a wine bottled in 1959 (2) at the Château Lafite-Rothschild (3) near the town of Pauillac (4) in the Haut-Médoc region of Bordeaux (5) in the country of France. And, at three hundred dollars or so a bottle, they're telling you that it was a very good year and you rate among their best of friends — or business accounts.

Ordering the Right Wine

The first rule of thumb is "White wine with white meat or fish; red wine with red meat." Full-blown wine snobs know this ain't necessarily so and will be unmercifully condescending to you if you say it out loud. A light red wine (perhaps a Château LaTour-de-Mons red Bordeaux), they note, is a perfectly fine accompaniment for braised chicken, for example. But, for day-in and day-out use, this rule is as good as any.

The second general rule is don't order the cheapest wine on the list (the house wine that is squeezed while you wait) or the most expensive (just about anything from Château Lafite-Rothschild). If these are one and the same, then you're probably eating at the wrong restaurant. Rarely is the most expensive wine on the list the "best" the restaurant has to offer. Most likely it's merely the most faddishly chic variety (Pouilly-Fuissé [Poo-yee fwee-SAY], a popular but overpriced white Burgundy, for example) at the moment. Find something economically pleasing in the middle range and savor your purchase with due appreciation.

Making Sense of the Wine List

Ideally, the restaurant's wine list contains recommendations about which wines go best with which foods (for those — unlike you — who don't know such things). Feel free to follow these recommendations when offered.

Especially helpful are wine lists that tell you a good deal about the wines being offered. For example, where they came from (not just France or Italy, but the district and the vineyard), when bottled (the vintage), and how much they cost.

Absolutely useless are wine lists that do nothing beyond listing the names of the wines (usually Italian Swiss white) and their prices.

Going with the house wine is not a bad idea for a beginner, but feel free to ask for details about the house wine (its bottler, vintage, etc.). If the waiter doesn't know (the wine steward should *always* know), ask him or her to find out.

Assorted and Varied Wine Rituals

If you're accustomed to simply screwing the cap off your bottle of Gallo and pouring a glassful into a jelly jar, coping with the rituals of wine while dining out can be intimidating. They needn't be.

Basically, there are two rituals to deal with: tasting the wine and decanting the wine.

Tasting the wine: The server will bring your wine to the table, usually showing you (the host) the label to verify that it is indeed what you have ordered.

The server will then remove the foil wrapping and uncork the bottle for you, pouring a small portion into your glass. Contrary to popular myth, it is not your prerogative to decide whether this particular bottle of wine meets world-class standards and should be awarded a gold medal — this is, after all, a meal, not a taste competition. Nor can you send the bottle back just because you don't like the way the wine tastes.

All you are being asked to do is determine whether it's a

Check for a moist and bloated cork

"good" bottle of wine or a "bad" bottle (one that has gone bad through improper storage, a faulty cork, whatever). Just as you would not serve a piece of meat that has gone bad, the restaurant doesn't want to serve you a bottle of wine that has gone bad.

What do you look for? A bad bottle will usually be noticeably bad, often with a foul, sulphurous odor; a good bottle may not taste exactly the way you thought it would, but it is drinkable and tastes the way that particular wine is supposed to.

If the server displays the cork, you simply are being shown that the cork is moist and bloated (the way it should be) and not dry (which would indicate improper storage — the bottles standing up as opposed to lying on their sides). A dry cork is a tipoff that you may have a bad bottle on your hands.

What to do if you think the bottle is bad? Rather than making a preposterous scene to let the entire Western world know you've

spotted a bad bottle, it's best simply to ask the wine steward for a second opinion. Say something diplomatic, such as "Hmm, I'm not sure about this — what do you think?" A good wine steward will be pleased to offer a professional opinion. If indeed you have hit upon the rare bad bottle, any wine steward worth doing business with will immediately return with another bottle, no questions asked.

But unless you live, eat and breathe wines and are dealing with vintages that are twenty years or older, chances are you're not going to run into a bad bottle. Let's admit it, there's just not a whole lot that can go wrong with a 1984 Cabernet Sauvignon.

Decanting the wine: This procedure is usually done only with red wines and then only with those at least ten years old. What you are doing is being sure you don't serve someone a glass of wine that contains an unwanted serving of sludge from the bottom of the bottle.

To decant the wine, you hold the bottle close enough to a candle flame to be able to see any sediment as it reaches the neck of the bottle. Usually, this will occur only when you get down near the dregs in the bottom inch or so.

Wines that haven't been stored at least ten years probably haven't been sitting long enough to need decanting. It's silly, therefore, to decant a two-year-old bottle of Beaujolais.

Drinking Wine With Appropriate Aplomb

Proper drinking technique requires that you swirl the wine in the glass (to help it *breathe*, that is, mix with the air) before taking a sip, which you also make a point of allowing to meander through your mouth casually and not as if it's on the way to put out a fire.

To be able to swirl the wine also means that your glass should be filled no more than halfway. Pouring more wine than that indicates that you are simply trying to get snockered, in which case you should dispense with the glasses altogether and drink from the bottle.

A comment about the wine's bouquet (its smell) being delightful or wonderful or whatever shows you possess the proper appreciation for the finer things in life.

Wine enthusiasts never merely say that a wine tastes "good." You always speak of wines in human terms, employing adjectives you might use for describing a personal friend. When describing the wine's taste, go for adjectives that conjure up visions of people you'd like to spend more time with: "cheerful," "joyous," "brilliant," and so forth.

Young wines (a relative term, but generally those bottled within the past ten years) are usually described in youthful, kick-up-your-heels terms: "bouncy," "playful," "seductive," "intense," and so forth.

Old wines (those older than ten, but more likely, older than fifteen) are described the way you'd characterize a mature companion who has come through life's hard times and is now full of charming wit and wisdom: "toasty," "mellow," "complex," "discreet," or simply "elegantly lazy."

List of Terms for the Compleat Oenophile (Wine Snob)

Now that you've got your bearings, here's a short course in wine terminology. There are many more words in the wine snob's vocabulary, but this list should stand you in good stead for most occasions. If you really want to impress, there's nothing at all wrong with spending time with Alexis Lichine's *Guide to the Wines and Vineyards of France*, an erudite and sophisticated tour of the wine lover's Holy Land.

Aftertaste: In a wine, this is good; aftertaste indicates a wine with a complex character.

Appellation contrôlée (ah-pel-ah-SHEON kahn-troh-LAH): French government equivalent of the Good Housekeeping Seal of Approval; a system of certifying that wines bearing certain names come from specific regions of the country and use certain grapes in their production.

Balance: When a wine has its act together, it's got balance, the just-right combination of body, bouquet, taste and color.

Blanc de blancs [Blahn duh BLAHN]: Not French profanity, but a term meaning a champagne is made exclusively from Pinot Blanc [PEE-noh BLAHN] grapes. Can be very expensive, so blankety-blank may be your reaction when the bill arrives.

Bouquet: The way a wine smells; also called the nose. Always compare the bouquet of a wine to flowers, fruits, herbs, etc. Avoid comparisons to Liquid Drano or ammonia.

Brandy: Liquor may be quicker, but brandy is worth the wait and comes from grapes, just like wine; Cognac [KOHN-yak] and Armagnac [AR-mun-yak] are two French brandies. To suitably impress, top off any serving of brandy with Samuel Johnson's apt remark: "Claret is the liquor for boys; port for men; but he who aspires to be a hero must drink brandy."

Brut [BROOT]: Very dry wine; a word usually used to describe champagne.

Champagne: Sparkling wines, the best of which come from the Champagne region of France; top of the line is Dom Perignon [DOHN Pay-rhee-NYON]. Pink champagne is nearly always a no-no, unless you're throwing a gangster party which also features bathtub gin.

Claret [KLAR-reht]: What the English call red wines from Bordeaux.

Imperial: When eight is enough; a wine bottle that holds eight times the standard measure.

Jeroboam: For four on the floor; a wine bottle that holds four times the standard measure.

Magnum: Double the pleasure; a wine bottle that holds twice the standard measure.

Methuselah: Same as an imperial, except usually used to describe such a bottle for champagne.

Nose: Wine snob's term for the way a wine smells. Also known as its bouquet.

Port: Strong, fortified Portuguese wine from the Oporto area. "Any port in a storm" may be great advice when sailing, but steer clear of just any port when drinking. The best ports are aged: the longer, the better. Vintage ports are fantastic when twenty-one years old.

Sherry: Strong, fortified Spanish wine from Jerez de la Frontera in southern Spain. Fino sherry is very dry; cream sherry is very sweet; cooking sherry is not for drinking unless you're desperate and the wine shop is closed for the day.

Varietal: American wines are usually known by the variety of grapes that are used: Cabernet Sauvignon, Chardonnay, etc.

'Here's Looking at You, Kid'

Though Humphrey Bogart was more of a hard liquor fan when he uttered that immortal line to Ingrid Bergman in *Casablanca*, Bogie was wise to the ways of the world and knew that a little *panache* (a self-confident, if at times showy, style) goes a long way.

When it's your turn to order the wine, just keep Bogie in mind and don't let the wine list intimidate you. Don't crack any lame jokes about "a bottle of your best Thunderbird." If it's a classy place, the waiter will think you a terribly dull-witted clod. If it's not classy, you may get a bottle of Thunderbird. In either case, you lose.

Don't expect a bottle of wine that costs you ten bucks at Harry's Liquor Store to be anywhere close to that price in a restaurant. Typically, restaurant wine prices run two to five times retail.

If the prices are too steep, there's nothing wrong with drinking water. To gracefully exit the wine list, say something along the lines of "I think we'd rather not," closing the cover with an authoritative finality that implies your disappointment at the selections offered.

However, if price is no object and you want to make a suitably grand impression, remember that Château Lafite-Rothschild has been producing the Rolls-Royces of wine for years. Château Lafite is always the right wine, but be warned that the price often is in the same class as ... well, a Rolls-Royce.

If the occasion calls for champagne, Dom Perignon — at more than a hundred bucks a bottle at most restaurants — should lend the proper touch of class.

Do tip the wine steward for services performed, especially if she or he was gracious, polite, courteous, and helpful in selecting a wine that meant the difference between just another meal and a meal to remember.

Who knows, the right wine, the right meal, it might all add up to, as Bogie put it, "the beginning of a beautiful friendship."

DINING OUT

Taking Fear off the Menu

Strange to see how a good dinner and feasting reconciles everybody.

— Samuel Pepys

Dining out, at worst, subjects you to a seemingly endless round of culinary fads and whims. Today's salad bar becomes next week's soup and salad bar which, in turn, becomes a potato with soup and salad bar, which all becomes a gastronomical cliché at some point.

You — a cultured person — cannot escape such faddishness, even at the "better places." They have to make money, too, and fads are guaranteed moneymakers. When blackened seafood swept the country, it swept everything in its path, including more than a few menus of the finest purveyors of *haute cuisine* [OAT kwuh-ZEEN]; literally, "high kitchen" in French — it means fine cooking.

Be aware before dining out that there are no easily enforceable regulations governing truth in advertising on menus and keep in mind a general rule of thumb — the more flowery the language,

the deeper you'll probably have to dig into your purse or pocket by evening's end. "Medallions of veal" may sound elegant, but all it means is you're getting some extremely small ovals of an expensive piece of meat.

Also remember that a large percentage of all restaurants fail in their first year. If you really must impress someone, you will want to stick to the older, established places in town rather than subjecting your guests to the caprices of newer places still in the throes of learning how (and, worse yet, how not) to run a restaurant.

Word of mouth is the best advertising the best places employ. Asking around is still the best available way to find out which restaurants are likely to give you and your guests a night to remember for all the right reasons.

Making Your Way to the Table

Once you've established that your reservations (you did remember to make them — and reconfirm them a day ahead of time, didn't you?) are in order and your table is ready, the maître d' [meh-truh DEE] (the headwaiter) will lead the way. When a couple dines socially, the lady should follow immediately behind the maitre d', followed by her escort. Usually, the maitre d' will pull the lady's chair out for her, allowing her to be seated. The gentleman should not stand around whistling "Strangers in the Night" and tapping his toes on the carpet.

Speak up immediately if the location of the table is not satisfactory. Unless the restaurant is one where it takes six months to get reservations and you don't feel like waiting that long, be insistent that you be seated in a place where you feel comfortable.

There's nothing worse than a meal ruined because you have to sit next to the kitchen door or underneath an air-conditioning vent or next to someone smoking a watermelon-sized cigar. Likewise, if you were promised a table overlooking the waterfront when you made your reservations, now is the time to say so.

Once seated, it's fine to go ahead and place your napkin on your lap (not underneath your chin). If you're at a formal dinner

or banquet, you wait for the hostess to take the lead, then follow. Your napkin should not go back on the table until the whole meal is finished (including dessert and coffee) and then should be placed to the side of your plate. Don't attempt to refold your napkin.

Depending on how many courses you'll be eating, you might find an array of silverwear and glasses at your table resembling a window display at Tiffany's. Don't panic.

The general rule is to start on the outside left with the forks (usually a salad fork, which will be shorter than the dinner fork) and work your way in. Glasses will take care of themselves as water (usually in a large goblet), wine or whatever are poured into them. If more than one wine is being served, there will be a glass for each wine, and the used glass will be removed from the table.

Silverware placed "due north" of your plate (the noon position on the clock) is for use with your dessert. This dessert silver will be a spoon or fork or a knife and fork depending on the dessert to be served. In any case, don't use these until the proper time.

Likewise, a stubby butter knife should be supplied on your bread-and-butter plate, which will be found to the upper left of the dinner plate.

Utensils should never be placed directly on the table while eating. They should always rest on the upper right corner of the dinner plate. When you have finished eating, place the used utensils in the center of the plate to signal that you are ready for everything to be removed. Don't shove your plate out of the way or stack your dinnerware as if preparing to help with the dishes afterward.

When the table is correctly set, your accessory dishes (bread plate, for example) will be to your left, while your glasses (water, wine, and so forth) will be on your right. At crowded settings (such as benefit banquets), there's nothing wrong with easing your dinnerware closer to you if that helps avoid confusion at the table.

If at some point you find yourself needing a utensil you don't have — or find a leftover clump of something unappetizing clinging to a spoon or a fork — speak to the waiter and have it taken care of.

Accidents can happen at the dinner table

It's not considered polite to bang on the table with the silver-ware just because your veal scalloppine doesn't arrive at your table as quickly as a Big Mac with fries.

While eating, remember that everyone at some time drops food or spills something at the table. There's no need for endless recriminations. If the accident is messy enough, the waiter should help out with the cleaning up.

If you should find something in your food that you don't think should be there (this happens even at the best of places), avoid bellowing "Waiter, there's a fly in my soup." Simply call the waiter to the table, discreetly display the offending object, and ask "Would you take care of this, please?" The results should be immediate. If not, ask to speak with the maître d'. At good restaurants, a word to the waiter should always be sufficient.

Snapping your fingers in the air to summon the waiter (or

yelling "Garçon," which literally means "boy" in French) is considered tacky in all forty-eight contiguous states as well as Alaska and Hawaii.

What to Do When the Menu Is in French

Although the names of any number of French foods are part of everyday parlance (hors d'oeuvres, quiche, omelet, crêpes, soufflé, Hollandaise sauce, mousse), the sight of a menu entirely in French can be intimidating, especially if you don't know French. But if you're really trying to score points with your dinner companion, French cuisine is definitely considered the tops in snob appeal.

The two basic styles of French cooking are *haute* and *nouvelle* [noo vehl], a newer style that does not rely so much on the heavier sauces associated with traditional French fare.

Your first problem, though, could be dealing with the menu. You can, of course, look for the words that are similar to their English cousins (*boeuf* [BUHF] is beef, *carottes* are carrots, *salade* is salad, etc.), but what to do about something that looks definitely dangerous, like *poisson* [PWAH-sahn]? It's obviously not poison, but what is it? Fish, it turns out. It's never wrong to ask the waiter (or your dinner companion) for help. But just in case you want to impress, here are some selected French menu terms that should help out. Be forewarned, however, that the pronunciation can be the trickiest part:

Canapés [kan-ah-PAY], **hors d'oeuvres** [ohr DURV] appetizers — *crudités* [kroo-dee-TA] raw vegetables (celery, broccoli, etc.), and *fromage* [froh-MAHZH] cheese.

Potage [poh-TAHZH] or **Soupe** [SOOP] soup — *pot-au-feu* [poh-toh-FUH] vegetable beef soup, *soupe du jour* [SOOP duh ZHOOR] soup of the day and *vichyssoise* [vee-shee-SWAH] leek and potato soup, served cold.

Entrees [ahn-TRAY] main courses — *boeuf à la Bourguignonne* [buhf ah lah boor ghee NYAHN] beef in a red-wine sauce, with onions, mushrooms and other vegetables, *canard à l'orange* [kah-NARH ahloRAHNZH] duck in an orange sauce and *coq au vin* [koh-koh-VAHN] chicken in a wine sauce.

Viande [VYAHND] meat — *agneau* [ah-NYOH] lamb, *chateaubriand* [shah-toh-bree-AHN] beef tenderloin, *côte* [KHOT] chop, *gigot* [zhee-GOH] leg of lamb, *jambon* [zhahn-BAHN] ham, *poulet* [poo-LAY] poultry and *rosbif* [rohz BEEF] roast beef.

Poisson, etc. — *coquilles* [koh-KEE-yuh] scallops, *homard* [oh-MAHR] lobster, *crevette* [kreh-VEHT] shrimp, *écrevisses* [eh-kreh-VEESS] crayfish, *moules* [MOOL] mussels, *saumon* [soh-MAHN] salmon and *truite* [troo-EE] trout.

Legumes [la-GOOM] vegetables — *asperges* [ah-SPERZH] asparagus, *champignons* [shahn-peen-YONZ] mushrooms, *épinard* [eh-pee-NAHR] spinach, *oignons* [ah-NYAHNZ] onions, *pois* [PWA] peas, *pommes de terre* [puhm duh TEHR] potatoes; apples are simply *pommes*, and *tomates* [toh-MAHT] tomatoes.

Dessert [day-SEHR] dessert — *bombe* [BAHMB] molded ice cream concoction, *gâteau* [gah-TOH] cake and *sorbet* [sohr-BAY] sherbet.

Singling Out Certain Foods for Special Mention

It might also be helpful if you know a little bit more about certain French foods that you may not necessarily encounter in your daily trips to the company cafeteria. Here's a quick guide to what's really lurking behind some of those exotic words.

Escargots are snails. Some people find the thought of eating snails repulsive. Actually, though, escargots can be a delightful appetizer, especially when downed with just the right wine.

When the escargots come to you in the shells, don't attempt to

crack the shells open with your teeth. You should also receive a special utensil to reach down into the shells and pull the escargots out. If the snail fights back and won't come out, your escargot is undercooked.

Pâté de foie gras (PAH-tay duh fwah grah) is basically an expensive French meat paste made from goose livers. Those who love it swear by it, but its expense gives new meaning to the saying about the "goose that laid the golden egg." Pâtés, which are usually served as appetizers at dinner, may also be made from other meats, and you may encounter a vegetarian pâté. Pâté should be eaten on a bit of bread, toast or a cracker.

Truffles (*truffes* in French) are potato-shaped fungi (if you don't like snails, you'll probably have trouble with truffles) that are dug from the ground, usually in Europe. In some places, specially trained dogs or hogs root them up. Long considered a delicacy, truffles are rarely served in American restaurants because of the expense involved.

Despite the reputation as a rich person's food, caviar can be found on the shelves of most supermarkets these days. The expensive stuff (fifty dollars or more an ounce), though, is beluga, a variety that comes from white sturgeon, a fish caught mostly in the Soviet Union. There is something inherently ironic about this most aristocratic of delicacies being a money-making export item for the world's leading proponent of classless society (though Kremlin bosses get all the beluga they can handle, no doubt). And just what is caviar? Fish eggs, that's all. You can always eat caviar straight, but often it will be served with crackers for easy eating at informal buffets.

Perrier is a brand of mineral water from France. It comes in little green bottles that have become popular symbols of alcoholic abstinence and good health at bars the world over. To go one up, however, order a Dewar's (scotch) and Perrier for a before-dinner drink. Then you can have the best of both worlds. Never order a Perrier and water.

What to Do With Finger Bowls, Hot Towels

Don't attempt to wash your whole hands in the finger bowls (when provided) and, for goodness sake, don't drink the water. If there's a fire in the restaurant (be sure it's not the baked Alaska or some other flambé dish), you are allowed to toss the water on the fire, then make for the nearest exit.

Usually the finger bowl will be about half-filled with water and, depending on how elegant the occasion, decorated with a few floating flower petals. Simply dip the tips of your fingers in the bowl and then wipe them dry on your napkin. If a particularly sticky meal has been served (lobster or crab legs, for example), the water in the bowl may be warm and include a lemon slice to facilitate your cleaning up.

And those nice, steamy moist towels some restaurants give you are not to be curled over your face as if you're about to get a shave. They are also for the fingers.

Tipping: How Much and Why

Waiters make their livings from the tips they receive for the service they render. Stiffing a waiter — not leaving a tip — even for poor service is unclassy unless the waiter and only the waiter is to blame. Stiffing the waiter for undercooked or overcooked food (it's up to you to let the waiter know about such problems while there's still a chance for remedies) is punishing the wrong person. Leaving the minimum tip (say, 10 percent) is the best way to respond to minimum service.

If you think a particular waiter has been out of line or especially inattentive to your needs, a word with the maître d' or the host or hostess will generally achieve results. Often, the explanation is that "We're shorthanded tonight," but good waiters work their legs off to give you good service — shorthanded or not.

Showing appreciation for good service means tipping generously, 15 to 20 percent at least. For a meal that stretches out over several hours, a 25 percent tip for service above and beyond the call of duty is not excessive.

Many restaurants now attach a service charge of 15 to 20 percent on checks for large parties. In some parts of the country, this strategy is also being used on individual checks. While this eliminates certain problems connected with tipping, the imposition of a service charge should always be a sign that you should expect — and demand — only the very best of service.

The Trend Toward Prix Fixe Dining

What looks like "pricks fix" is really more like "pree feeks." All it means is that you'll pay a fixed price for the meal, say thirty-five dollars or up per person. Dining from a menu where you pay for individual items is known as *à la carte*.

The *prix fixe* may or may not include all your drinks, but generally wines or other drinks you want beyond the basics (a glass or two of a particular wine) on the menu will cost extra. Generally, you will have options of what to eat for each of the courses.

Prix fixe is simply a more sophisticated way of doing the $5.95 all-you-can eat buffet, except that you'll be seated to be served. And you won't get all you can eat — only all you can afford to eat.

When it Comes to Dining, Vive La Différence!

Not all food — especially when dining out — comes to you American-style, that is, a meat and a couple of vegetables on a plate. You should be able to deal with Japanese and Chinese settings.

The biggest problem for some people is dealing with chopsticks. Here's a tip: The chopsticks are not for the won-ton soup. Try not to think of them as drumsticks. If you have to tap out a rhythm on the table, do so with your fingertips. It's also nice if you don't stab your sweet-and-sour pork chunks with the chopsticks. *Lift* the meat with the chopsticks.

The basic idea is to cross the sticks between the first two

Whirling knives are safe at Japanese restaurants

fingers, using the thumb as a support. Do your best and most hosts will give you an *A* for effort. Don't resort to using your fingers. If all else fails, simply ask the waiter, as politely as possible, for some Western utensils.

Sushi is raw fish, Japanese style. Going to a sushi bar is not the same as going to the bar and ordering a stiff saki, which is a type of Japanese rice wine. Sushi bars, as an eating fad, seem to have peaked before reaching the one-on-every-block stage. Whether you like sushi or not depends a lot on whether you like raw fish. Many people don't.

Don't panic at a Japanese restaurant if the waiter brings your food, raw, to the side of your table and begins hurling knives, salt shakers and hunks of meat into the air, while making scrambled noises like a berserk banzai bayonet basher. This is all part of the Japanese shtick, and it's considered polite for you to applaud any

performance that ends with cooked food on your plate and all those large knives back on the serving cart instead of stuck in the top of your skull.

Some ethnic foods do not normally require the use of utensils. You may, if you wish, use a fork or spoon when eating Ethiopian cuisine, for example, but if you want to go for the real cultural experience, you'll want to use your fingers to lift food onto bits of bread that you then place in your mouth — as they do in Ethiopia. Given the consistency of the food being eaten (soft and pasty), knives and forks become redundant.

All the World's a Smorgasbord

Much of the fun in dining out comes from the simple pleasure of trying new foods. In communities with a diversity of restaurants, this can mean learning the ins and outs of Cajun, German, Greek, Indian, Italian, Jewish, Mexican, Polynesian, Scandinavian, soul, Spanish and West Indian cooking, to name a few.

Remember that the basic principle that applies when dealing with a French menu will hold you in good stead when you decide to give any of these cuisines a try: It helps to do a little homework ahead of time, and it's never wrong to ask for help when you need it.

One of the better sources of expert advice to help you smooth your way is *Emily Post's Etiquette,* which contains such helpful advice as how to eat artichokes and, perhaps more importantly, what to do if you decide you don't like the way artichokes taste once you get a mouthful. Jan Darling's *Outclassing the Competition: The Up & Comer's Guide to Social Survival* contains excellent chapters on restaurants and dining out.

Newspaper restaurant reviews can be extremely helpful, especially if you find that you and your local reviewers generally agree on what makes good dining and what doesn't. Also, scanning any of the various ethnic and regional cookbooks (especially those with lots of pictures) should help you decide the sorts of meals you'd like to try.

In the meantime, bon appetit!

MANNERS

Sailing Through Life's Difficult Moments

Manners must adorn knowledge, and smooth its way through the world.

— *Philip Stanhope, Earl of Chesterfield*

Let us now praise good manners.

Is there a soul so hardened that it doesn't simply melt at the sight of good manners? The truly cultured elite — the Rockefellers, Kennedys and so forth — probably have learned their manners from a governess or tutor or while away from home at some exclusive boarding school. They have attended numerous formal occasions where proper manners are observed. And they were taught at an early age the right from the wrong in the world of social etiquette.

Because of this, they have a great advantage over the rest of us: a knowledge of correct manners that serves as a comforting safety net in social settings that range from the boringly familiar club luncheon to the totally unexpected encounter with a member of the Royal Family. And the fact is, good manners are the same whether you're dining at the captain's table aboard ship — or

Situations change but good manners do not

politely waiting your turn while the lifeboats are being lowered over the side. The situation may change rapidly, but good manners don't.

Unfortunately, most of us haven't had the advantage of formal training in manners. Therefore, our psyches shrink at the thought of committing some terrible social *faux pas*. Most of us know when to say "please" and "thank you" and have dabbled enough in Emily Post, Amy Vanderbilt, and Judith Martin (you know, *Miss Manners*) to know not to place a napkin underneath our chin. But what do you do if you spill wine all over the hostess's Oleg Cassini gown?

What you need then is a quick confidence-booster, a few words of reassurance from a friend that regardless of the situation, you'll be able to make your way through life's difficult, sometimes sticky, situations with a minimum of anxiety or embarrassment.

You need a DOT-TO-DOT guide to the social graces.

But first, we must reintroduce a concept that got lost somewhere between the self-centered rush to gratification of the do-your-own-thing culture of the sixties and the present time. There are "ladies," and there are "gentlemen," and there are those who know the difference between those who are and those who aren't. Ladies and gentlemen are those people who hold to high standards of good taste and manners and who have an appreciation for the niceties of life. Just as they appreciate the finer things in the world of art, they appreciate a certain elegance of style when it comes to social conduct. Their behavior is impeccable and they do not seek to gain from the misfortunes of others. If they misstep, they know the meaning of a sincere apology. They are selfless and considerate and the soul of kindness. They are, in short, an endangered species.

An apology is usually sufficient

Yes, Accidents Do Happen...To the Best of People

First, you should clear your mind about what's really troubling you the most: What if an accident happens?

There you are, at the boss's dinner table, surrounded by the top three rungs of the company's organization chart: You reach for your wine, and the Baccarat [bah-ka-RAH] wineglass slips, crashes to the floor, shattering. In the process you have managed to spill wine on that sleek Bill Blass original worn by Mrs. Clarence Harrumphries, the wife of the senior vice-president in charge of export sales to Outer Mongolia. Suddenly, you see images of yourself serving as a pack animal in the company's Outer Mongolia shipping department.

You must resist the powerful, seemingly overwhelming urge to grovel.

No, this is a time to remain calm. Your first concern should be for Mrs. Harrumphries. After all, she's a human being, and, regardless of how much the crystal wineglass cost, she's a hundred times more important.

Offer her your handkerchief, perhaps dipped in water from your water glass, to help wash the stain from her garment. Apologize sincerely, but briefly, and ask her please to send you the bill for having the dress cleaned. Above all, don't dwell on the event. (Likewise, don't bring it up the next half-dozen times you run into her somewhere.) Get through the whole thing as efficiently as possible.

By this time someone should be taking care of the broken glass and spilled wine on the floor; your host will have either one of the household helpers or the caterer take care of things. If it's left for you to do, again be as efficient as possible.

At a large gathering, there is no need to shout across the room that you'll pick up the tab for any damages, but at some point, be sure to speak to the host and make such an offer, along with your apology. Just don't go waving your American Express gold card all over the place as if it is the solution to all the world's problems — especially your most pressing one — in a flash.

Accidents *do* happen. Good manners simply mean that you react to an accident in a mature, responsible way, offering regrets for your actions (which are naturally assumed to be unintentional) and offering to accept the responsibility (even though technically you're not at fault). The good host, of course, will relieve you of any responsibility for picking up the tab, but will feel better knowing that you offered.

Meanwhile, Lurking Behind Door No. 3...

The simplest of courtesies involves one of the oldest inventions: the door.

The question of door etiquette perhaps became more difficult with the disappearance of doormen and footmen. When these people guarded doors at all respectable places, one simply allowed them to perform their function in society.

If such people are available, they will be happy to take care of the door. A cheery smile and a thank you are all that's required, unless the doorman or footman is *your* doorman or footman, in which case, light banter is permitted ("Market's up, Jeeves" or "Market's down, Jeeves" are appropriate remarks; avoid offering advice on particular buys or sells, or you could face your doorman's wrath — or a possible lawsuit — in the event of a bad day on the Street).

When a doorman is available, the gentleman allows the lady to enter or exit first. If exiting into a torrential downpour, the gentleman attempts to exit immediately behind the lady while covering her with his umbrella.

If there is no doorman, the gentleman holds the door open while the lady enters or exits. These being liberated times, it is also acceptable for the lady to hold the door for the gentleman if the situation works out that way. But in neither case should one or the other race to the door merely to perform this task or to show their stand on this crucial matter of social importance.

For the Proper Manners Born...An Assortment of Tips

There are certain daily situations that also call for good manners. While these may not be as distressing as the dreaded spilled wine at the big banquet, they do present occasions where you may have pause to wonder what the proper etiquette is.

Handshakes: When gentlemen and ladies shake hands, the gentlemen should avoid the energetic pump-handle action so popular with the boys down at the gas station. Neither is this an occasion to see if person can make the other shout "uncle." A polite handshake is nothing more than a simple grasping of the hand as a symbol of friendship.

Elevators: The strange mechanized boxes seem to bring out the zombie in us all. You've been there a million times. Ten people in an elevator and nobody speaks. All twenty eyes are glued

to the lighted numbers as they rise or fall. Does this seem at all courteous?

Apparently, we are terribly afraid of missing our floor and being trapped forever on an elevator, winding up on some faraway planet in a distant galaxy. You'd think the newspaper pages were filled every day with sad tales of people who became lost while taking an elevator from the tenth floor to the ground. You see, they missed their floor and ... just kept riding forever.

Next time you're on an elevator, try something unusual. Try a little bit of courtesy and manners. Say hello to someone. Strike up a conversation with that intense number-watcher.

Coats: Getting in and out of coats is a problem for everyone. It has something to do with the geometry of arms and bodies and the shapes of coats. It's too bad Einstein spent so much time on the theory of relativity. He should have been working up a formula that would allow you to get in and out of your coat without feeling like you're one of Harry Houdini's distant relatives.

In any case, for a lady and a gentleman to help each other with the coats is a most welcome, gracious gesture. The gentlemen should, of course, help the lady first. And he should offer to place the coats in whatever spot the host has designated (in the absence of hired help to take care of such matters). But, again, this is nothing to fight over — sometimes putting the coats away is a great way to skip the busy-talk chitchat that usually occurs as you enter the door at a party. And, for smokers, it may be a perfect time for a quick one before going forth into the fray.

Car doors: The gentleman shall open and close the car door for the lady at all times. This includes even situations where the lady is the gentleman's wife.

The lady, in turn, once seated in the car, unlocks the driver's door for the gentleman. This is especially appreciated when the wind is blowing fifty miles per hour, it's twelve below zero, and the gentleman's key won't fit in the lock because of the ice.

Should the car be the lady's — especially if it's a Mercedes or a Ferrari — she can, of course, unlock the door for the gentleman

and open the door for him, but she should always let him close the door on his own. This subtle strategy gives men, who are such insecure souls when it comes to matters involving their masculinity, an inordinate feeling of strength and physical well-being. It also lets him know she's not the valet parking attendant. Likewise, he should reach over and unlock her door for her.

When the gentleman is the passenger, it is perfectly acceptable for him to come around to the driver's side and open the lady's door for her at the appropriate time. For instance, when the car has stopped and they have reached their destination.

However, if the gentleman is filthy drunk and losing his dinner out the window all over the side of the lady's Alfa Romeo, it is perfectly acceptable for the lady to shove the gentleman out the passenger's door upon reaching his home or the first convenient stop sign.

Smoking: There was a time when a gentleman asked a lady if it was acceptable for him to light up a cigarette. Then gentlemen started lighting up without asking and, pretty soon, the ladies joined in. Now the question of smoking has become a battleground having more to do with rights than with good manners or etiquette.

To put smoking in the proper perspective, good manners require observing the following:

• When visiting someone's home, assume that smoking is not permitted if you see no ashtrays out on tables. If you must have a smoke, ask to be excused and slip outside, where you will probably encounter a gaggle of like-minded people, puffing away and having an incredibly good time despite their irritation at being treated like children. The well-mannered host will, however, supply several ashtrays in appropriate spots (good ventilation, away from food, etc.) for smokers' convenience.

• Return to the custom of asking if it's acceptable to light up. And don't be offended if you're told no. Always carry gum or Life Savers for such occasions and make the best of it.

Smoking is still a burning issue

Drinking: Good manners generally means you know how to hold your liquor. Or at least you know your limits and live within them. But just in case you're not quite sure when you've reached your limit — when you've had that one drink too many, here are some suggestions.

You know you've had too much to drink when:

• You challenge the hostess to an arm-wrestling contest atop her baby grand piano;

• You talk for fifteen minutes to somebody's coat hanging on a rack in a hallway;

• You compliment the caterer on the marvelous *hors d'oeuvres* only to be told that you're munching on wet cigarette butts from an ashtray;

• You lead guests in a disorganized rendition of "Ninety-Nine Bottles of Beer," continually starting over because by the time you reach seventy-eight bottles of beer on the wall, you can never remember what comes next;

• You lock the door, wave to the last guests to leave, turn out the lights and go to bed, waking up an hour later with a start, realizing you're not in your own house.

Letting Good Manners Become Second Nature

The nicest thing about good manners — aside from the fact that they are contagious — is that the more you use them, the less you have to think about them. After a while, they become second nature.

At that point, you've really won half the battle. Being self-confident in social settings is more a matter of mental attitude than anything else. Basically, if you think you can handle any situation, even the most potentially embarrassing ones, you're much more relaxed, much more able to deal with the *serious* matters at hand, such as talking about art, music, theatre, dance, and all that stuff.

British actor Michael Caine, himself the son of a fish merchant and a cleaning woman — and therefore neither a Kennedy nor a Rockefeller — explained in a television interview why he decided that in a movie role that required him to portray a prince, he would always place his hands behind his back when walking. "The prince always had other people to open the doors for him," he said. And the proper mental attitude, he might have added.

Putting Your Best Foot (and Shoe) Forward

The fashion wears out more apparel than the man.
— *William Shakespeare*

The invitation to the Big To-Do (the one Everybody Who Is Anybody attends) has just arrived.

Your first thought is one of sheer terror: You have nothing to wear. But your second thought is even more horrifying: You don't have the slightest inkling what you *should* wear.

After all, the last time you "dressed up" was for the spring formal in high school or college. You wore your best *faux* [FOE] (French for "fake") pearls or "gold" cuff links and felt all grown up. But this time, you're talking about Truly Important People you'd like to impress. Surely, the rules are different. What to do?

Don't bust a gusset getting all in a tizzy over such things.

Here is a quick and easy guide to some clothing commandments that are guaranteed always to be in style.

Dealing With Formalities: That Old 'Black Tie' Magic

When an invitation says "black tie," that doesn't simply mean to wear a black tie, nor does it apply only to the male of the species. And it certainly doesn't mean a black tie with the plaid Western blouse or shirt you wear when you take in a Willie Nelson concert.

Black tie is part of the cultural connoisseur's social code, but you don't need a full-blown CIA covert operation to figure out what message it's sending. Basically, black tie means formal attire. For men, that means a black tuxedo (or white in the summer; stay away from the pastels — they tend to make you look like one of John Travolta's pals in the movie *Saturday Night Fever* (and absolutely no camel blazers, please).

For women, black tie means cocktail dresses. And just what's a cocktail dress? You might say it's anything too fancy for the office, but not necessarily a party dress. Unless, of course, the invitation is for a New Year's Eve party, in which case almost anything goes. In any case, running shoes are not permitted for either sex, even if you have seen television and movie celebs dressed that way. For ladies, the ever-fashionable discreet pump with medium heel is always in style (no stilettoes or spikes, please).

It's also acceptable to wear colored bow ties (red, for example) when black tie is indicated. In any case, the tie should be the real thing and not a clip-on. Only teenagers and grocery store clerks wear clip-ons.

However, if the invitation states "white tie," be warned that this signals the most formal of events. For men, that means white shirt, vest and tie, black trousers (with the traditional stripe), tails, and black dress shoes (patent leather is a nice touch, but definitely no loafers!).

For women, it's time to haul out the long gown and the diamond necklace you keep hidden in the fake (*faux*) eggplant in the refrigerator. Although some fashion *mavens* (Yiddish for connoisseurs, especially self-proclaimed ones) declare shorter lengths acceptable, leave the style-setting (and the risk-taking) to others until you're more comfortable with your role in the fashion

scene. And white tie doesn't mean women can't wear black or any other color, for that fact.

It goes without saying that pants are not acceptable for women at any formal event.

Tuxedo Junction: Tails for All Seasons

If a man doesn't wear formal attire often enough to own a tuxedo, he probably also faces the quandary of wondering when he should — or should not — wear a tux. Any social invitation worth attending will, of course, let you know the type of dress required. But what about the symphony, the ballet, and so forth?

Nobody wants to show up in formal clothes when you're the only one decked out that way. Wearing a tux to the company picnic will put a crimp in your style when you try to take part in the office softball game.

It's always acceptable to wear a tux:
• When the invitation says "formal attire" or "black tie";

• When you're going to the symphony, opera or ballet, although generally you'll reserve such dress for opening-night benefits and other such special occasions;

• When one of your children or your ex-wife is getting married;

• When attending a charity function where the price of the tickets is more than season football passes for the local professional or college team;

• When you know the mayor, governor or president will be in attendance.

It's not a good idea to wear a tux:
• When taking in a wrestling match with your friend from the office who insists it's a fun way to spend a Saturday night. In a tux, you'll probably be mistaken for the ring announcer or be asked to fill in for one of the wrestlers' managers — in either case, at some point, you'll probably have a chair smashed over your head;

The hanky would have been useful in Eden

• When bowling, taking in a dollar matinee movie, horseback riding, or hiking the Appalachian Trail;

• When the invitation says "BYOB" ("Bring Your Own Booze" — this is nearly always a tipoff the affair is not formal; wear a tux and people will be asking you to mix drinks for them all night — and with your own booze!).

Less Than Formal Fashion Notes for Women and Men Only

If you wear nothing else at all, carry a hanky.

The handkerchief wasn't invented when Adam and Eve were booted out of the Garden of Eden, but think how handy it would have been when they had to make their hasty exit ("Don't even pack your bags, folks. You've got five minutes to be biblical history"). Instead, they had to settle for some scratchy fig leaves. What if Adam had grabbed a handful of poison ivy by mistake? (Was "Leaves of three, leave them be" even one of the Ten Commandments then?)

At any rate, future generations yet unborn can be grateful Adam didn't latch on to poison ivy. Instead of being plagued by original sin, we'd all be scratching the daylights out of ourselves day and night and be praying for calamine lotion. ("No manna, this time, Lord, just another airdrop of calamine, please.")

There was a time when people always carried handkerchiefs. T. S. Eliot nearly always packed one. It was considered the proper, polite thing to do. Apparently the practice died out when people started making room in their purses and pockets for birth control devices. ("No room for a hanky today, but I'll be sure to pack the diaphragm and a three-day supply of condoms.")

For a woman, a delicate hanky, softly scented with a subtle perfume (Not Lusty Night of the Rutting Musk in Paris No. 7) was just the right hint to drop at social occasions. For a man, a handkerchief was always at hand for dusting off a lady's chair or removing a speck of dust (imaginary or otherwise) after a particularly hard motorcar trip. In a pinch, you could always blow your nose or clean up a spilled drink.

Somewhere along the line, people stopped carrying hankies. Instead an entire generation has come along who can only bleat: "Does anybody have a Kleenex?" How *déclassé* [day-clah-SAY] (the French equivalent of "low-rent").

Usually, of course, if someone does have a Kleenex, it's caked with last month's makeup or cruddy stuff that you don't even want to try to guess the origins of.

Take that first step in returning society to a more civilized time. Be a connoisseur of good taste: Always carry a hanky.

Rally 'Round the Power Handkerchief

In an office setting, you may want to go for the power hanky. For ladies or gentlemen who wear suit coats, this is referred to as the "pocket square." Rather than just stuffing a white hanky in your back pocket or in your purse, dress up your outfit with a colorful pocket square that lets people know you mean business.

Red is the power statement you want to begin with. Blue is your secondary color, followed by white. Yellow is fine, as is green. But avoid pastels; they say you're bold enough to show your hanky, but not brassy enough to do it in style.

It's also best that the handkerchief complement any other major sources of color (shirt, blouse, tie, belt) rather than match it exactly. Matching hanky and tie (you know, the ones that come boxed together for easy Father's Day gift-giving) should be avoided as too much of a good thing. Having the same splash of color in two separate spots simply takes away from the effect of either. If the tie is deep red, then go with a lighter hanky, or vice versa.

A hanky with a tasteful pattern (but nothing that anyone with 20/20 vision can detect from more than three feet away) is acceptable.

Hint: Avoid the American farmer bandanna pattern and the checkered tablecloth design.

It's All a Matter of Good Taste

Good taste in jewelry means more than biting into someone's ring to see if it's the real thing or just part of a six-piece *faux* gold ensemble ordered from television for $19.95. Discretion and understatement are the keys to good taste. Not everyone who can afford jewelry has enough of either.

Generally, the idea is that gobs of jewelry are a good investment, and, hey, you can wear the stuff and impress people at the same time. Slaves as they are to the bigger-is-better theory of life, some people tend to deck themselves out in tons of gold chains, precious stones, watches, and other assorted baubles, bangles, and beads. They are, in a word, gaudy.

The hands especially should never be "dripping with diamonds." If you've amassed an enviable collection of stones over the years, it's much better that you show them one piece at a time.

It makes you wonder why some insecure souls don't simply wear a sandwich board with an accountant's appraisal of their net worth. Or, how about one of those stick-on name tags? "Hi, I'm Pat. I'm worth a cool $2.5 million."

For a woman, the watch can be an expressive piece of jewelry that adds to her overall fashion statement. For a man, the watch can be his most important piece of jewelry. For every day, working at the office, it could possibly be his only piece of jewelry, apart from a ring or possibly a collar bar or cuff links.

In either case, the watch should not shout out its existence to anyone within a hundred yards. Such, of course, is exactly the problem with some of the bigger, bulkier show-timepieces (Rolexes included) that you see more and more often these days.

Stay away from digital, mass-produced watches if you want to make a fashion statement. Granted, you can spend big bucks on a digital watch, but why do so just to look like everybody else? You want to separate yourself from the pack to express your own individuality in a classic, sensible way. Classic watches still have those funny devices (*hands*) on them, and you still have to pick up the knack of telling time at some point in your life ("When the big hand is on five and the little hand is on twelve, it's five o'clock.).

While a Rolex is a fine watch (and expensive, to boot), the true

connoisseur would prefer the prestige of a fine collectible watch, such as a Swiss Patek Philippe, a line that has been manufactured for almost 150 years. Such watches can cost anywhere from one thousand to forty thousand dollars and are vintage examples of the watchmaker's art.

Other classics include Cartier, Vacheron & Constantin, as well as the American-made Bulovas and Hamiltons.

A White Sport Coat, a Pink Carnation, But No White Socks

There is nothing morally wrong with a man wearing white socks. But, remember Ecclesiastes: "There is a time for white socks and there is a time for black socks." Most formal occasions call for black or navy socks. White socks look especially bad when a man is wearing a tux. They're also not acceptable for office wear, unless the office is the pro shop at the local country club.

For women, the fad of wearing socks with heels is frowned upon. At formal occasions, hosiery should be the sheerest, in a color that matches your footwear; fancier silks and shimmery silk imitations are permissible.

How it became faddish to dress to the nines for the office or the opera and then sign the whole outfit off with a pair of dirty (or clean, for that matter) running shoes is one of those subjects best left to objective anthropologists in the next century. Humans who wear running shoes anywhere except to the supermarket or to the gym (or, heaven forbid, while running) should have their family trees checked for termites.

Some defenders of this practice argue in its behalf on the basis of comfort. One only wonders what comes next. Will flannel nightgowns and striped pajamas become acceptable office wear? Or tennis skirts and shorts in the summer? Suffice it to say that *outré* [oo-TRAY], the French word applied to any sort of exaggerated (literally, outrageous) behavior, is the most generous description for such antics.

Running shoes are not appropriate business attire

Fashionable Terms and Names of Note

Although *Women's Wear Daily* can keep you posted on what's going on in the rag trade, and *GQ* or *W* or *Cosmopolitan* can show you what it's hip to wear, there are some fashion names and terms you'll encounter from time and time that it's *assumed* you already know. In case, you don't, here goes.

Beau Brummell: He was actually George Bryan Brummell, a friend of the Prince of Wales (later George IV) and an English style trendsetter of the early nineteenth century. Unfortunately, his fondness for gambling outstripped his ability to meet his debts, and he had to flee to France in 1816 to escape creditors. The same habits that led to his downfall in England subsequently resulted in his being tossed into a cell in France. Having friends in the right royal places, however, led to his appointment as British consul. He died in 1840 in a lunatic asylum. His name, however, is still associated with elegance and good taste in dress.

Braces: In England, and in the trendier fashion shops, this is what they call suspenders.

Chesterfield: A single-breasted, beltless overcoat, usually with a velvet collar.

Cummerbund: Fashion import from India, thanks to the British raj and all that stuff, old chap, the cummerbund is a wide waistband, in various colors, worn with formal wear in the West.

Dashiki: Loose-fitting robe or tunic modeled after African tribal garment; despite the sound of the name, the word was actually coined by a manufacturer in 1967.

Designers/Labels: Names worth knowing (or to drop) include Giorgio Armani, Geoffrey Beene, Bill Blass, Pierre Cardin, Liz Claiborne, Christian Dior, Perry Ellis, Romeo Gigli, Nancy Johnson, Anne Klein, Calvin Klein, Christian Lacroix, Karl Lager-

feld, Maryll Lanvin, Ralph Lauren, Claude Montana, Evan-Picone, Oscar de la Renta, Mary Ann Restivo, Yves Saint-Laurent, Ann Taylor, Emanuel Ungaro and Mario Valentino.

French cuff: Not a form of masochistic behavior related to the French kiss; it's simply a double cuff that folds back on itself; for use with cuff links; generally not considered quite as functional as the single cuff, which tends to fit better in a coat sleeve.

Lady Godiva: Fashionable eleventh-century noblewoman who taught her husband, Leofric, the earl of Mercia, the true dangers of offering a woman a tempting dare. According to legend, she rode naked — *au naturel* [oh-nah-too-REHL] as the French put it — on a white horse through the streets of Coventry, England, after the earl promised to reduce the tax burden of the people if she would do so.

Godey's Lady's Book: Founded in 1830 by Louis Antoine Godey, this Philadelphia magazine was the first successful women's periodical in the United States.

Madras: Cotton fabric named after the Indian port city; usually in colorful plaids, noted for its tendency to "bleed," which allows the fabric to change its look as it is washed.

Morning coat: The formal cutaway coat worn as formal daytime wear for men. Don't get confused and think it's a *mourning coat* for solemn occasions such as funerals.

Oxford cloth: Heavy, basketlike weave used in making blouses and shirts, usually of cotton.

Paisley: Intricate, colorful pattern that returned to popularity briefly during the sixties; paisley patterns resemble a colorful collection of slipper-shaped paramecia.

Savile Row: Section of London's West End known for its quality tailoring shops. Here, you can purchase custom-made shirts, fine suits, the works. Just as Fleet Street is known as the home of London's press lords (though most have abandoned the street itself) and Harley Street is where the city's top doctors have their offices, Savile Row is home to many of the city's finest tailors.

Tattersall: Checkered pattern originally used in blankets at Richard Tattersall's horse market in London.

Zoot suit: High-waisted, baggy pants, with narrow cuffs, worn with a too-long coat; popularized in the thirties.

Keeping One Step Away From the Crowd

Well-dressed people for years have avoided trendiness when it comes to clothing. Check out any of the authorities on the subject (*Dress for Success* or *The Woman's Dress for Success Book*, among others) and you'll find the same message: In formal and business settings, the conservative dresser, the one who doesn't swing and sway to the winds of the moment, will always come out ahead.

That doesn't mean you can't slip into sneakers and jeans while sitting on the dock during a weekend at a mountain lake, but keep in mind that casual clothing is simply that: casual, and not intended for formal or office wear.

Fortunately, the rules of decorum for formal and business attire have changed little over the years.

At any rate, you can let someone else take the lead when it comes to being avant-garde (a trendsetter, in fashion or other fields). The best rule of thumb when it comes to clothing is to follow the established rules until you're comfortable enough to know when and how much you can deviate from the accepted norm.